DATE DUE

NO 13'00		
OC 31'01		
JE 11'03		

Sculpture of
the Kamakura Period

Volume 11

THE HEIBONSHA SURVEY OF JAPANESE ART

For a list of the entire series see end of book

CONSULTING EDITORS

Sculpture of the Kamakura Period

by HISASHI MORI

translated by Katherine Eickmann

New York · WEATHERHILL/HEIBONSHA · Tokyo

This book was originally published in Japanese by Heibonsha under
the title *Unkei to Kamakura Chokoku* in the Nihon no Bijutsu series.

A full glossary-index covering the entire series will be published
when the series is complete.

First English Edition, 1974

*Jointly published by John Weatherhill, Inc., 149 Madison Avenue, New York,
New York 10016, with editorial offices at 7-6-13 Roppongi, Minato-ku, Tokyo
106, and Heibonsha, Tokyo. Copyright © 1964, 1974, by Heibonsha; all rights
reserved. Printed in Japan.*

LCC Card No. 73-88470 ISBN 0-8348-1017-4

Contents

Sculpture of
the Kamakura Period

The Beginnings of Kamakura Sculpture

THE OPENING OF the Kamakura period (1185–1336) marked one of the most crucial turning points in Japanese history. During the tenth and eleventh centuries the aristocratic Fujiwara clan had been the ruling power, with complete control over the imperial court in Kyoto and the government of the country. But the Fujiwara became so involved in the pursuit of the cultured, leisurely pleasures of court life that they neglected the martial arts and came to rely on warrior clans from the outlying provinces for the maintenance of their political strength. In this lay their downfall. The twelfth century saw the rise to power of two rival clans, the Taira and the Minamoto. For a brief period the Taira enjoyed absolute authority under the leadership of the dynamic Taira Kiyomori* (1118–81). In 1160, Yoshitomo, the leader of the Minamoto clan, was assassinated after an unsuccessful bid to overthrow Kiyomori, and Yoshitomo's four youngest sons were sent into exile. Twenty years later, however, just a short while after the death of the aged Kiyomori, Yoritomo (1147–99), the eldest of the surviving Minamoto sons, rose in rebellion against the Taira and defeated them in the long

and bloody Gempei War (1180–85). Yoritomo, one of Japan's greatest generals and statesmen, reorganized the administration of the country and established the capital of his *bakufu*, or military government, at Kamakura, hundreds of miles east of Kyoto and the debilitating influence of court life. The power of the aristocratic Fujiwara was ended, and the long age of Japan's military feudalism, which would last, under one warrior clan or another, until the Meiji Restoration in 1868, had begun.

THE NARA BUSSHI In the midst of this political and social upheaval, an innovative style in Buddhist statuary was born. The brilliant sculptor Unkei (d. 1223) is so well known as the representative artist of this genre that his name comes to mind immediately at the very mention of Kamakura-period sculpture. Indeed, Unkei was largely responsible for the formation of this new style. Before we discuss his life and art, however, let us examine his origins.

He was born into a sort of guild of professional sculptors, or *busshi*, as they were called—a title that literally means "Buddhist master." Although they were laymen with independent workshops, the busshi exclusively produced statuary for Buddhist temples. Each group of busshi had a hereditary

* The names of all premodern Japanese in this book are given, as in this case, in Japanese style (surname first); those of all modern (post-1868) Japanese are given in Western style (surname last).

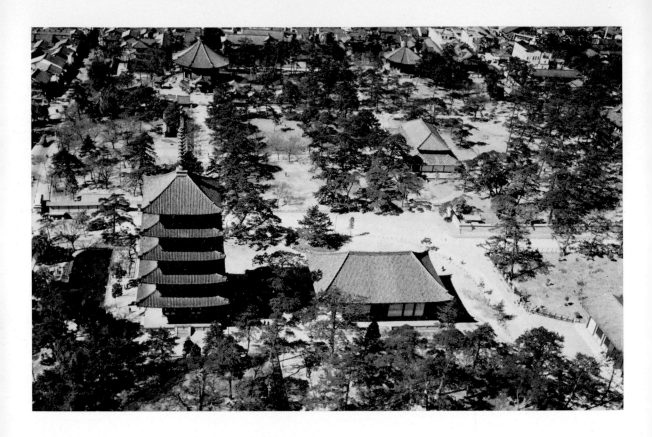

chief, and Unkei's father, Kokei, was the head of a line of busshi who had lived in the city of Nara for generations.

The founder of this Nara line was a busshi from Kyoto named Raijo. Raijo was the successor of Kakujo, who in turn was the successor of the great Jocho (d. 1057), a busshi whose genius earned him the patronage of the Fujiwara clan when they were at the peak of their power. Despite his prestigious background, Raijo was not content in Kyoto. An extremely powerful group of busshi had formed around Jocho's apprentice Chosei, and still another group was headed by Kakujo's apprentice Injo. Raijo decided to leave Kyoto, where the production of sculpture was completely controlled by these two groups, and concentrate his activities in the former capital city of Nara. There seem to have been cer-

tain complicated circumstances behind his move, but the details are not clear at present.

As far as considerations for the future of this offshoot group of busshi were concerned, however, Raijo's move to Nara was wise indeed. The Ko-fuku-ji, clan temple of the influential Fujiwara, was located in Nara, and Kakujo in the previous generation and Jocho before him had participated in the production of Buddhist statuary there. It so happened that the Kofuku-ji had been destroyed by a fire in 1096, and Raijo undertook the repair of its Buddhist images. In reward for this, he received the title *hokkyo*, a Buddhist priestly rank often conferred on artists. In this way Raijo's sphere of activity shifted to Nara, and he came to be thought of as a busshi connected with the Kofuku-ji.

1. *Aerial view of Kofuku-ji, Nara, from the east. At lower left is the Five-storied Pagoda; to the right of it, the Tokondo (East Golden Hall). The circular building at top left is the Nan'endo (South Octagonal Hall); the one at top right is the Hokuendo (North Octagonal Hall). At center right, below the Hokuendo, is the Chukondo (Middle Golden Hall).*

2. *Ni-o (Naraen Kongo), by Unkei and Kaikei. Painted wood; height of entire statue, 848 cm. Dated 1203. South Main Gate, Todai-ji, Nara. (See also Figures 41, 53.)*

Raijo's successor, Kojo, was also known by the people of his time as a Nara busshi. It is evident that Kojo settled permanently in Nara, where he had both a home and a workshop. He was succeeded by Kocho. Since there were no large-scale projects to work on in Nara during the lifetime of either Kojo or Kocho, they often undertook assignments in Kyoto. But there is no doubt that they had their base in Nara.

Kocho was succeeded by Seicho. In 1180, when Seicho was head of the Nara busshi, both the Kofuku-ji and the Todai-ji, another famous Nara temple, were burned to the ground by the forces of one of Taira Kiyomori's sons because the priests and monks of these two temples were known to be in sympathy with the rebelling Minamoto. (The Great Fire of 1180 and its far-reaching effect on

Unkei and the Nara busshi will be discussed in detail in the following chapter.) In 1181, Seicho presented the imperial court in Kyoto with a genealogy of the Nara busshi in which six generations were listed: Jocho, Kakujo, Raijo, Kojo, Kocho, and Seicho. This genealogy was part of a claim pleading the right of the Nara busshi to reconstruct the statuary of the Kofuku-ji, which was located in their own territory. Seicho made his claim in an attempt to prevent all the important reconstruction work from being awarded to the aggressive Kyoto busshi. The two groups of busshi who had forced Raijo to move to Nara were still extremely powerful, one of them headed by Inson, a descendant of Injo, and the other by Myoen, a descendant of Chosei.

It is not clear to what extent Seicho succeeded in

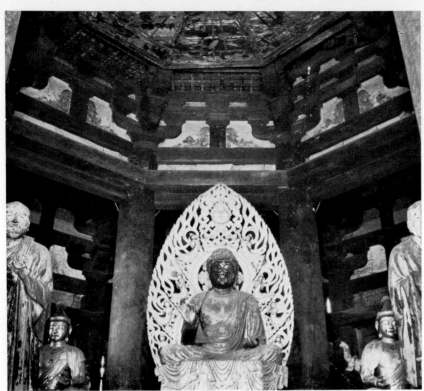

3. *Interior view of Hokuendo, Ko-fuku-ji, Nara. Statues from left to right: Seshin, Daimyoso Bosatsu, Miroku Butsu, Ho-onrin Bosatsu, Mujaku.*

4. *Genealogy of the major busshi of* ▷ *Kyoto and Nara.*

his claim at this time. We do know, however, that in 1185 he was invited to Kamakura by Minamoto Yoritomo to produce the Buddhist statuary for the now vanished Shochoju-in, thus paving the way for the movement of the Nara busshi to the east. Although Seicho appears to have been a very energetic and creative artist, he did nothing else outstanding after his work in Kamakura, and his name disappears in the stream of time. Since he left no son to succeed him, it is possible that he died at an unusually early age.

The Nara busshi line was carried on by Unkei's father, Kokei, who had no blood ties with Seicho. No one has been able to trace Kokei's ancestors with any accuracy, but it is thought that he was an apprentice of either Kojo or Kocho. Kokei came to be head of the Nara group at a time when the restoration of the Buddhist statuary in the Kofuku-ji and the Todai-ji (both destroyed in the Great Fire of 1180, as we have previously noted) was being carried out on a grand scale, and in this venture the activities of the vigorous Nara busshi group became prominent. Unkei, who was already regarded as an exceptional sculptor at the time, played an important part in the work—perhaps a more important part than that of Kokei, his aged father, whose assistant he technically was.

TRADITION AND CREATIVITY As we have already noted, when we trace Unkei's predecessors, at least after Raijo, we find that these busshi worked largely with Nara as their base. In that sense there can be no objection to labeling them the Nara busshi. It goes without

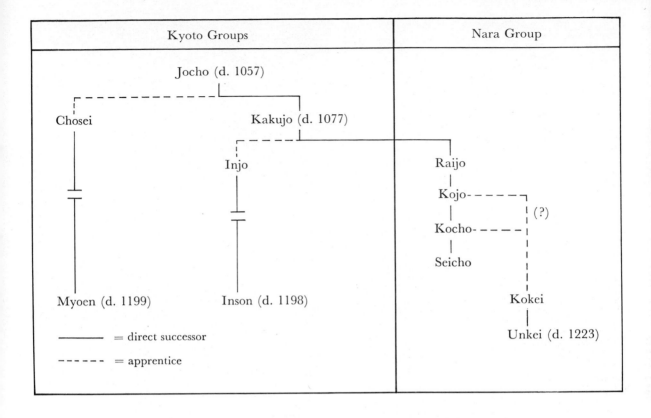

Kyoto Groups	Nara Group

Jocho (d. 1057)

Chosei Kakujo (d. 1077)

Injo Raijo

Kojo

Kocho

Seicho

Myoen (d. 1199) Inson (d. 1198) Kokei

(?)

Unkei (d. 1223)

———— = direct successor

‐ ‐ ‐ ‐ ‐ ‐ = apprentice

saying that the city of Nara was famed for its traditional sculpture produced during the late Nara period (710–94). In particular the Kofuku-ji, with which the Nara busshi had a very close relationship, was a stronghold of such traditional art. Thus it was only natural for the late-Nara sculptural style to exert a strong influence on the Nara busshi, who carried on their work in such surroundings.

Since Kokei is the only one of all the Nara busshi before Unkei to be represented by any sculpture that survives today, it is not sufficiently clear what the characteristics of this group's style were. It should be pointed out, however, that Kokei's surviving works in the Nan'endo (South Octagonal Hall) of the Kofuku-ji—including the Six Patriarchs of the Hosso Sect (in Japanese, Hosso Rokuso; Figs. 33–35, 55, 146, 147); the Four Celestial

Guardians, or Shitenno (Figs. 5, 6); and the Fuku-kenjaku Kannon (Figs. 9, 12)—already show a tendency toward the innovative style of Kamakura sculpture, while at the same time they strongly reflect the traditional style of the late Nara period. This unusual stylistic mixture will be discussed in more detail in later chapters.

Also, although Kocho's statue of Dainichi Nyo-rai, carved in 1158 for the Henjo-in on Mount Koya, in Wakayama Prefecture, is no longer extant today, it is of interest to note that a member of the Kyoto aristocracy criticized the statue as being "extraordinarily crude." Undoubtedly this denunciation shows that Kocho's statue, in comparison with the refined sculpture being produced by the Kyoto busshi at that time, had a kind of primitive strength.

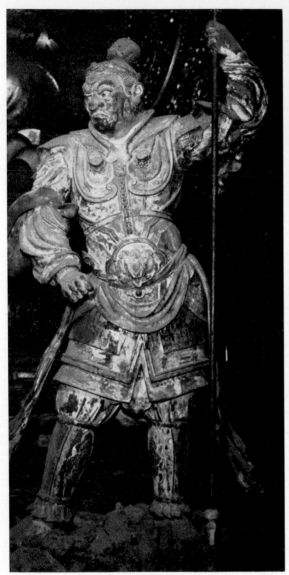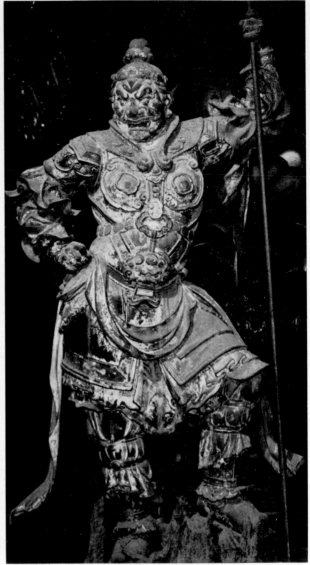

5. *Jikoku Ten, one of the Shitenno (Four Celestial Guardians), by Kokei. Painted wood; height of entire statue, 207 cm. Dated 1189. Nan'endo, Kofuku-ji, Nara.*

6. *Zocho Ten, one of the Shitenno (Four Celestial Guardians), by Kokei. Painted wood; height of entire statue, 203.6 cm. Dated 1189. Nan'endo, Kofuku-ji, Nara.*

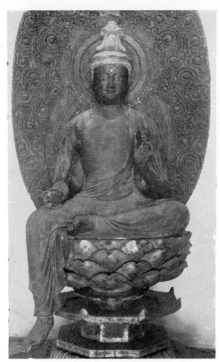

7. Seishi Bosatsu. Lacquer and gold leaf over wood; height, 100 cm. Dated 1151. Chogaku-ji, Nara Prefecture.

8. Amida Nyorai. Lacquer and gold leaf over wood; height of entire statue, 143 cm. Dated 1151. Chogaku-ji, Nara Prefecture.

Actually there is one example that gives us some idea of what the Nara busshi style might have been like before Kokei. This is the Amida Triad (Amida Sanzon), consisting of Amida Nyorai (Fig. 8) and his attendant Bodhisattvas (Bosatsu), Kannon and Seishi (Fig. 7), enshrined in the Chogaku-ji, a temple located at Yanagimoto in the outlying regions of Nara Prefecture. An inscription establishes the date of its production as 1151, but the sculptor's name does not appear. The figures in this triad, with their proud, stately bodies and deeply carved garments, are quite different from the more delicate, elaborate statuary common to this period. This difference can be attributed either to the influence of the traditional sculptural style of the late Nara period or to the fact that the new

Kamakura-period genre had already begun to appear. Moreover, all three figures in the triad have crystal eyes set in from the inside, and it is of great interest to find such an early use of this realistic technique, which became quite popular in Kamakura times. Also, both of the attendant Bodhisattvas have intellectual facial expressions and high topknots done in the Chinese style of the Sung dynasty (960–1279). Such features are all part of the new Kamakura-period genre of sculpture. Considering both the location and the special characteristics of the Amida Triad, I believe it is safe to assume that the creator of this unusual work was a member of the Nara busshi group. Perhaps Kocho's statue of Dainichi Nyorai at the Henjo-in was similar in style to the Amida Triad at the Chogaku-ji.

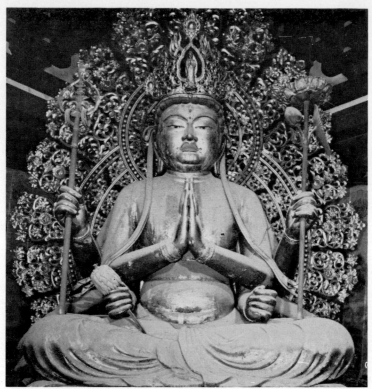

9. *Fukukenjaku Kannon, by Kokei. Lacquer and gold leaf over wood; height, 348 cm. Dated 1189. Nan'endo, Kofuku-ji, Nara. (See also Figure 12.)*

Because of the very nature of their locale, the Nara busshi were influenced by the time-honored traditions of late-Nara sculpture and thus left behind unique works. If we consider this matter only superficially, we might conclude that the influence of such an ancient artistic tradition was a conservative one. But it is also possible for such an ancient tradition to inspire a breakthrough into a fresh and innovative art form. This is what happened in the case of the Nara busshi. Instead of mechanically copying the late-Nara sculptural style, they took fresh life from it and created a new and different style of their own. The Amida Triad at the Chogaku-ji shows this creative trend quite well, and we can foresee in it the advent of the Kamakura sculptural style.

We should also note that the Nara busshi group formed and developed during a time of unprecedented change: the twelfth century, when the warrior class replaced the aristocracy as the rulers of Japan. Socially and culturally, old frameworks were shattered, and a growing expectation of something new was in the air. Even in sculpture and painting, it was as though the approaching footsteps of the Kamakura age could be heard. But it was in the Nara area rather than in Kyoto that the early stirrings of the new genre in Buddhist sculpture were first felt. The so-called Nara busshi group was of central importance in this artistic revolution, and it is therefore not at all surprising that Unkei, who inherited their leadership, brilliantly brought this new style of sculpture to fruition.

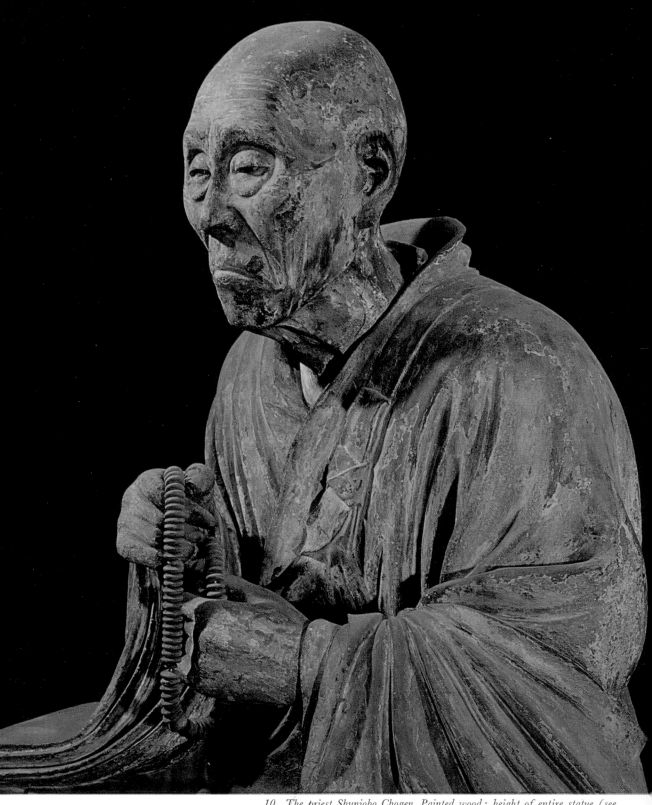

10. *The priest Shunjobo Chogen. Painted wood; height of entire statue (see Figure 137), 82 cm. Early thirteenth century. Shunjodo, Todai-ji, Nara.*

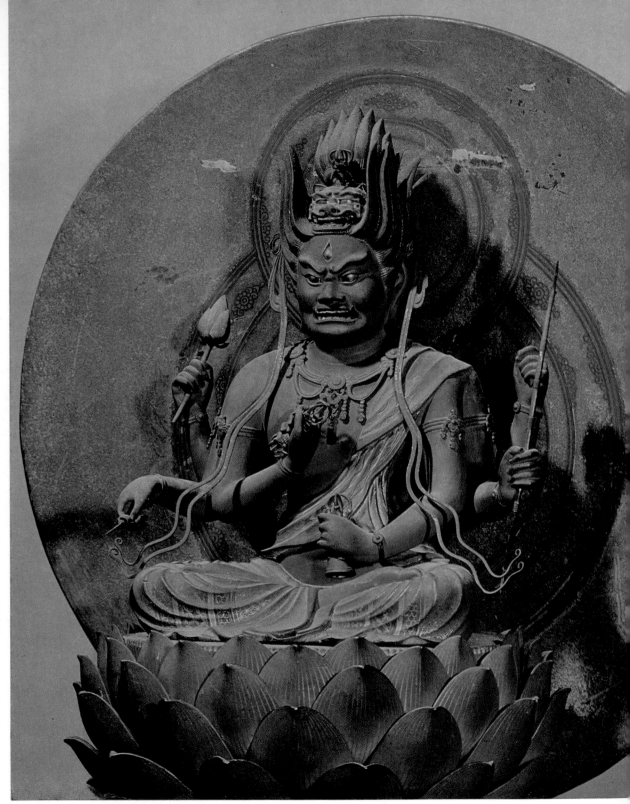

11. Aizen Myo-o, by Zen'en. Painted wood; height, 42.4 cm. Dated 1247. Aizendo, Saidai-ji, Nara.

12. Fukukenjaku Kannon, by Kokei. Lacquer and gold leaf over wood; height, 348 cm. Dated 1189. Nan'endo, Kofuku-ji, Nara. (See also Figure 9.) ▷

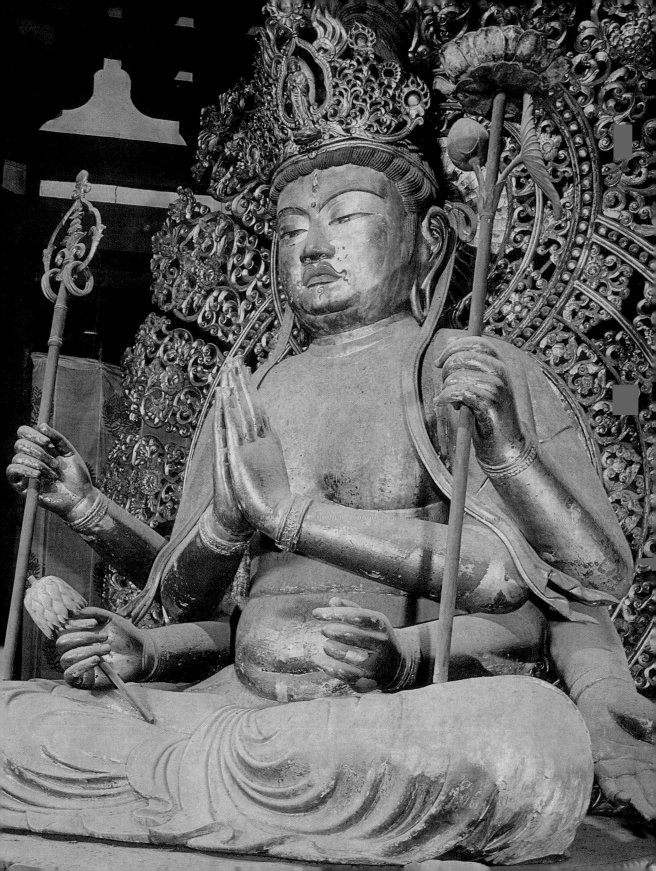

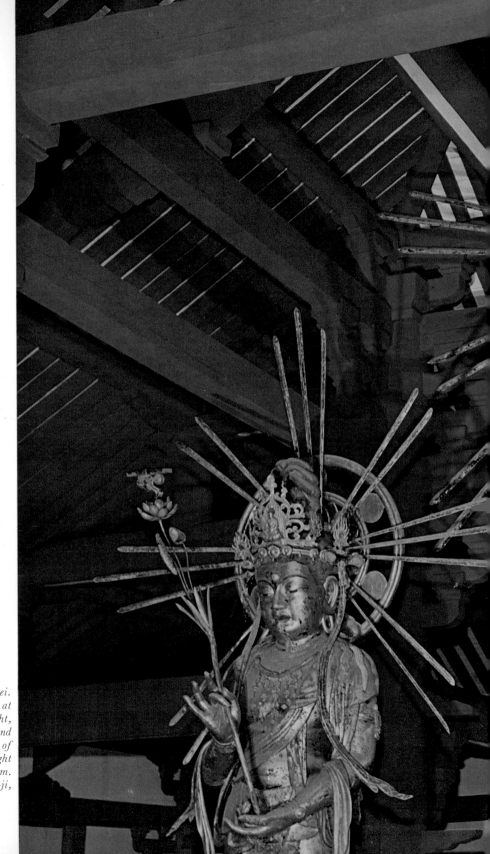

13. *Amida Triad, by Kaikei. At center, Amida Nyorai; at left, Kannon Bosatsu; at right, Seishi Bosatsu. Lacquer and gold leaf over wood; height of Amida Nyorai, 530 cm.; height of each attendant, 371 cm. Dated 1197. Amidado, Jodo-ji, Hyogo Prefecture.*

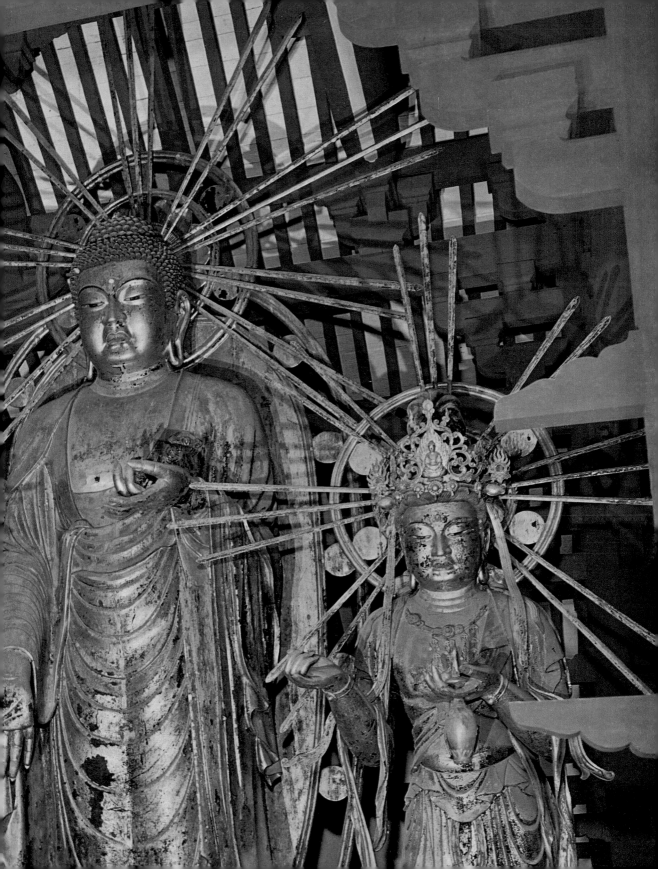

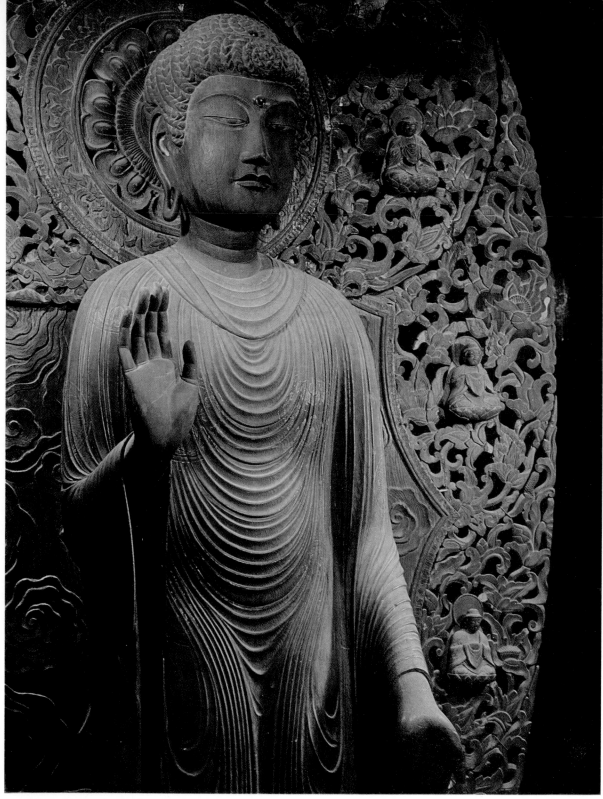

*14. Shaka Nyorai, by Zenkei. Unpainted wood with gold-leaf patterns;
height of entire statue, 167 cm. Dated 1249. Saidai-ji, Nara.*

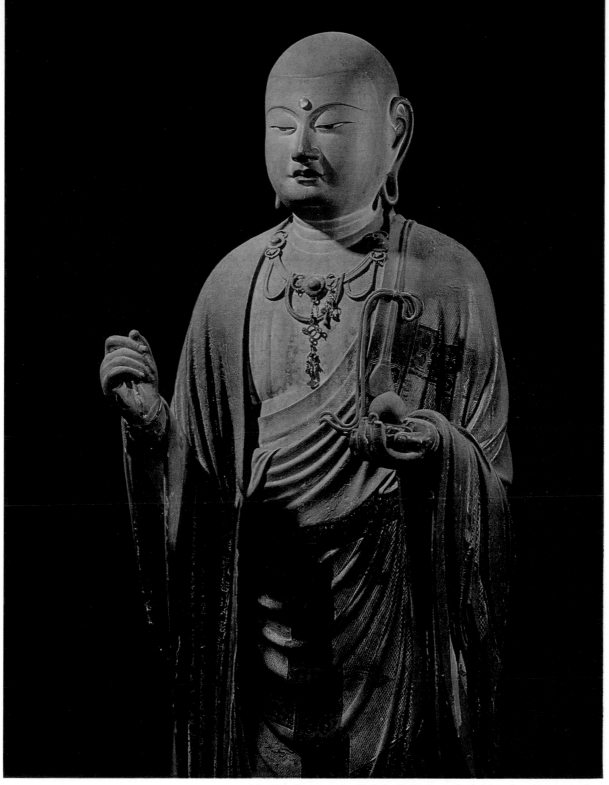

15. *Jizo Bosatsu, by Kaikei. Painted wood; height of entire statue (see Figure 152), 90.6 cm. Early thirteenth century. Kokeido, Todai-ji, Nara.*

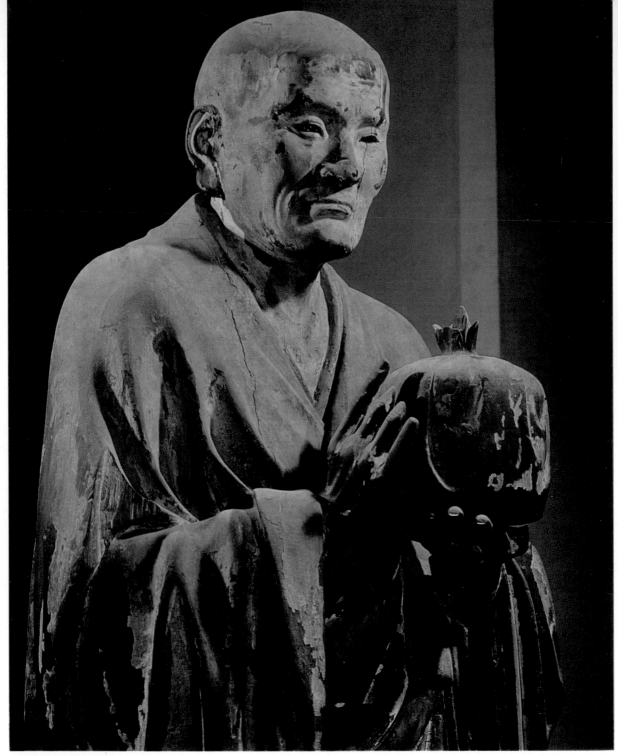

16. *The Indian patriarch Mujaku, by Unkei. Painted wood; height of entire statue (see Figure 149), 194 cm. About 1208–12. Hokuendo, Kofuku-ji, Nara. (See also Figure 48.)*

CHAPTER TWO

Unkei: The Man and His Art

THE EARLY YEARS Before we begin the story of Unkei's spectacular artistic career, let us examine the wooden statue, thought to be a portrait of him, that stands in the Rokuhara Mitsu-ji in Kyoto (Fig. 18). It is the only likeness of him that we have, and it shows him as a Buddhist monk with a rosary in his hands. But this is no ordinary Buddhist monk. The aged face has an obstinate severity, and the hands are big and strong. Indeed, this statue looks very much like a portrait of a sculptor. It was undoubtedly produced somewhat later than 1223, the year of Unkei's death, but we cannot help feeling that there was some reliable source or other from which the unknown busshi who carved it was able to copy these features.

The earliest existing work authentically produced by Unkei is the statue of Dainichi Nyorai at the Enjo-ji, in Nara (Figs. 17, 49, 60, 61, 145). According to the inscription on the pedestal, work on the statue began late in 1175 and ended nearly a year later, in 1176. Unfortunately the date of Unkei's birth is uncertain, but we know from this inscription that he must have been active as a busshi before 1175. Since he died nearly fifty years later, he must have been quite young when he carved this image of Dainichi Nyorai. In fact, the inscription, which identifies him as "the chief busshi Unkei, true apprentice of Kokei," makes it clear that Unkei made the statue under the guidance of his father, Kokei, while he was still a youth and perhaps not entirely independent as a busshi. Furthermore, the words "true apprentice" signify that Unkei was actually Kokei's son as well as one of his apprentice sculptors.

In 1175, when the Taira were still in power, the loveliness and delicate charm of the aristocratic Fujiwara clan's culture lingered on. Looking at Unkei's statue of Dainichi Nyorai, few of us can fail to experience a sense of tranquility that links this work with the representative sculpture of the Fujiwara period (897–1185). But let us compare it with another work produced in the very same year, 1176, by the Kyoto busshi Myoen: the group of the Five Great Kings of Light, or Go Dai Myo-o, at the Daikaku-ji, in Kyoto (Figs. 19–23). Although these statues have the extremely polished style so favored by the aristocracy, they are lacking in inner strength. Certainly Unkei's Dainichi Nyorai does not display the stylish taste of Myoen's Go Dai Myo-o, but there is a natural calmness about its pose and an animated youthfulness in the fully fleshed face. Moreover, the Dainichi Nyorai has crystal eyes set in from the inside and a large, high topknot, in which features we note the early appearance of the new Kamakura style in Buddhist statuary. These features are quite similar to those pointed out in our discussion of the Amida Triad at the Chogaku-ji and are definitely part of the style common to the Nara busshi of the latter part of the twelfth century. Thus the statue of Dainichi Nyorai speaks clearly to us of the origins of Unkei,

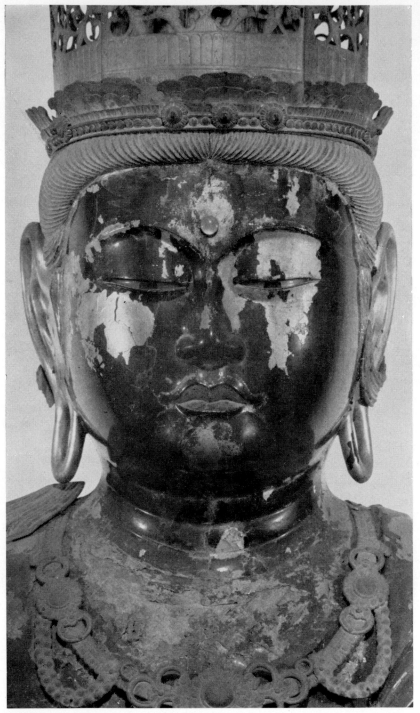

17. Dainichi Nyorai, by Unkei. Lacquer and gold leaf over wood; height of entire statue (see Figure 145), 101 cm. Dated 1176. Enjo-ji, Nara. (See also Figures 49, 60, 61.)

18 (opposite page, left). The sculptor ▷ Unkei. Painted wood; height, 77.6 cm. Thirteenth century. Rokuhara Mitsu-ji, Kyoto.

19 (opposite page, right). Kongo ▷ Yasha Myo-o, one of the Five Great Kings of Light, by Myoen. Painted wood; height, 69.7 cm. Dated 1176. Daikaku-ji, Kyoto.

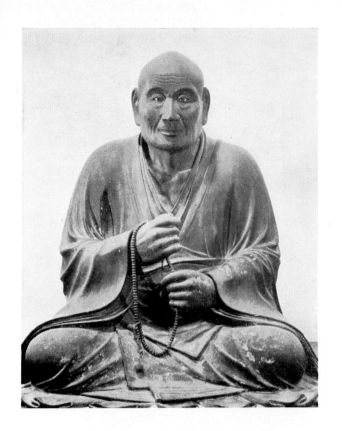

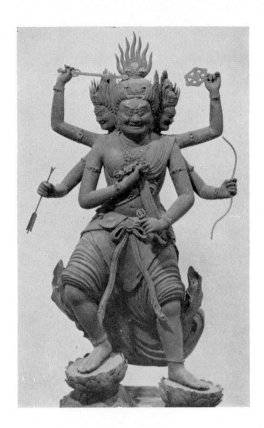

the Nara busshi. At the same time it is a magnificent work of art that gives us a glimpse of the character of the man who would later gain fame as one of the greatest sculptors in Japanese history.

The Gempei War, which we took note of in the previous chapter, came just four years after the young Unkei completed his statue of Dainichi Nyorai for the Enjo-ji. It began in the spring of 1180, when Minamoto Yorimasa, an aged Kyoto courtier and a distant relative of the banished Minamoto Yoritomo, plotted to overthrow the Taira and place on the imperial throne the dissatisfied Prince Mochihito, who had been bypassed for the succession in favor of Taira Kiyomori's infant grandson, the emperor Antoku. The plot was discovered and ended in death for Yorimasa and Prince Mochihito, but this incident served to incite Yoritomo to raise troops in rebellion from his place of exile on the Izu Peninsula in eastern Japan. The enmity between the Taira and the Minamoto, which had smoldered for nearly two decades, now burst into flames of war. Late in 1180, on the twenty-eighth day of the twelfth month, Taira Shigehira, one of Kiyomori's sons, set fire to the Kofuku-ji and the Todai-ji, which were regarded as powerful centers of anti-Taira sentiment. In one night all the buildings and Buddhist statuary of these two temples, the pride of Japan since the eighth century, were reduced to ashes. Shigehira had committed a rash and foolish act that aroused the antipathy of all men of conscience. The Taira were only digging their own grave.

Such an unexpected tragedy undoubtedly came as a shock to Kokei, Unkei, and the other Nara

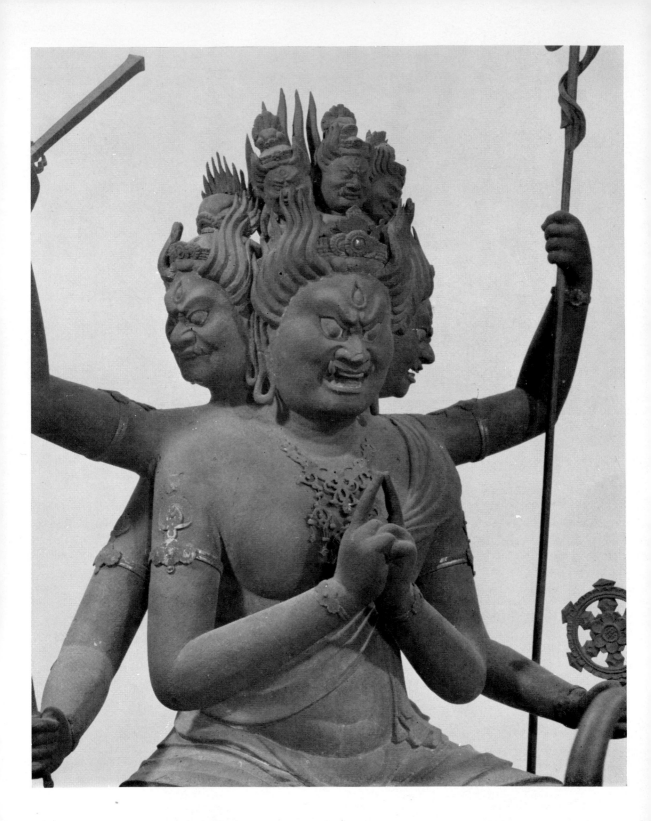

◁ *20. Daiitoku Myo-o, one of the Five Great Kings of Light, by Myoen. Painted wood; height of entire statue, 58.2 cm. Dated 1176. Daikaku-ji, Kyoto.*

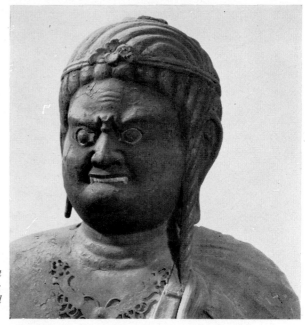

21. Fudo Myo-o, one of the Five Great Kings of Light, by Myoen. Painted wood; height of entire statue, 51.5 cm. Dated 1176. Daikaku-ji, Kyoto.

busshi. As a result, however, they were provided with a superb opportunity to show their skills in the replacement of the destroyed Buddhist images. In this sense the Great Nara Fire of 1180 was truly an epoch-making event.

It was just at this time that Unkei arranged to have the *Hoke-kyo* (Lotus Sutra), one of the sacred Buddhist scriptures, transcribed. In this, he was following the common practice of commissioning professional sutra scribes to copy out a sutra as a means of petitioning the Buddha for a favor. Fortunately, seven of the eight scrolls of the *Hoke-kyo* transcription commissioned by Unkei have been preserved, and a copy of the postscript of the missing first scroll also survives. Each scroll has a postscript, and there are also inscriptions on the shafts of the scrolls. According to these sources, two copies of the sutra were originally commissioned, one copied by the scribe Chinga and the other by the scribe Eiin. The extant copy was transcribed by Chinga. In the postscript to the eighth scroll (Fig. 62), the petitioner who commissioned this tran-

scription is clearly named as "the priest Unkei, with the support of his benefactress Ako Maru." Since the names of a number of Nara busshi contemporary with Unkei—including Kaikei, Ryokei, Genkei, Jokei, and Ninkei—also appear in this postscript, there can be no doubt that the petitioner was none other than the Nara busshi Unkei.

Unkei first thought of commissioning a transcription of the *Hoke-kyo* as early as 1177 or even before, but he let several years pass without realizing his plan. It was not until 1183 that he finally achieved his goal and, with the aid of his patroness Ako Maru, saw two copies of the sutra completed.

In 1175, Unkei had just begun his first important assignment: the statue of Dainichi Nyorai at the Enjo-ji. Then came the Great Nara Fire of 1180. Three years after that tragedy Unkei's sutra transcriptions were completed. If we consider the transcriptions in connection with the rapid changes of circumstances, it is possible for us to guess at what Unkei's hidden feelings were at that time.

We should not forget that throughout the Fuji-

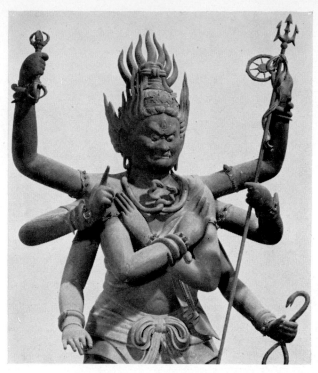

22. *Gundari Myo-o, one of the Five Great Kings of Light, by Myoen. Painted wood; height of entire statue, 69.2 cm. Dated 1176. Daikaku-ji, Kyoto.*

wara period the Nara busshi were thought of as an obscure group of provincial sculptors. After the Great Nara Fire they were offered an unexpected chance for fame in the restoration of the Buddhist statuary of the Kofuku-ji and the Todai-ji. Although there were difficulties at first, they did not miss this golden opportunity, and they demonstrated all their accumulated abilities in a burst of outstandingly creative activity. Could it not be that Unkei, when he finally decided to have the sutra transcriptions made, was secretly praying for the success of the Nara busshi during this crucial period? The purpose of the transcriptions is stated simply as a "great petition." We have no concrete explanation of the nature of this petition, but a very important clue lies in the use of wood from the charred pillars of the Todai-ji for the scroll shafts. It is no mere supposition that the eager young Unkei looked upon the restoration of the Buddhist statuary in the Kofuku-ji and the Todai-ji as the

chance of a lifetime. Although he did not declare it openly, surely his "great petition" in commissioning the transcriptions of the *Hoke-kyo* was for success in this project.

UNKEI'S SOJOURN IN EASTERN JAPAN

After the Great Nara Fire, restoration work began at the Todai-ji. In the sixth month of 1181, Fujiwara Yukitaka was appointed director of reconstruction of the temple buildings and the statuary they were to contain. The tireless priest Shunjobo Chogen (1121–1206) had already begun the collection of contributions to finance the monumental task of restoring the Todai-ji and was promoting the cause with fervor. The first and most important project was to recast the melted head and right hand of the temple's Daibutsu (Great Buddha), an enormous bronze statue of the Buddha Birushana (Vairocana). Under the direction of Ch'en Ho-ch'ing, a crafts-

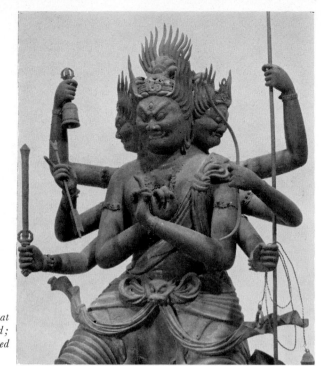

23. *Gozanze Myo-o, one of the Five Great Kings of Light, by Myoen. Painted wood; height of entire statue, 68.2 cm. Dated 1176. Daikaku-ji, Kyoto.*

man brought over from Sung-dynasty China, the casting was begun, and in the eighth month of 1185 the official celebration for the completion of the newly repaired Daibutsu took place. Then began the construction of the Daibutsuden (Great Buddha Hall), in which the Daibutsu was to be housed. After great expenditure of time and money, the Daibutsuden was finally completed in the third month of 1195.

While the Daibutsu was thus the focus of all the restorative efforts in Nara, Unkei, who carved only in wood, knew that he must wait a little longer for his chance at fame. So he repressed his impatience and began a completely different project. It may come as something of a surprise, however, to learn that Unkei actually left Nara and went to the Kanto region in eastern Japan to carve Buddhist statuary. Yet historical documents show that he produced statues in 1186 for the Ganjoju-in, in Shizuoka Prefecture, and in 1189 for the Joraku-ji, in Kana-gawa Prefecture. In order to explain why Unkei migrated eastward, it will be necessary to explore the background events.

We have already noted in the previous chapter that Minamoto Yoritomo established the capital of his military government in Kamakura after defeating the Taira in 1185. Besides being a brilliant general and statesman, Yoritomo was a deeply religious man. Not only did he worship faithfully at his clan's shrine, the Tsurugaoka Hachiman-gu, in Kamakura, but he also sponsored the construction of a number of Buddhist temples in the same area. One of these temples was the now vanished Shochoju-in, which Yoritomo founded in 1185 in memory of his deceased father, Minamoto Yoshitomo. He invited the busshi Seicho from Nara to make the main image, a statue of Amida Nyorai of *joroku* height. (*Joroku*, or one *jo* and six [*roku*] *shaku*, equals nearly five meters by modern conversion rules and is one of the largest standard

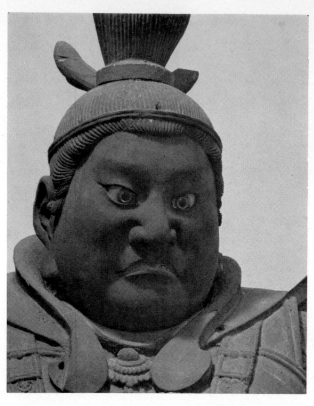

24. Bishamon Ten, by Unkei. Painted wood; height of entire statue, 147 cm. Dated 1186. Ganjoju-in, Shizuoka Prefecture.

25, 26. Details of Amida Nyorai, by Unkei: ▷ left foot and right knee (25) and head (26). Lacquer and gold leaf over wood; height of entire statue (see Figure 57), 143.5 cm. Dated 1186. Ganjoju-in, Shizuoka Prefecture.

heights in Japan for statues of the Buddha.) Yoritomo also brought the painter Takuma Tamehisa from Kyoto to paint murals of the twenty-five Bodhisattvas and a plan of the Amida Jodo (Pure Land) Paradise on the back walls of the Shochoju-in. Undoubtedly he had to invite these artists from western Japan because there were as yet no real busshi or painters in the newly settled community of Kamakura.

It is interesting to note that Yoritomo selected Seicho, a busshi of the revolutionary Nara group, and Tamehisa, son of Takuma Tameto and a painter of the Takuma school, which had taken up the new Sung-dynasty style of brushwork. That Yoritomo invited artists who were pioneering in such new trends not only shows his rebellion against the triteness of the aristocratic culture in Kyoto but

also tells us something of the tastes and sensibilities of the new warrior class in eastern Japan. The seeds of painting and sculpture thus sown in the soil of Kamakura put forth shoots and gradually grew into art forms that fitted this region.

But while Seicho was thus employed in Kamakura, the Kyoto busshi took advantage of his absence from Nara and tried to usurp the assignment of restoring the statuary in the Kofuku-ji's Tokondo (East Golden Hall)—an assignment that had finally been awarded to the Nara busshi. In 1187, Seicho protested to Yoritomo, who took some action on behalf of the Nara busshi, although the final results are not known. But we do know that the feelings of traditional rivalry between the Nara and the Kyoto busshi were as strong as ever at the time and had flared up once again in this incident. In the same

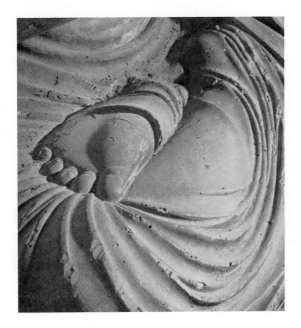

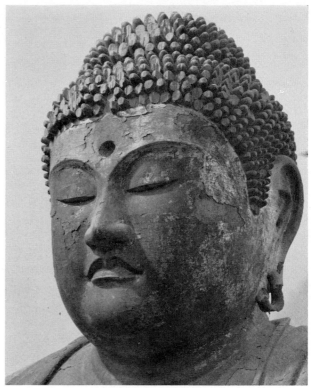

year, Kokei, who later succeeded Seicho as the chief of the Nara busshi, was acting as Seicho's substitute in Nara, and Kokei's son Unkei had already gone to the east upon invitation. It is also possible that Seicho took Unkei with him as an assistant, but the exact facts are not clear.

In 1186, the year after Seicho carved the main image of Amida Nyorai for the Shochoju-in, Unkei was at work on statuary for the Ganjoju-in, in Shizuoka Prefecture—a temple built by Hojo Tokimasa, Yoritomo's father-in-law, to obtain divine favor for the success of his campaign against the Fujiwara of Oshu, in the north. (This clan was indeed related to the famous Fujiwara clan of Kyoto but had separated from the main branch of the family centuries earlier to live as fierce warriors in Oshu, an area comprising the modern prefectures

of Aomori, Fukushima, Iwate, and Miyagi.) The celebration for the newly enshrined images was held on the sixth day of the sixth month in 1189, but some of the statues, including an Amida Triad (the main object of worship), Bishamon Ten, and Fudo Myo-o, had been completed earlier. Unfortunately, the two attendant Bodhisattvas in the Amida Triad were lost long ago, but we may still view the images of Amida Nyorai (Figs. 25, 26, 57); Fudo Myo-o (Figs. 29, 56) and his two boy attendants, Seitaka Doji (Fig. 27) and Kongara Doji (Fig. 28); and Bishamon Ten (Fig. 24) at the Ganjoju-in today. In 1752, wooden panels bearing inscriptions in black ink were discovered inside the Bishamon Ten and the Fudo Myo-o. The inscriptions state that work on the statues began on the third day of the fifth month in 1186; that their

UNKEI'S SOJOURN IN EASTERN JAPAN · *33*

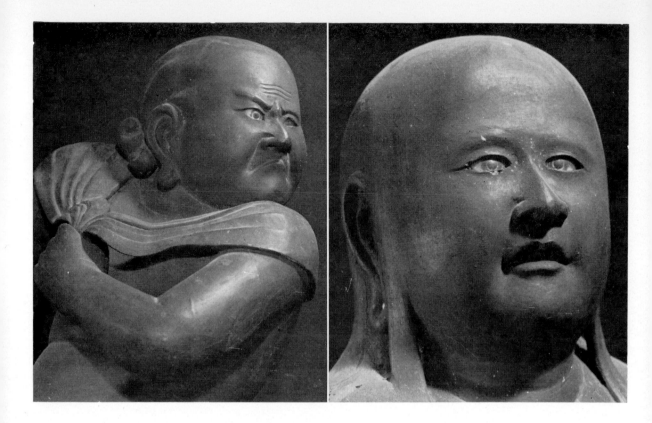

creator was "Unkei, the skilled craftsman and *koto*" (a low-ranking Buddhist officer in charge of miscellaneous temple business); and that their sponsor was Hojo Tokimasa.

Unkei next carved statuary for the Joraku-ji, in Kanagawa Prefecture. This temple was sponsored by Wada Yoshimori, a warlord who supported Yoritomo with troops during the Minamoto uprising in 1180. Today the Joraku-ji houses an Amida Triad (Fig. 52), including Amida Nyorai (Fig. 30) and his two attendant Bodhisattvas, and statues of Fudo Myo-o (Fig. 31) and Bishamon Ten (Figs. 32, 50). Inscribed panels found not long ago inside the Fudo Myo-o and the Bishamon Ten state that they were completed on the twentieth day of the third month in 1189 and were carved by "Unkei, chief busshi and *koto* of the So-o-in on the

grounds of the Kofuku-ji, with ten assistant busshi." Another inscribed panel attributing the Joraku-ji's statue of Amida Nyorai to Unkei had been known of for centuries, but the writing on this panel had been tampered with at some later time and had thus been rendered doubtful as evidence. The discovery of the inscribed panels inside the Fudo Myo-o and the Bishamon Ten at the Joraku-ji was an event of unprecedented importance in the study of Unkei's life and art. At the same time it revealed the interesting fact that Unkei had held a post at the Kofuku-ji. This evidence corresponds well with his being one of the orthodox Nara busshi, who, as we know, were closely connected with that temple.

The inscribed panels found inside the Fudo Myo-o and the Bishamon Ten at the Ganjoju-in and also those at the Joraku-ji offer fairly positive

27 (opposite page, left). *Seitaka Doji, by Unkei. Painted wood; height of entire statue, 78 cm. Dated 1186. Ganjoju-in, Shizuoka Prefecture.*

28 (opposite page, right). *Kongara Doji, by Unkei. Painted wood; height of entire statue, 82.6 cm. Dated 1186. Ganjoju-in, Shizuoka Prefecture.*

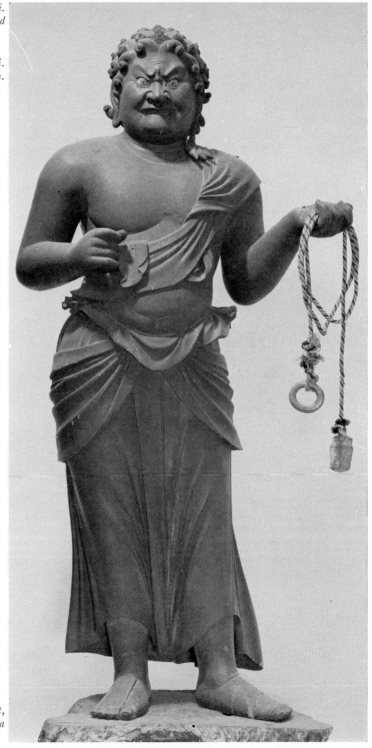

29. *Fudo Myo-o, by Unkei. Painted wood; height, 136.5 cm. Dated 1186. Ganjoju-in, Shizuoka Prefecture. (See also Figure 56.)*

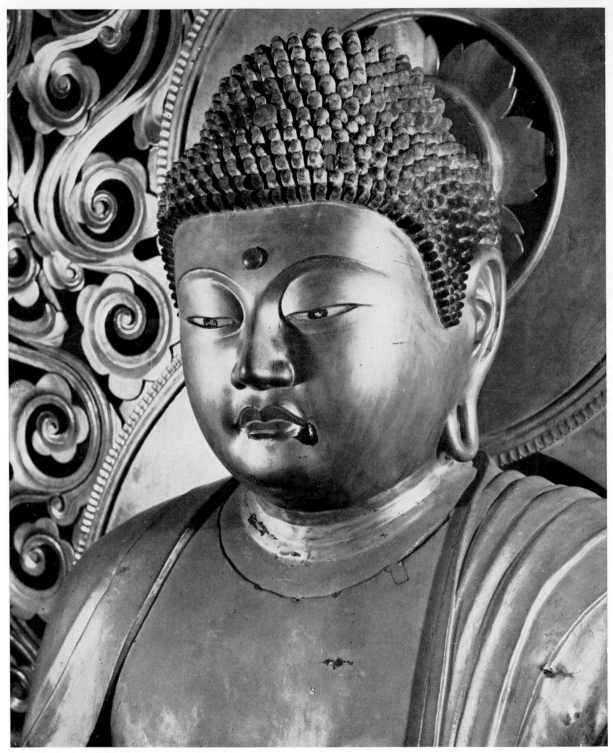

30. *Amida Nyorai, by Unkei. Lacquer and gold leaf over wood; height of entire statue (see Figure 52), 140 cm. Dated 1189. Joraku-ji, Kanagawa Prefecture.*

proof that these four statues are indeed works by Unkei. Moreover, some scholars have proposed the theory that the remaining six statues—that is, the Amida Nyorai, Seitaka Doji, and Kongara Doji at the Ganjoju-in and the Amida Nyorai, Kannon Bosatsu, and Seishi Bosatsu at the Joraku-ji—should also be attributed to Unkei. But another very plausible theory reasons that, granting the credibility of the date of production, none of these statues can be attributed to Unkei because of stylistic considerations alone. In other words, although all of the statues are quite powerful-looking in the accepted Unkei manner, they somehow seem rustic and representative of a different carving technique when compared with statues in the Nara region that are more certainly recognized as Unkei's work. This is a very difficult problem, but for the time being I prefer to support the former theory.

Let us now make a comparative study of the statuary in the two temples. We find that the two statues of Amida Nyorai both have deeply carved yet free-flowing robes and massive-looking physiques. A dynamic force has been added to this same type of massive-looking physique in the statues of Fudo Myo-o and his two attendants at the Ganjoju-in and in the statues of Bishamon Ten and Fudo Myo-o at the Joraku-ji. (Unfortunately the latter two statues have been spoiled by the application of gaudy colors in later times.) Considering the similarity in style of these seven statues, it certainly cannot be wrong to assume that they are all the work of the same artist. Perhaps the statue of Bishamon Ten at the Ganjoju-in gives a slightly different impression at first glance. Rather than seeking to impress us with its massive-looking physique, this statue has a body that stresses a tense vitality. But if we observe carefully, we see that this same tense vitality also exists to some extent in the statues of Fudo Myo-o's two attendants, Seitaka Doji and Kongara Doji. Thus it does not seem necessary to think of the Ganjoju-in's statue of Bishamon Ten as separate from the other statuary under discussion.

If we can thus detect a sculptural style common to all the statuary in the Ganjoju-in and the Joraku-

31. Fudo Myo-o, by Unkei. Painted wood; height of entire statue, 134 cm. Dated 1189. Joraku-ji, Kanagawa Prefecture.

ji, it would seem only reasonable to believe the evidence of the inscribed plaques found in some of the statues and attribute them all to Unkei. The next problem we face is why Unkei produced such unique statuary during his sojourn in eastern Japan.

First of all, I believe that such powerfully stalwart statues could never have been produced in Nara but were possible only after Unkei had set foot on eastern soil and experienced the life style of the people there. Indeed, when we consider the actual construction of the statues, we must remember that among the assistant busshi employed by Unkei there must have been a number of local craftsmen. Their special regional style might very well have affected Unkei's style to a certain extent. Also, the sponsors upon whom Unkei depended for

32. Bishamon Ten, by Unkei. Painted wood; height of entire statue, 139.5 cm. Dated 1189. Joraku-ji, Kanagawa Prefecture. (See also Figure 50.)

33 (opposite page, left). Gyoga, one of the ▷ Six Patriarchs of the Hosso Sect, by Kōkei. Painted wood; height of entire statue, 76.3 cm. Dated 1189. Nan'endo, Kofuku-ji, Nara.

34 (opposite page, right). Gempin, one of ▷ the Six Patriarchs of the Hosso Sect, by Kokei. Painted wood; height of entire statue, 78.4 cm. Dated 1189. Nan'endo, Kofuku-ji, Nara.

his living during his stay in eastern Japan were battle-scarred warriors who had no use for the delicate style of sculpture popular with the aristocrats of Kyoto. In this simple, virile atmosphere, Unkei, himself overflowing with vitality, must have begun his work with the ambition of creating a new type of sculpture.

At first glance these statues may seem crude. If we look more deeply, however, it should become clear that sculpture of a stirring and heroic style was being shaped here—a style that was realized gradually over the three years that Unkei worked in eastern Japan. This development can be best understood if we compare the earlier statue of Amida Nyorai at the Ganjoju-in with the later statue of Amida Nyorai at the Joraku-ji.

It seems only natural that these statues produced in eastern Japan should be different from the statue of Dainichi Nyorai at the Enjo-ji, carved by Unkei in his younger days. Indeed, we sense in these statues the true nature of Unkei the artist, endowed with a richly creative spirit. For Unkei was a man who swiftly attempted to create sculpture in a style appropriate to the new age of the warrior. In this sense, even though his departure for eastern Japan in the mid-1180s may have come about by pure chance, it had an important effect on the completion of his artistic style in the future.

UNKEI IN NARA AND KYOTO While Unkei was at work on the statuary at the Joraku-ji in eastern Japan, his father, Kokei, in Nara, was bending every effort toward the reconstruction of the statuary at the Nan'endo

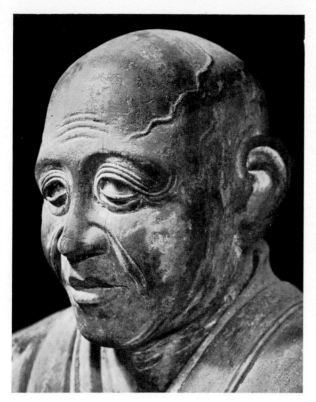
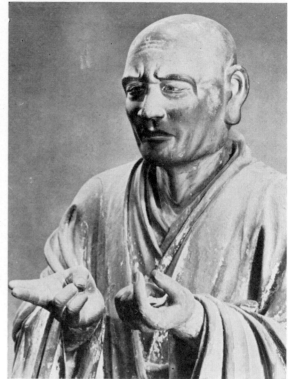

on the grounds of the Kofuku-ji. Since the Nan'en-do was sacred to the memory of the Fujiwara clan's ancestors, it had always occupied a special place at the Kofuku-ji. Thus the building was restored with the utmost swiftness after the Great Nara Fire of 1180. Work on its Buddhist statuary began in 1188 and ended in 1189. The Fukukenjaku Kannon, which is the main image, and the statues of the Shitenno and the Six Patriarchs of the Hosso Sect are now enshrined there. Because these statues are the oldest extant sculpture to have been restored by the Nara busshi after the Great Fire, and even more because they are the work of Unkei's father, Kokei, it is important that we discuss them briefly here.

The Fukukenjaku Kannon (Figs. 9, 12) is a huge seated figure of *joroku* proportions. The flesh of the face and body has a fresh, strong tenseness. The solemnity of the image reminds us of the late-Nara statue of the Fukukenjaku Kannon housed in the nearby Hokkedo (Lotus Hall) of the Todai-ji.

The Shitenno (Figs. 5, 6) have forms full of movement and change, and they demonstrate quite well the special qualities of the new era's sculpture. Furthermore, their legs have a particularly nimble look because, unlike other Shitenno of the same period, they do not wear long cloaks that hang down in back below the knees. This again testifies to the influence of late-Nara sculpture on Kokei, for statues of comparable deities from that period do indeed wear very similar costumes, without long cloaks.

Because the Six Patriarchs of the Hosso Sect (Figs. 33–35, 55, 146, 147) are portraits of a sort,

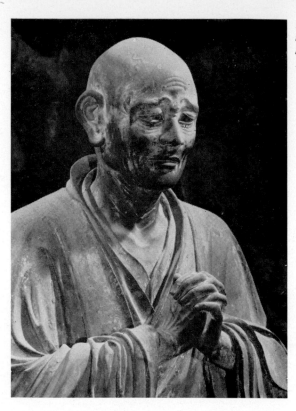

35. *Gembo, one of the Six Patriarchs of the Hosso Sect, by Kokei. Painted wood; height of entire statue, 86 cm. Dated 1189. Nan'endo, Kofuku-ji, Nara.*

36. *Shoko-o, one of the Ten Kings of Buddhism, by Koyu. Painted wood; height of entire statue (see Figure 160), 102 cm. Dated 1251. En'o-ji, Kamakura.* ▷

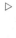

Kokei tried an ambitiously realistic approach with them. It goes without saying that he took great care to give variety to their features, and there are also extremely complicated pleats in their robes. Unfortunately the overall effect of the statues is much too fussy, and the group lacks unity. It is obvious that Kokei never completely grasped the techniques of realism.

But as we look at his statuary in the Nan'endo, we recognize how a new energy and a new realistic spirit came to be added to the firm traditions of late-Nara sculpture. The individual character of the Nara busshi Kokei comes to life in them. We can see clearly how this sculptor, who lived during a crucial time of change when the aristocracy lost its grip and the warrior class rose to power, struggled to create a new art form for a new age.

One of the last records of Kokei states that in 1196 the Todai-ji commissioned him to carve masks for Gigaku, the ceremonial dances performed at Nara monasteries and handed down from the sixth century. This information confirms Kokei's strong ties with the traditions of Nara. The exact year of his death is unknown, but he probably died not much later than 1196.

The dedication ceremony of the new Daibutsuden at the Todai-ji took place on the twelfth day of the third month in 1195. On this occasion Kokei, who knew he would not live much longer, transferred his title of *hogen* to his son and successor, Unkei. (*Hogen* was the second highest rank in Buddhism conferred on artists, the highest being *hoin*.) We may thus assume that Unkei participated in the making of some of the Todai-ji's statuary before the

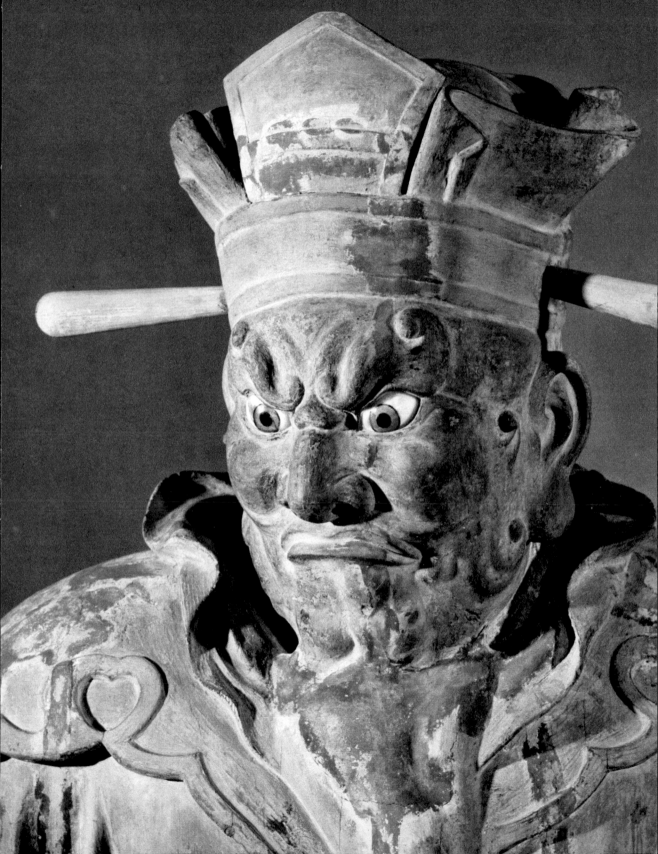

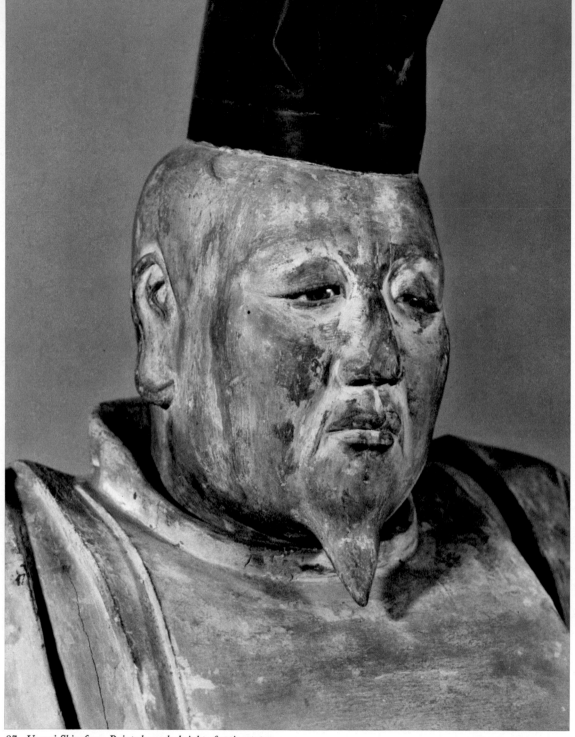

37. *Uesugi Shigefusa. Painted wood; height of entire statue,*
68 cm. Thirteenth century. Meigetsu-in, Kamakura.

38. *Basu Sennin, one of the Twenty-eight Followers of Kannon. Painted wood;* ▷
height of entire statue, 156 cm. Thirteenth century. Sanjusangendo, Kyoto.

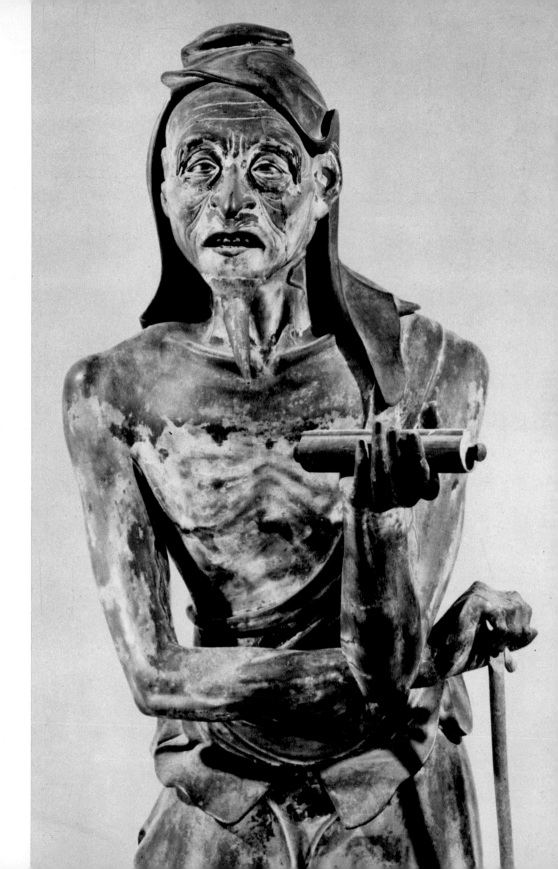

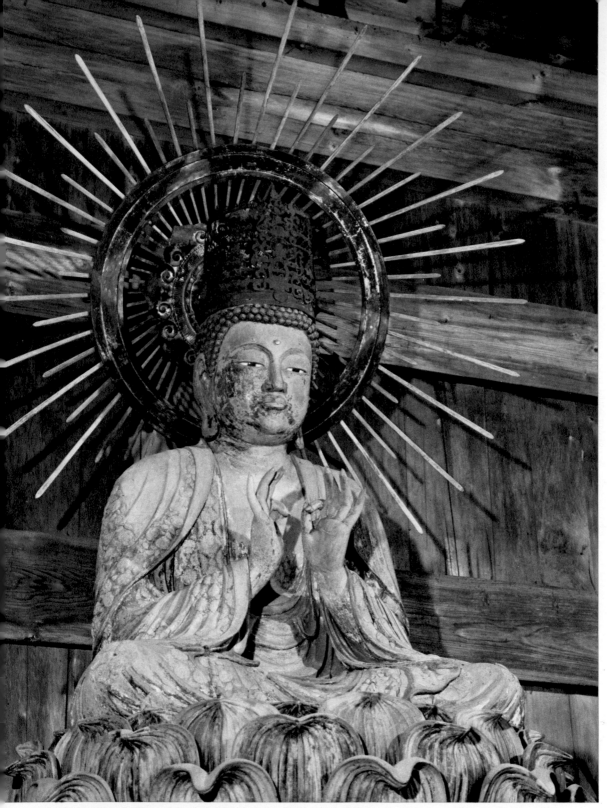

39. *Amida Nyorai. Painted wood; height, 144 cm. About 1299. Jokomyo-ji, Kamakura. (See also Figure 162.)*

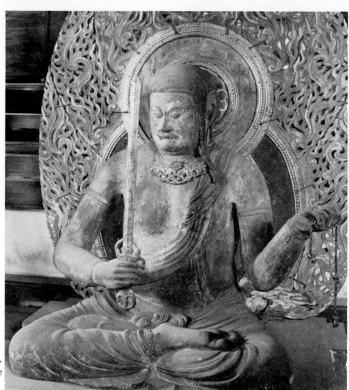

40. *Fudo Myo-o, one of the Five Great Kings of Light. Painted wood; height, 173.2 cm. About 839. Lecture Hall, To-ji, Kyoto.*

dedication ceremony of 1195, but we have no recorded evidence of this. Still, when we consider how the indigenous Nara busshi and the distant Kyoto busshi had been carrying on a confused battle for assignments at the two great temples Kofuku-ji and Todai-ji, it seems only natural to conclude that once Unkei had brought his work in eastern Japan to a certain stage of completion, he rushed home to Nara to assist his fellow busshi in this monumental task in which he himself placed such great hopes.

There is recorded evidence that Unkei participated in the production of statuary for the Daibutsuden in the following year, 1196. Unfortunately all these statues have since been lost, but we should note here their names and the division of labor. Kokei and Unkei had joint direction of the statue of Kokuzo Bosatsu, which stood on the left side of the Daibutsu, while Kaikei, one of Kokei's most brilliant apprentices, and Jokaku, Unkei's younger brother, had joint direction of the statue of the Nyoirin Kannon, which stood on the right. Of the Shitenno, which stood around the Daibutsu, Unkei carved the eastern guardian, Jikoku Ten; Kokei, the southern guardian, Zocho Ten; Jokaku, the northern guardian, Tamon Ten; and Kaikei, the western guardian, Komoku Ten. These were all very large statues, but in the space of only one year they were completed in rapid succession. The project was backed by the military government in Kamakura, and for each statue one of Minamoto Yoritomo's ministers was sponsor. It is of great interest to note here the close relationship between the Nara busshi and the victorious warrior class.

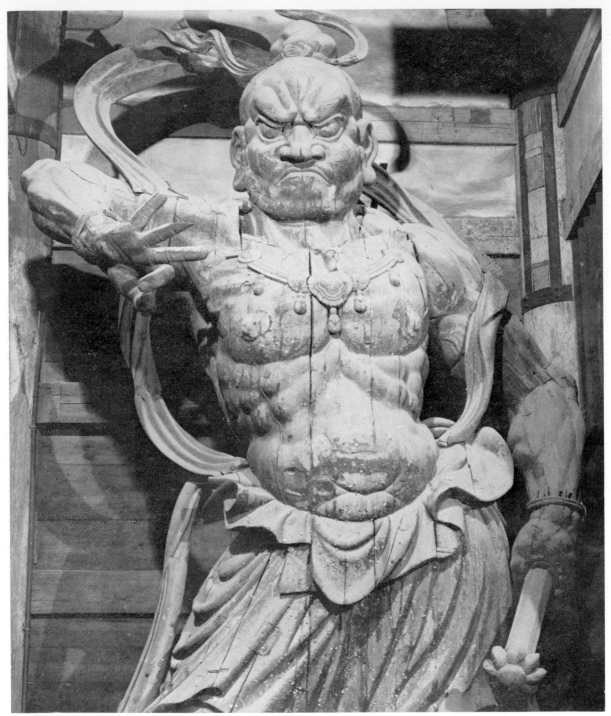

41. Ni-o (Naraen Kongo), by Unkei and Kaikei. Painted wood; height of entire statue, 848 cm. Dated 1203. South Main Gate, Todai-ji, Nara. (See also Figures 2, 53.)

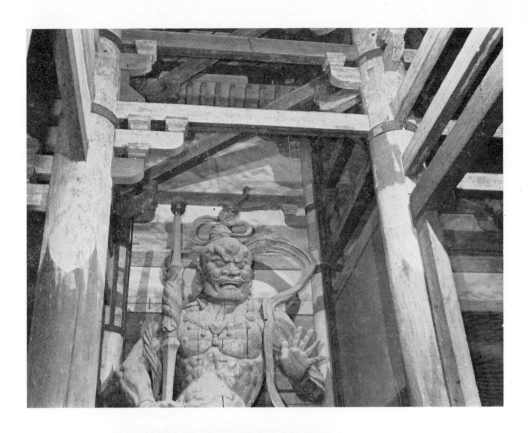

42 (above). Ni-o (Misshaku Kon-go), by Unkei and Kaikei. Painted wood; height of entire statue, 842 cm. Dated 1203. South Main Gate, Todai-ji, Nara. (See also Figure 43.)

43. Detail of Ni-o (Misshaku Kongo), by Unkei and Kaikei. Painted wood; height of entire statue, 842 cm. Dated 1203. South Main Gate, Todai-ji, Nara. (See also Figure 42.)

These four men—Kokei, Unkei, Kaikei, and Jokaku—were the standard-bearers of the Nara busshi at that time. Kokei, however, was already quite advanced in years, and Jokaku was young and inexperienced. Undoubtedly Unkei and Kaikei were the ones who applied themselves most vigorously to their work. Kaikei was not a direct descendant of the Nara busshi line, but as a promising apprentice of Kokei's he proved a good rival for Unkei. Stimulated by this friendly competition, Unkei and Kaikei must have created some very ambitious masterpieces in the statuary for the Daibutsuden. It is indeed regrettable that none of these statues have survived to the present.

In 1196, after the completion of the Todai-ji's two most important structures, the Daibutsuden and the Inner Gate, Unkei and his fellow Nara busshi were able to catch their breath. At this point in his career, Unkei traveled to Kyoto to carve and repair statuary for the Jingo-ji and the To-ji (or the Kyo-o-gokoku-ji, as it is more properly but less familiarly called). As early as 1196, Unkei copied statues of two deities and eight demons at the Gango-ji, in Nara. The copies, no longer extant today, were carved for the Jingo-ji, where they were enshrined in the Inner Gate. It is important to note here that one of the sponsors of the production of these copies was the influential priest Shoga, who had been appointed to say prayers for the personal safety of Minamoto Yoritomo.

From 1197 to 1198, Unkei repaired wooden statuary at the Lecture Hall of the To-ji, including statues of Fudo Myo-o (Fig. 40) and Kongoho Bosatsu (Fig. 44). The majority of these statues, originally produced around 839, are extant today and are famous examples of the sculpture of the early Heian period (794–897). It is also recorded that Unkei and his eldest son, Tankei, jointly worked on statues of the Ni-o (Benevolent Kings)— the two mighty guardians in the To-ji's South Main Gate—probably around this time, although no exact dates are given for the project and the statues themselves have not survived. Both of these assignments at the To-ji were supported by contributions solicited by Minamoto Yoritomo's intimate friend the priest Mongaku, and Yoritomo's military gov-

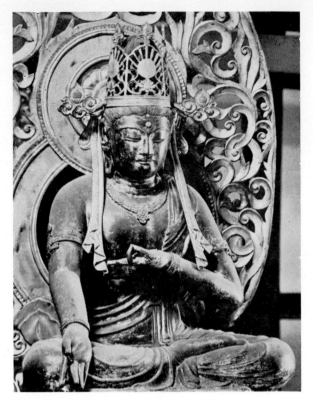

ernment contributed money for the second of the two. Unkei would never have received the commission for such assignments if he had not been deeply trusted by the Kamakura authorities.

With the aid of these connections, Unkei was appointed chief busshi of the To-ji in 1198. Shortly thereafter he again journeyed to the Jingo-ji, in the mountains outside Kyoto, and produced three statues for the Lecture Hall there: Dainichi Nyorai, Fudo Myo-o, and Kongo Satta. Carved at the request of Mongaku, these were all copies of the same statues Unkei had repaired in the To-ji's Lecture Hall and were probably not completed until after Mongaku's death in 1203. Like the Ni-o at the To-ji, the statues were destroyed centuries ago.

◁ 44. *Kongoho Bosatsu, one of the Five Great Bodhisattvas. Lacquer and gold leaf over wood; height, 96 cm. About 839. Lecture Hall, To-ji, Kyoto.*

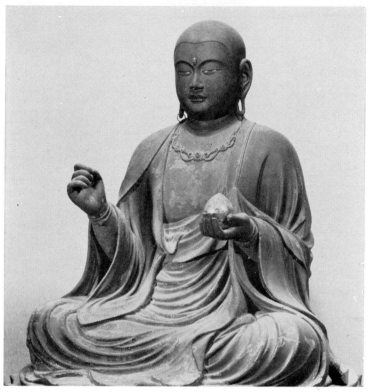

45. *Jizo Bosatsu, attributed to Unkei. Painted wood; height, 89.5 cm. Late twelfth or early thirteenth century. Rokuhara Mitsu-ji, Kyoto. (See also Figure 58.)*

During this period of his life, Unkei came into close contact with the most basic and representative sculpture of the Heian period when he repaired the statuary in the To-ji's Lecture Hall. At the Jingo-ji he also had the chance to observe such masterpieces of early-Heian sculpture as the Yakushi Nyorai and the Five Great Kokuzo Bodhisattvas (in Japanese, Go Dai Kokuzo Bosatsu). These influences proved to be of great advantage to Unkei's art. In his native Nara he had been exposed only to the ancient dry-lacquer statuary of the late Nara period, but in the early-Heian statues at the To-ji and the Jingo-ji he undoubtedly discovered the beauty and severity that carved wood could have. It will be helpful for the reader to note here that Buddhist statuary carved in wood did not become popular

in Japan until the beginning of the Heian period.

At the same time, these assignments gave Unkei the opportunity to establish himself in Kyoto. Inson, the veteran leader of the Kyoto busshi since the early part of the twelfth century, died in 1198, and Myoen, an equally important figure among the Kyoto busshi, followed him in 1199. Thus the stage was left to Unkei, who in 1198, as we have noted, managed to be appointed chief busshi of the To-ji, one of Kyoto's largest temples. In 1202, he was given special recognition by the court when the imperial regent Konoe Motomichi commissioned him to carve a white sandalwood statue of Fugen Bosatsu.

Even among the conservative circles of the Kyoto busshi, this was a time of unprecedented change,

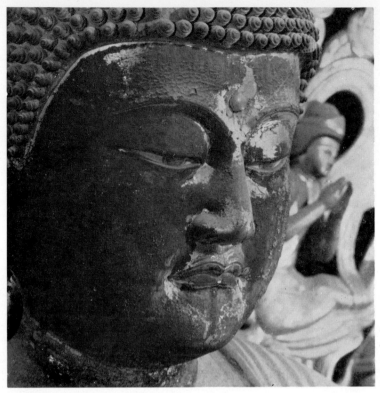

46. *Head of Miroku Butsu, by Unkei. Lacquer and gold leaf over wood; height of entire statue (see Figure 51), 143.5 cm. About 1208–12. Hokuendo, Kofuku-ji, Nara. (See also Figure 47.)*

and the Nara busshi, so full of the new revolutionary spirit, were able to extend their activities to Kyoto with Unkei in the vanguard. According to the findings of recent research, Unkei's daughter Nyoi was adopted by Reizei Tsubone, lady-in-waiting to Fujiwara Shokushi, the consort of Emperor Takakura and the mother of Emperor Gotoba. In 1199, Nyoi inherited from her adopted mother an estate in Omi, near Kyoto, called Konosho. Undoubtedly this provided further incentive for Unkei to establish himself in Kyoto, and we note with interest how his move to that city was reflected in his family affairs.

Around this same time Unkei must have set up his own workshop in Kyoto somewhere in the Shichijo (Seventh Avenue) area and built his own family temple, the Jizo Jurin-in, in the nearby neighborhood of Hachijo (Eighth Avenue) Takakura. Unfortunately this temple is no longer extant, but it must have contained many statues carved by Unkei and his apprentices. What is thought to have been the main image of the Jizo Jurin-in, a statue of Jizo Bosatsu (Figs. 45, 58), is at the Kyoto temple Rokuhara Mitsu-ji today. Although the statue has classically beautiful features, it is not excessively delicate in style but has a dignified air of stability. A degree of refinement has been added to the Jizo Bosatsu, but we can see that it is similar in style to the statues of Amida Nyorai at the Joraku-ji and at the Ganjoju-in in eastern Japan. There is no actual proof that Unkei carved this statue, but from the style and the historical background it is

47. Right hand of Miroku Butsu, by Unkei. Lacquer and gold leaf over wood; height of entire statue (see Figure 51), 143.5 cm. About 1208– 12. Hokuendo, Kofuku-ji, Nara. (See also Figure 46.)

certainly permissible to cite it as prominent among the works attributed to Unkei.

Now work on the statuary for the Todai-ji, from which Unkei had taken a temporary holiday, began again. In 1203, statues of the two temple guardians, or Ni-o (Figs. 2, 41–43, 53), were completed and enshrined in the South Main Gate, giving the finishing touch to the temple's central complex of buildings. Produced under the direction of Unkei and Kaikei, the statues tower nearly 8.5 meters high and were completed in the amazingly short time of two months—from the twenty-fourth day of the seventh month to the third day of the tenth month in 1203. These masterpieces, the product of the joint efforts of two men who stood at the peak of the sculptors' world at the beginning of the

thirteenth century, fortunately survive today as priceless monuments to their genius.

In the case of such extraordinarily large statues, it is quite difficult to ascertain which was produced by Unkei and which by Kaikei. Let it be enough to say that we can recognize in these magnificent works the zenith of a new style achieved by the Nara busshi, or the Kei school, as they came to be called at this time, and that Unkei and Kaikei were the two most important leaders of this school. Because the statues are so muscularly built and so virile, we note in them, in particular, the artistic strong points of Unkei. In statues of the Ni-o by later sculptors, this muscular build became exaggerated to the point of vulgarity. In Unkei's statues, however, no such fault appears, and the force and

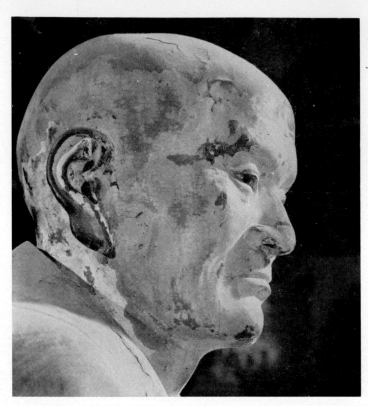

48. The Indian patriarch Mujaku, by Unkei. Painted wood; height of entire statue (see Figure 149), 194 cm. About 1208–12. Hokuendo, Kofuku-ji, Nara. (See also Figure 16.)

49. Dainichi Nyorai, by Unkei. Lacquer and gold ▷ leaf over wood; height of entire statue (see Figure 145), 101 cm. Dated 1176. Enjo-ji, Nara. (See also Figures 17, 60, 61.)

vitality of pure sculpture shine through. The statues carved by Unkei for the Todai-ji's Daibutsuden have been lost, but by looking at the heroic Ni-o in the South Main Gate we can imagine what the others were like. Shortly after the Ni-o were completed, a splendid dedication ceremony for the restored Todai-ji took place on the thirtieth day of the eleventh month in 1203, with the retired emperor Gotoba in attendance.

THE BRILLIANCE OF At this point in his career
UNKEI'S LAST YEARS Unkei was awarded the title of *hoin*, the highest rank an artist could achieve, and we know from his having attained this distinction how greatly he was acclaimed as a sculptor. The exact date is not clear, but it is possible that he received this honor at the

aforementioned Todai-ji dedication ceremony in 1203. In any case, we know that he was already known as the *hoin* Unkei by the time he began work on the statuary for the Kofuku-ji's Hokuendo (North Octagonal Hall) in 1208. Although, as we have noted earlier, Kokei carved statuary for the Kofuku-ji's Nan'endo, for the most part assignments for reconstruction work at this temple were awarded to Kyoto busshi like Inson and Myoen. But after Unkei completed the statuary for the Todai-ji, he managed to obtain an assignment from the Kofuku-ji, a temple with which he had very strong affiliations as a Nara busshi.

Before the Great Nara Fire of 1180, nine statues were enshrined in the Hokuendo: the main image, Miroku Butsu; his two attendants, Ho-onrin Bosatsu and Daimyoso Bosatsu; the Indian theologians

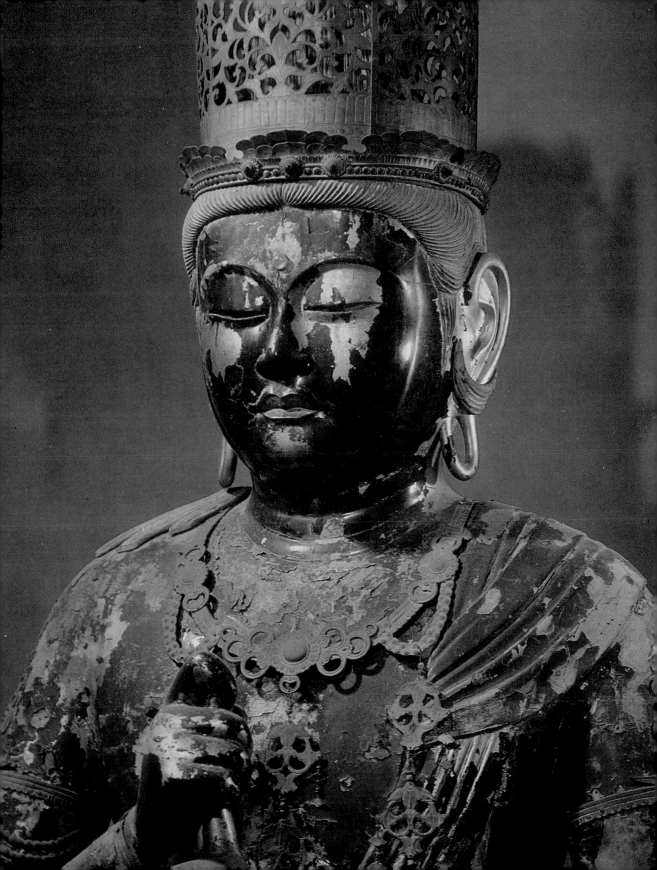

*50. Bishamon Ten, by Unkei. Painted wood; height of entire statue, 139.5 cm.
Dated 1189. Joraku-ji, Kanagawa Prefecture. (See also Figure 32.)*

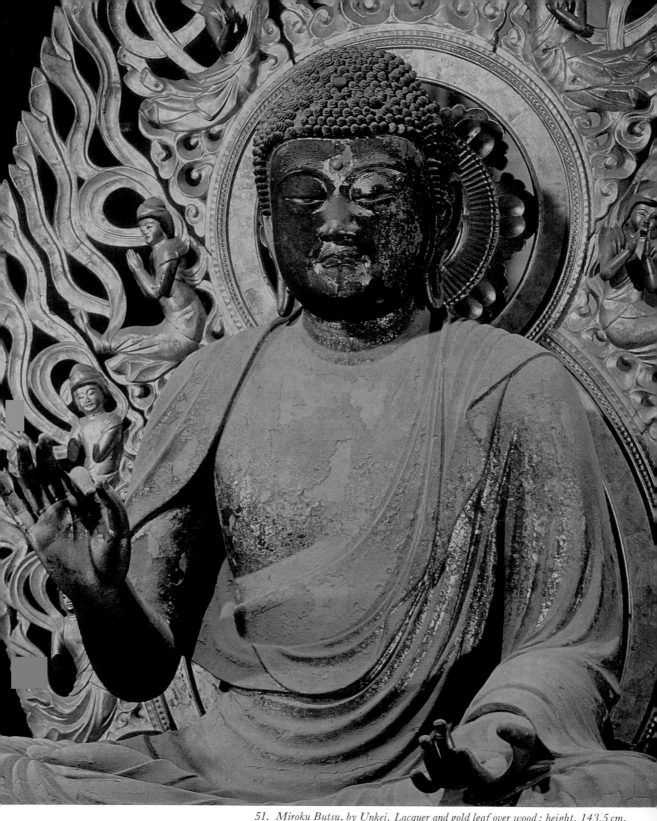

51. Miroku Butsu, by Unkei. Lacquer and gold leaf over wood; height, 143.5 cm. About 1208–12. Hokuendo, Kofuku-ji, Nara. (See also Figures 46, 47.)

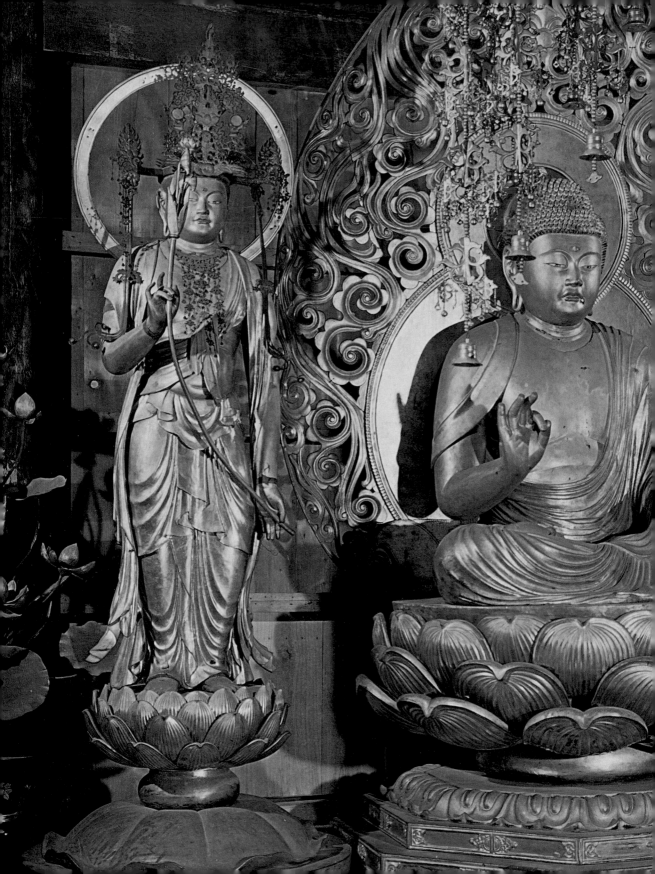

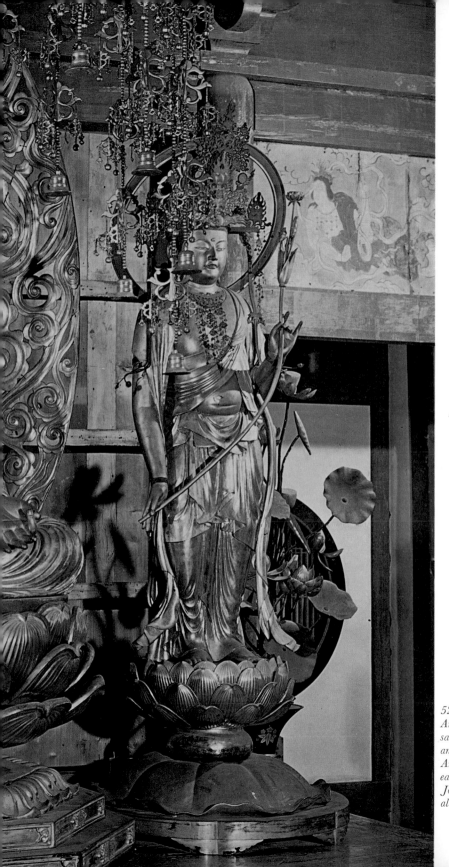

52. *Amida Triad, by Unkei. At center, Amida Nyorai; at left, Kannon Bo-satsu; at right, Seishi Bosatsu. Lacquer and gold leaf over wood; height of Amida Nyorai, 140 cm.; height of each attendant, 178 cm. Dated 1189. Joraku-ji, Kanagawa Prefecture. (See also Figure 30.)*

53. Ni-o (Naraen Kongo), by Unkei
and Kaikei. Painted wood; height of
entire statue, 848 cm. Dated 1203.
South Main Gate, Todai-ji, Nara. (See
also Figures 2, 41.)

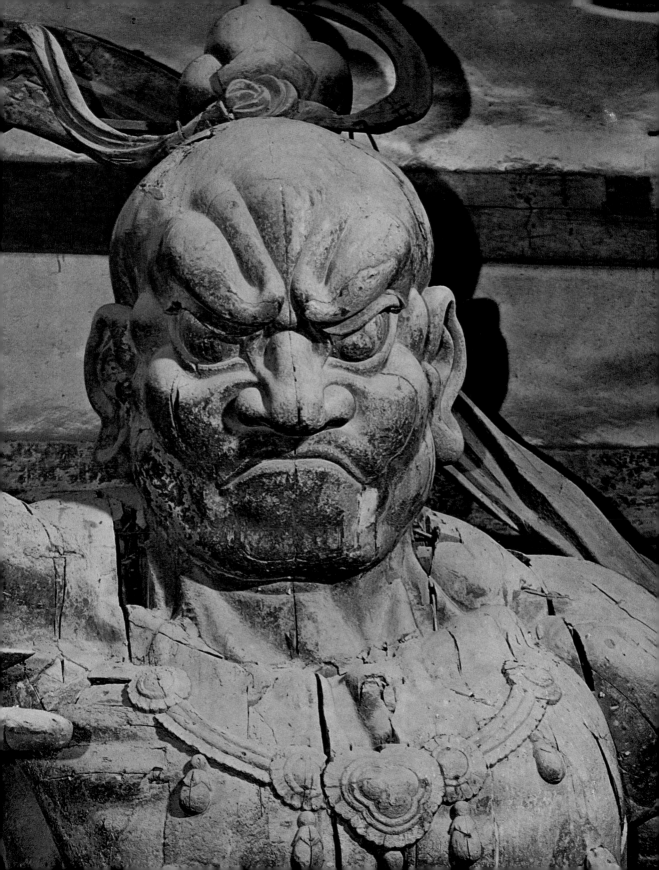

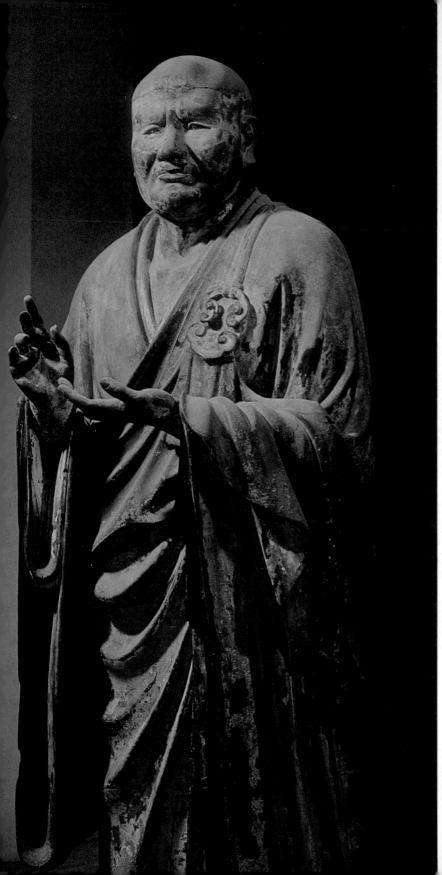

54. *The Indian patriarch Seshin, by Unkei. Painted wood; height of entire statue (see Figure 148), 189.5 cm. About 1208–12. Hokuendo, Kofuku-ji, Nara. (See also Figure 59.)*

55. *Zenju, one of the Six Patriarchs of the Hosso Sect, by Kokei. Painted wood; height of entire statue, 84.3 cm. Dated 1189. Nan'endo, Kofuku-ji, Nara.* ▷

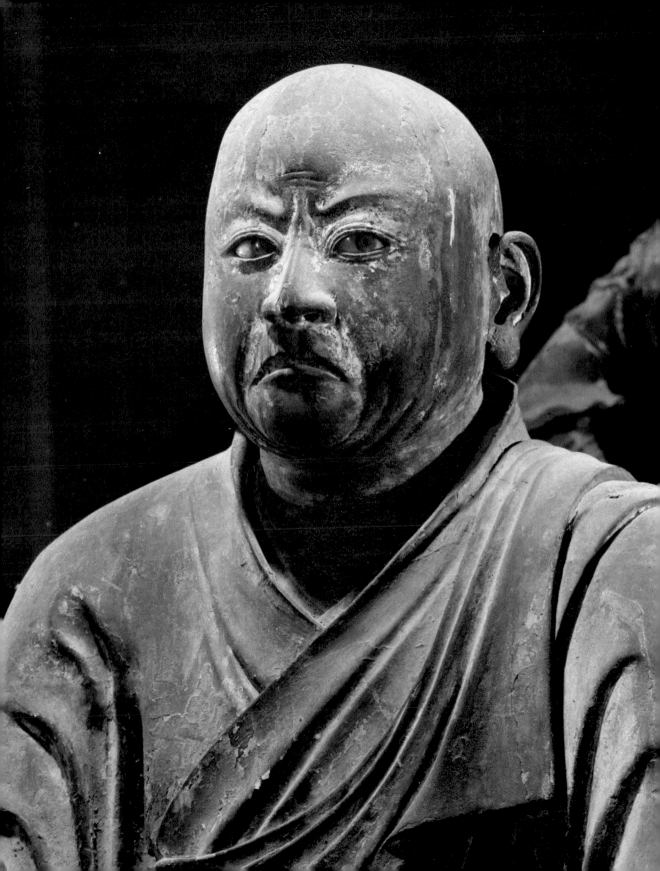

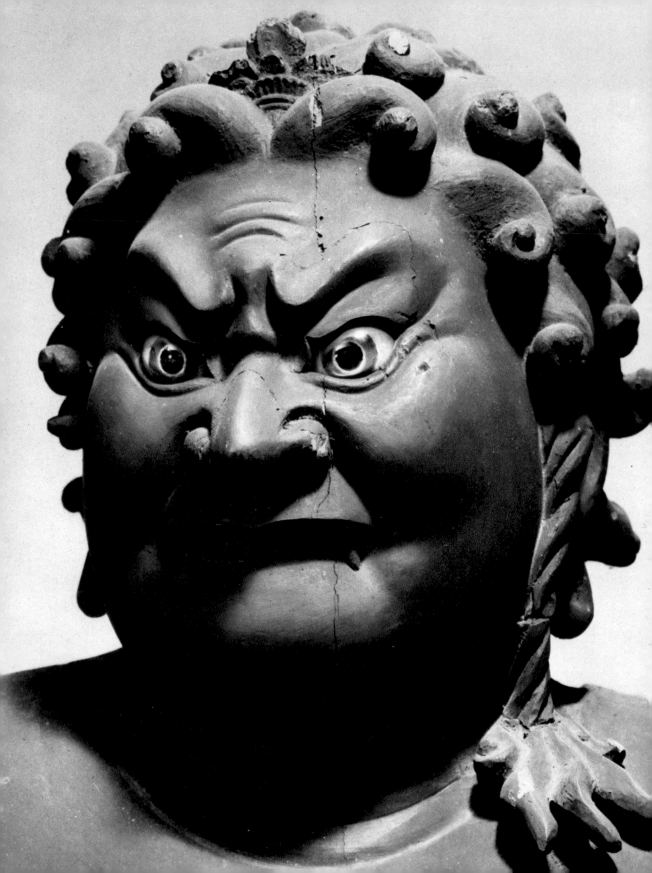

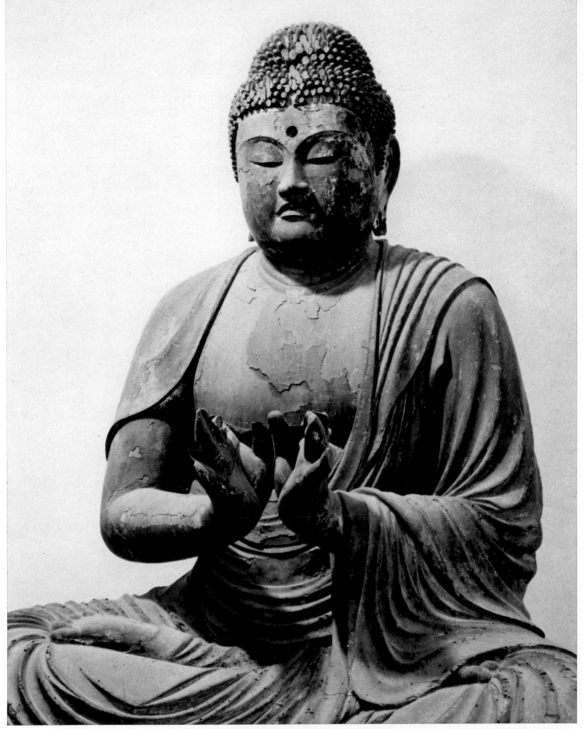

57. *Amida Nyorai, by Unkei. Lacquer and gold leaf over wood; height, 143.5 cm.
Dated 1186. Ganjoju-in, Shizuoka Prefecture. (See also Figures 25, 26.)*

◁ 56. *Fudo Myo-o, by Unkei. Painted wood; height of entire statue (see
Figure 29), 136.5 cm. Dated 1186. Ganjoju-in, Shizuoka Prefecture.*

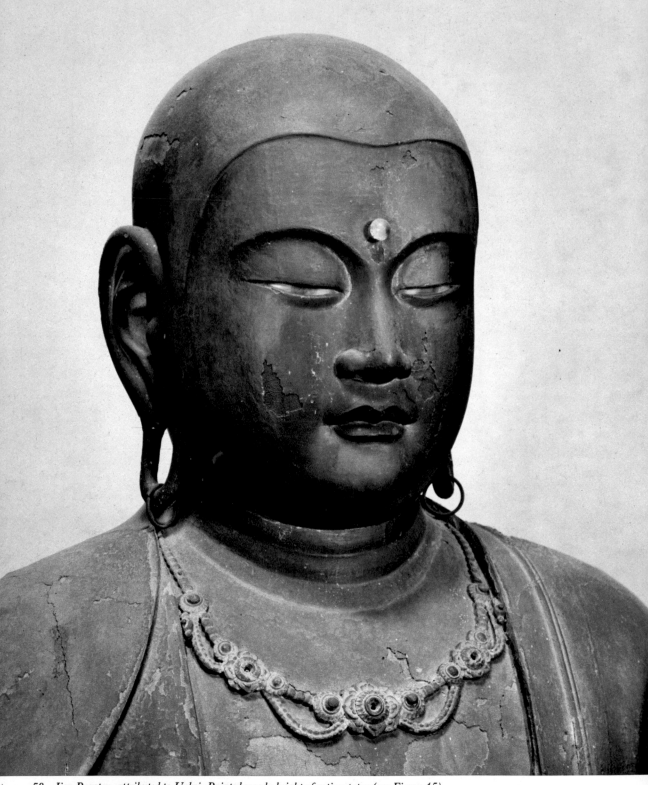

58. Jizo Bosatsu, attributed to Unkei. Painted wood; height of entire statue (see Figure 45), 89.5 cm. Late twelfth or early thirteenth century. Rokuhara Mitsu-ji, Kyoto.

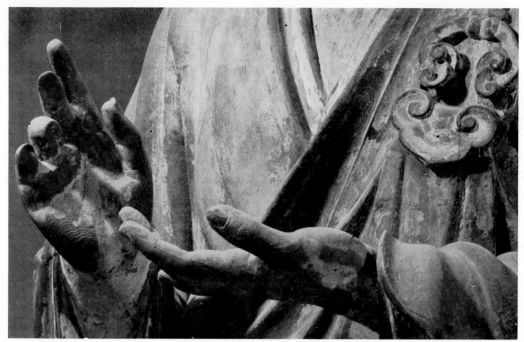

59. Hands of the Indian patriarch Seshin, by Unkei. Painted wood; height of entire statue (see Figure 148), 189.5 cm. About 1208–12. Hokuendo, Kofuku-ji, Nara. (See also Figure 54.)

Mujaku and Seshin; and the Shitenno. These statues, together with the building that housed them, were all burned to ashes in the disastrous conflagration. Reconstruction finally began on the seventeenth day of the twelfth month in 1208 and is thought to have been completed sometime in 1212. Unkei was the general supervisor for the production of all nine of the replacement statues. Under him worked ten busshi, two of whom were assigned to the main image, while the other eight were assigned to one statue each.

Only three of the nine statues begun in 1208 are extant today—the Miroku Butsu (Figs. 46, 47, 51), Mujaku (Figs. 16, 48, 149), and Seshin (Figs. 54, 59, 148)—yet all three display the fully developed style of the great sculptor Unkei. While the Miroku Butsu is not particularly different from many other statues of the enlightened Buddha, it is a piece of sculpture so perfectly formed that we sense in it the

quiet confidence of a man who had penetrated to the very depths of his art. If we compare this statue with other works of the same type, such as the Amida Nyorai statues at the Ganjoju-in and the Joraku-ji, carved by Unkei some twenty years earlier, we can easily recognize what great strides he made in the intervening decades. The statues of Mujaku and Seshin are so strikingly massive—as if they had sent roots into the earth—that we want to cry, as we gaze at them, "Here at last is real sculpture!" Since these two statues are imaginative portraits of a sort, it would not be amiss to compare them with Kokei's Six Patriarchs of the Hosso Sect in the Nan'endo. Even though Unkei was Kokei's son and apprentice, there are extraordinary differences to be found in the creations of the two men. In the Six Patriarchs, Kokei made a serious effort to express realism, but it is quite clear that his skills were too undeveloped to achieve his aim. In

contrast, the statues of Mujaku and Seshin capture the spirit of realism perfectly. We might even say that Unkei achieved here what his father failed to do in the Six Patriarchs. Thus we realize what important developments took place in the history of Japanese sculpture from Kokei's generation to Unkei's. The three statues in the Hokuendo are the latest dated works of Unkei extant today and are also considered to be the greatest of all his masterpieces.

We know from various historical documents that Unkei carved many more statues after completing those in the Hokuendo. In 1213, there took place a dedication ceremony for a nine-storied pagoda constructed on the grounds of the Hossho-ji, a temple in Kyoto no longer extant today. The images enshrined in this pagoda were the Kongokai Go Butsu (Five Buddhas of the Diamond World) and the Shitenno. Unkei worked on these statues with the aid of his eldest son, Tankei, and a number of Kyoto busshi, including Injitsu and Impan of the In school and Joen and Sen'en of the En school. It is indeed noteworthy that the Kyoto busshi of the In and En schools worked together on the project with the Nara busshi of the Kei school. Their cooperation may be considered as a sign that the style of the Kyoto busshi was becoming more and more like that of the Kei school during the first years of the Kamakura period.

One outstanding feature of Unkei's activities in his last years is that he again began to receive assignments connected with the military government in Kamakura. Minamoto Yoritomo had died in 1199 as the result of a fall from horseback. His widow, Masako, together with her father, Hojo Tokimasa, held the real power of government, even though Yoritomo's weak and dissolute son Yoriie succeeded his father as shogun. In 1203, Yoriie was replaced as shogun by his younger brother Sanetomo. Unkei carved the main image of Shaka Nyorai for Sanetomo's private temple, and this work was transported from Kyoto to Kamakura in the first month of 1216. In contrast with the time, many years before, when he worked at the Ganjoju-in and the Joraku-ji, Unkei carved this statue in Kyoto and never set foot on eastern soil. Two years later, in 1218, he carved the main image of Yakushi Nyorai for the Okura Shimmi-do, a temple in Kamakura managed by the shogunal regent Hojo Yoshitoki, who was Masako's brother and the son and successor of Hojo Tokimasa.

In 1219, Sanetomo, the third and last Minamoto shogun, was cruelly murdered by his own nephew, and in that same year Unkei carved statues of the Go Dai Son (another name for the Go Dai Myo-o, or Five Great Kings of Light) for the Shochoju-in's Gobutsudo, which Masako erected in Kamakura in supplication for the repose of her son Sanetomo's soul. It is also recorded that Unkei carved the main image that was enshrined in Masako's private temple, the Romi-do, in the eighth month of 1223. But because the records also state that this was actually the image to which Sanetomo prayed when he was still alive, it is more than likely that it was the same statue of Shaka Nyorai that Unkei made in 1216.

We have no reliable evidence that Unkei traveled to eastern Japan at this time, but in any case it is important to note that he continued to produce statues for leading figures in the Kamakura military government one after another. Unkei had already formed connections with the warriors of the east in his youth, and these connections grew stronger with the passing years, culminating in the projects we have noted. There is no doubt that his heroic style of sculpture appealed greatly to the warrior class, and his art, which flourished so vigorously in the new era of military feudalism, depended on this appeal. On the eleventh day of the twelfth month of 1223, Unkei died quietly, bringing to a close a brilliant artistic career.

UNKEI'S ARTISTIC ACHIEVEMENT

The extant statues carved by Unkei are certainly few in number. Nonetheless, when we observe these works, we cannot deny that Unkei not only mastered the techniques of realism but also imbued his art with a magnificent heroic spirit. His sculpture, at the same time that it had a high artistic value, was easily understood by the average man. Moreover, he was supported by the warrior class, which became the governing power in the Kamakura period. Thus his talents were

60, 61. Details of Dainichi Nyorai, by Unkei. Lacquer and gold leaf over wood; height of entire statue (see Figure 145), 101 cm. Dated 1176. Enjo-ji, Nara. (See also Figures 17, 49.)

given free rein, and he left us immortal works of art.

Unkei's art had its foundations in the traditional style of the late Nara period—a style fostered by the busshi of Nara, the city where he was born and grew up. With these ancient artistic traditions in the background, a gateway to a new type of creativity was opened. It was in Nara that the new style of Kamakura-period sculpture first developed. The Enjo-ji's statue of Dainichi Nyorai, carved by Unkei in his youth shortly before the beginning of the Kamakura period, is an exemplary product of this early development. Its fresh and vivid style foretold the glorious future that awaited its creator.

But there is much more to Unkei's sculpture than the development of the traditional style of the

Nara busshi. If this were all, then Unkei would merely have improved upon the style of his father, Kokei. As we have seen in his statuary at the Kofuku-ji's Nan'endo, Kokei's works have marked tendencies toward realism and at the same time show the influence of late-Nara sculpture, delineating quite well the new direction that the Nara busshi were taking. Unkei also moved in this same direction, to be sure, but he developed his own style so rapidly that I believe we must look for some special stimulus in his case.

When we consider the formation of the Unkei style, one very significant event is his sojourn in eastern Japan during the mid-1180s, a period during which he worked quite diligently. It was a great change in Unkei's life to leave Nara far be-

62. *Section of postscript to eighth scroll of copy of* Hoke-kyo *(Lotus Sutra) commissioned by Unkei and transcribed by Chinga. Ink on paper; height, 26.8 cm. Dated 1183. Ueno Collection, Osaka.*

hind and go to live in this new territory soon after the establishment of Yoritomo's military government. The statues he carved there, both for the Ganjoju-in and for the Joraku-ji, are works in which we sense a rustic but powerful energy. If we compare these statues with the Dainichi Nyorai at the Enjo-ji in Nara, they appear to be the work of a different man. When we ask ourselves why the statuary that Unkei produced in eastern Japan is so different, we cannot ignore the influence of the fresh, invigorating atmosphere of Kamakura during this time. It is true that the statuary at the Ganjoju-in and the Joraku-ji represents only a temporary variation in Unkei's long artistic career, but when we consider this together with the fact that Unkei had then first come into contact with the warrior class, we cannot deny that this period of his life

must have had an important effect on his later work. We must also remember that Unkei was still relatively young and not yet artistically mature when he was in eastern Japan; so he must have been particularly receptive to the influences of his environment.

Thus, in discussing the formation of Unkei's unique style, I place great importance upon his years in eastern Japan. Frankly speaking, I believe that the rough but freshly virile atmosphere of the east stimulated his artistic spirit just at the time when he was seeking to give a new direction to the orthodox traditional style of the Nara busshi.

It cannot be denied that when Unkei carved the statues at the Ganjoju-in and the Joraku-ji he was still too much concerned with creating striking visual effects. But he eventually returned to Nara

and became absorbed in the very demanding work at the Todai-ji. Having gained such splendid assignments as the production of the statuary for the Daibutsuden, he developed his artistic gifts with astonishing speed and nurtured his own characteristic style. Around this time he also went to Kyoto to repair and produce statues for the To-ji and the Jingo-ji. We cannot overlook the fact that he thus had the chance to come into direct contact with real masterpieces of early-Heian sculpture at these two temples. These statues, which we can still view today, impress us with their composed sense of fulfillment and the high artistic level of wooden sculpture that they represent. Unkei must have reacted to them in the same fashion, and we may also assume that as a professional sculptor he used them to gain suggestions for his own art.

The statue of Jizo Bosatsu at the Rokuhara Mitsu-ji, which is attributed to Unkei through a number of very persuasive arguments, shows quite well the special characteristics of the perfected Unkei style. While fulfilling the requirements of a traditional realism solidly based on the late-Nara style, it also displays a spirited and powerful modeling that does not at all carry on the rough style of Unkei's eastern period. Indeed, we might say that the rough style has been sublimated in this statue to express a heroic realism.

Because the statues of the Ni-o in the South Main Gate of the Todai-ji are figures of active rage, they demonstrate Unkei's special style even more strongly. Finally we come to the gentle image of Miroku Butsu, the Buddha of the Future, and the portrait statues of Mujaku and Seshin at the Kofuku-ji's Hokuendo. Although they differ in features and personality, these three statues realize the full perfection of the Unkei style.

Heretofore such realistic, heroic sculpture had almost never been seen. Through the genius of Unkei this new style achieved dominance. The warrior class of the time appreciated it fully and welcomed Unkei. His achievements in his last years attest to extraordinarily close connections with the military government in Kamakura, and it is evident that his art satisfied the demands of the new feudal era. It is only natural that we honor Unkei today as the greatest sculptor of the Kamakura period.

CHAPTER THREE

The Followers of Unkei

UNKEI'S DESCENDANTS AND APPRENTICES Unkei's six sons were Tankei, Koun, Koben, Kosho, Unga, and Unjo. All had careers as busshi, but only Tankei, Koben, and Kosho produced works that are extant today. If we examine these works carefully, we can see that the sculptural style perfected by Unkei was carried on by his sons.

It is recorded that Tankei, the eldest of the sons, was eighty-three years old when he died in 1256. Thus, if the record is correct, he was born in 1173. Although he had a remarkably long career, the only authenticated, dated works by Tankei that survive today are ten statues in the Sanjusangendo, or Hall of Thirty-three Bays (more properly but less familiarly called the Rengeo-in), at the Myoho-in, in Kyoto. The most important of these works is the main image in the hall: the large Senju (Thousand-armed) Kannon (Fig. 70), which took from 1251 to 1254 to complete. The other works—nine of the thousand smaller statues of the Senju Kannon (Fig. 71)—date from around the same time.

Since Tankei produced these ten statues during his last years, they give us a good opportunity to observe his perfected style. The stylistic precedents set down by Unkei have been followed quite faithfully in these works, but the heroic force expressed by Unkei has weakened in Tankei, whose style has a more gentle, subdued feeling. Although the personality of the sculptor is partly responsible for this impression, we also see displayed here one of several ways in which the style established by Unkei could be followed.

Three other statues are known to be Tankei's works, although they have not been dated successfully. These are the statues of Bishamon Ten (Fig. 73) and his two attendants, Kichijo Ten (Fig. 63) and Zennishi Doji (Fig. 64) at the Sekkei-ji, in Kochi Prefecture. The statue of Bishamon Ten best shows the placid quality so characteristic of Tankei. It should be noted here that the two attendants have been carved with an even more delicate touch, so that there is quite a stylistic gap between them and the works of Unkei.

Recent research indicates that the statues of Zemmyo Shin (Fig. 68) and Byakko Shin (Fig. 79) at the Kozan-ji, in Kochi Prefecture, together with smaller statues of mythical lions and other beasts at the same temple, are perhaps the works of Tankei. With regard to this sculptor, we should also consider the statues of the god of thunder, or Raijin (Fig. 66), and the god of wind, or Fujin (Fig. 65), as well as the statues of the Twenty-eight Followers of Kannon (Nijuhachibu Shu), including Basu Sennin (Fig. 38)—all at the above-mentioned Sanjusangendo. The makers of these statues remain unidentified, but it is more than likely that many of them were busshi who descended directly from Unkei, including, of course, Tankei.

Two statues are recognized as the work of Unkei's third son, Koben: the pair of demons at the Kofuku-ji, one known as the Tentoki, or Demon

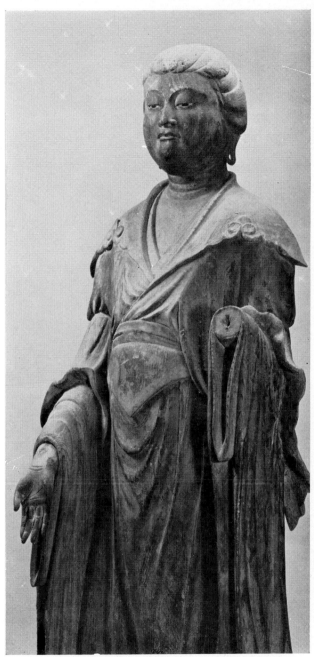

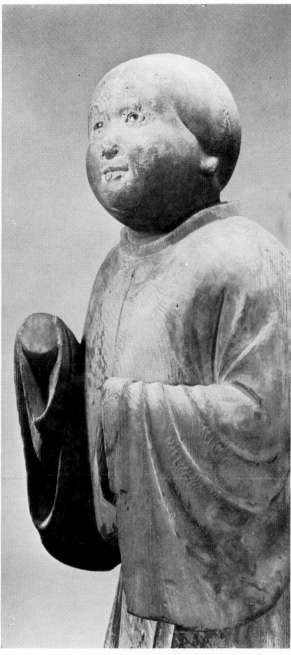

63. *Kichijo Ten, one of the attendants of Bishamon Ten, by Tankei. Painted wood; height of entire statue, 80 cm. Thirteenth century. Sekkei-ji, Kochi Prefecture.*

64. *Zennishi Doji, one of the attendants of Bishamon Ten, by Tankei. Painted wood; height of entire statue, 80 cm. Thirteenth century. Sekkei-ji, Kochi Prefecture.*

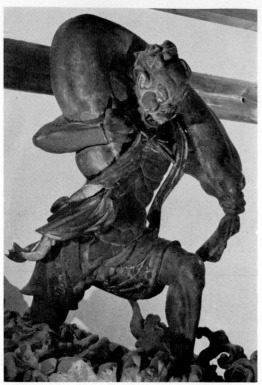

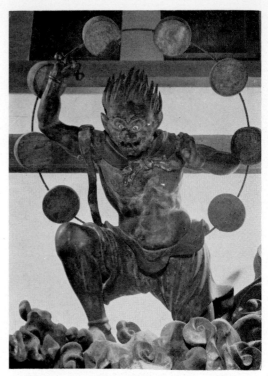

65. *Fujin, god of wind. Painted wood; height, 112 cm. Thirteenth century. Sanjusangendo, Kyoto.*

66. *Raijin, god of thunder. Painted wood; height, 100 cm. Thirteenth century. Sanjusangendo, Kyoto.*

Shouldering a Lantern (Figs. 80, 163), and the other as the Ryutoki, or Demon Carrying a Lantern on His Head (Fig. 67). The small figures of these two goblins, straining under the weight of their burdens, express strength and humor at the same time. We can easily recognize in them the ready wit of Kamakura sculpture as well as the faithful retention of the Unkei style. According to some scholars, the statue of the Tentoki is the work of another busshi.

By good fortune, three statues by Unkei's fourth son, Kosho, survive today. These are an Amida Nyorai (Fig. 84) at the Horyu-ji, near Nara; a portrait statue of the ninth-century priest Kukai (Kobo Daishi) at the To-ji, in Kyoto; and a portrait statue of the tenth-century priest Kuya (Figs. 72, 131, 153) at the Rokuhara Mitsu-ji, in Kyoto.

The Amida Nyorai is a deliberate imitation of Asuka (552–646) and early-Nara (646–710) sculpture and is one example of how the artists of the Kamakura period reflected upon the past.

As portrait statues, the other two works are interesting because of their extremely realistic technique. Kukai's robes have natural yet intricately flowing folds, a stylistic feature that can be found in the Jizo Bosatsu (Fig. 45) at the Rokuhara Mitsu-ji, attributed to Unkei, and in the even earlier Six Patriarchs of the Hosso Sect (Figs. 146, 147) by Kokei, at the Kofuku-ji's Nan'endo. The statue of Kuya is a superb example of the techniques of realism at work—down to such details as the wrinkled clothing and the veins in the arms. Some viewers might even feel that realism has been carried slightly too far in this case. At any rate, Kosho

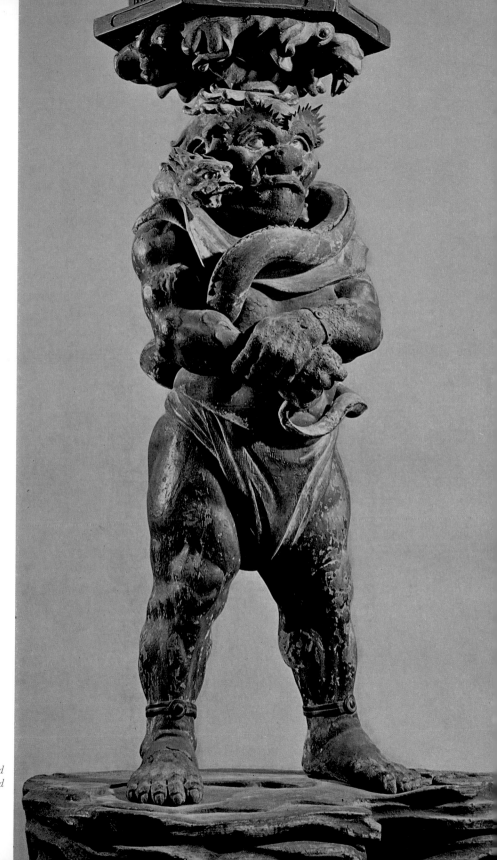

67. *Ryutoki, by Koben. Painted wood; height, 77.5 cm. Dated 1215. Kofuku-ji, Nara.*

68. *Zemmyo Shin, attributed to Tankei. Painted wood; height, 31.5 cm. About 1225. Kozan-ji, Kyoto.*

69. *Ni-o (Naraen Kongo), attributed to Jokei I. Painted wood; height of entire statue, 161.5 cm. Thirteenth century. Kofuku-ji, Nara.* ▷

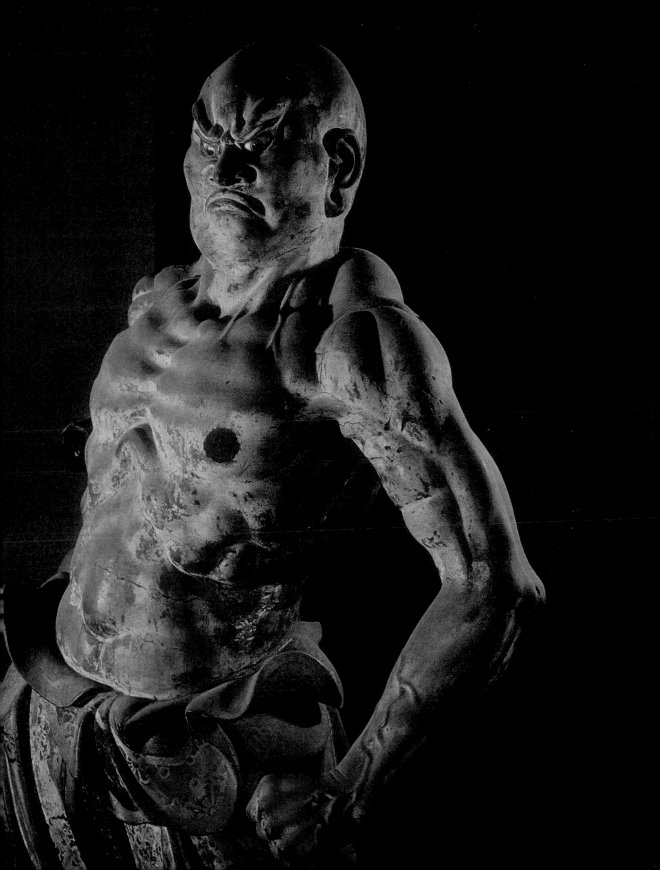

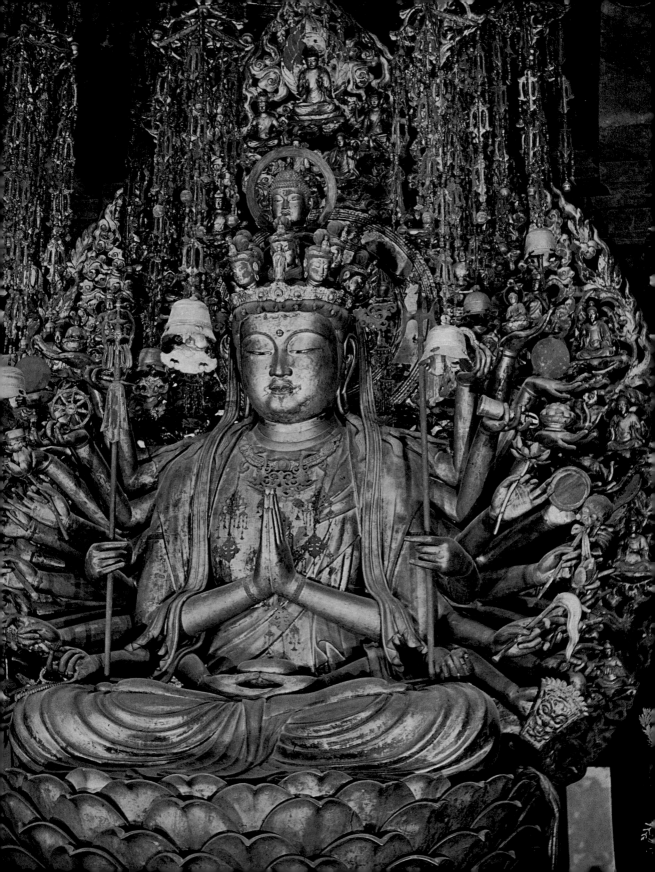

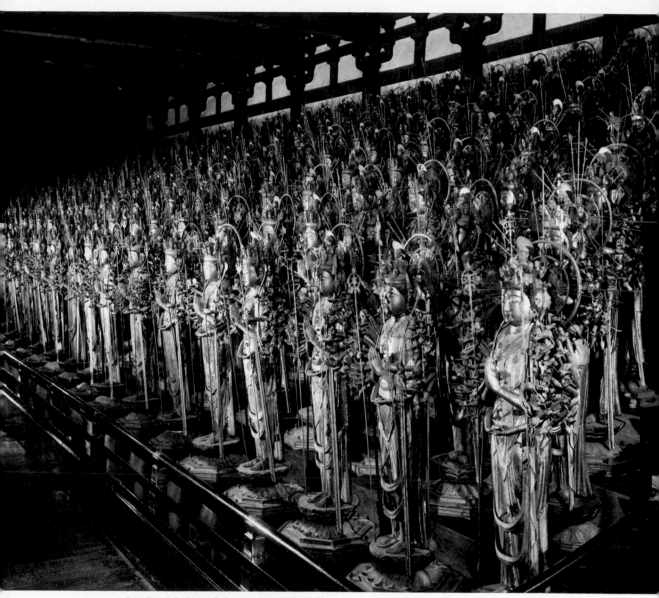

71. Partial view of the one thousand smaller statues of the Senju (Thousand-armed) Kannon at the Sanju-sangendo, Kyoto. Lacquer and gold leaf over wood; average height, 170 cm. Twelfth to thirteenth century.

◁ 70. Senju (Thousand-armed) Kannon, by Tankei. Lacquer and gold leaf over wood; height, 339.4 cm. Dated 1254. Sanjusangendo, Kyoto.

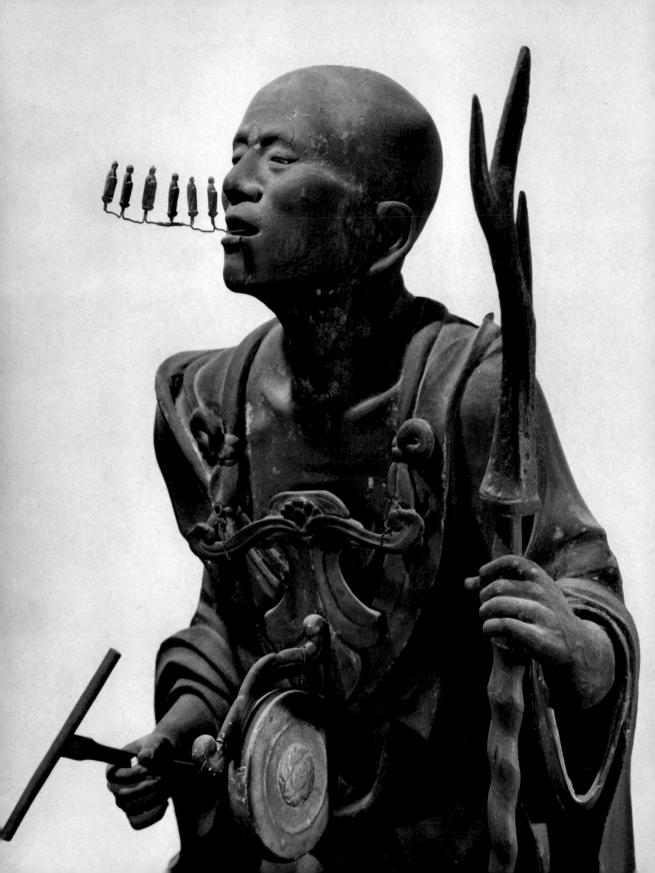

73. *Bishamon Ten, by Tankei. Painted wood; height of entire statue, 169 cm. Thirteenth century. Sekkei-ji, Kochi Prefecture.*

◁ 72. *The priest Kuya, by Kosho. Painted wood; height of entire statue (see Figure 153), 117.5 cm. Thirteenth century. Rokuhara Mitsu-ji, Kyoto. (See also Figure 131.)*

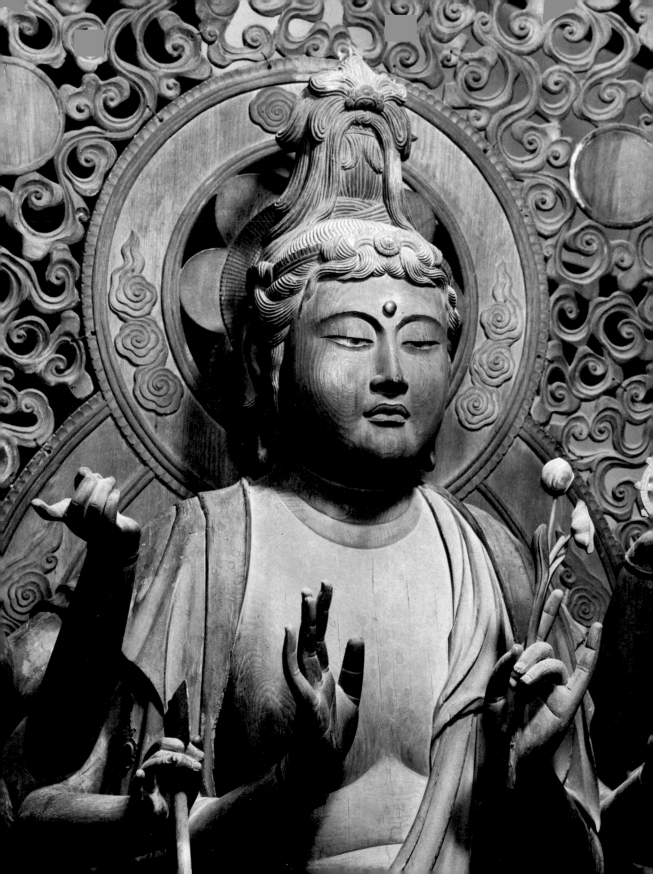

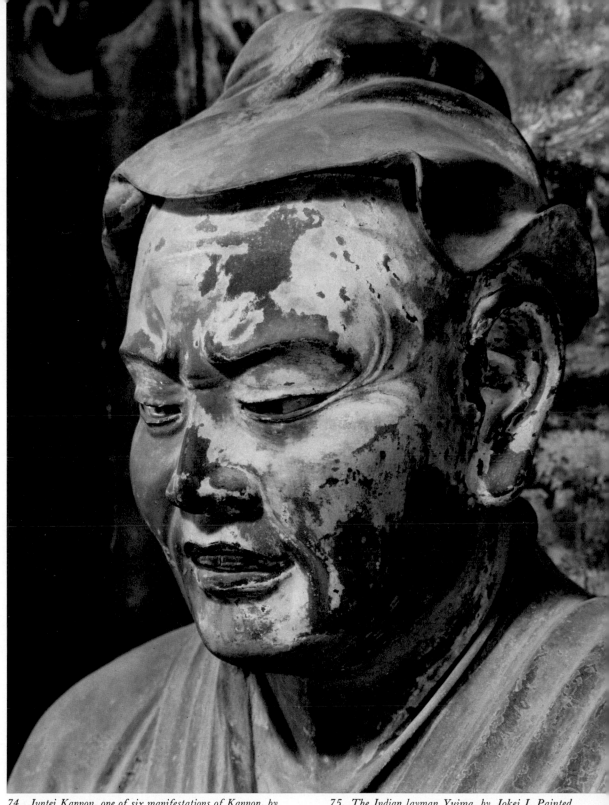

◁ 74. *Juntei Kannon, one of six manifestations of Kannon, by Jokei II. Unpainted wood; height of entire statue (see Figure 154), 176 cm. Dated 1224. Daiho-on-ji, Kyoto.*

75. *The Indian layman Yuima, by Jokei I. Painted wood; height of entire statue (see Figure 150), 89 cm. Dated 1196. Tokondo, Kofuku-ji, Nara.*

76. *Aizen Myo-o, by Koen. Painted wood; height of entire statue, 40.9 cm. Dated 1275. Jingo-ji, Kyoto.*

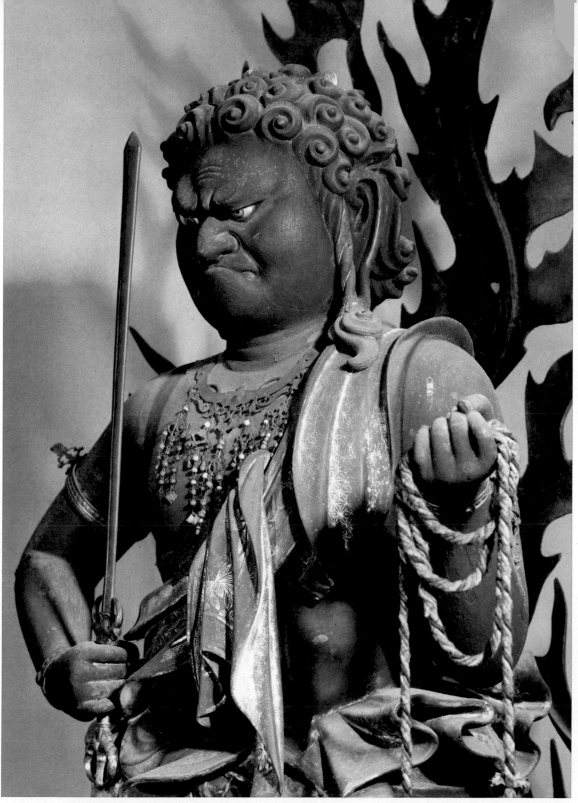

77. *Fudo Myo-o, by Koen. Painted wood; height of entire statue, 110.4 cm. Dated 1272. Kannon-ji, Tokyo.*

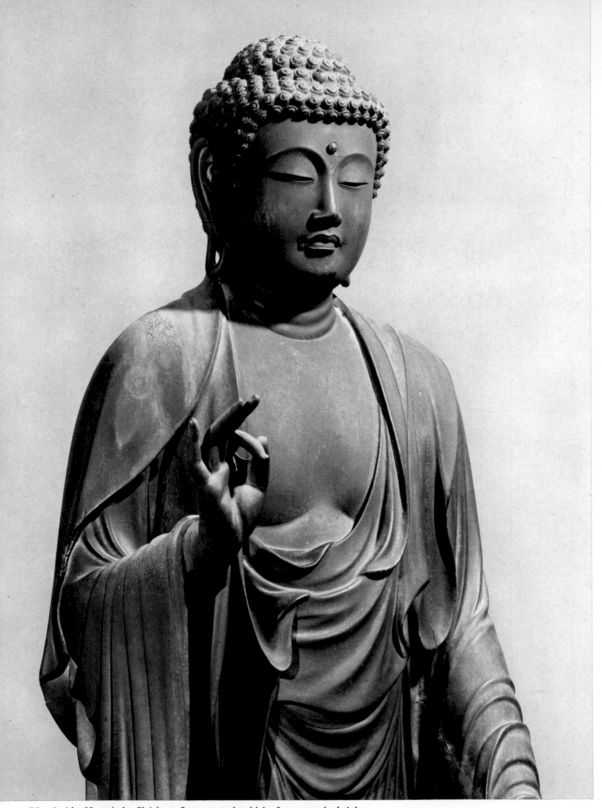

78. *Amida Nyorai, by Keishun. Lacquer and gold leaf over wood; height of entire statue, 97.3 cm. Dated 1240. Senju-ji, Mie Prefecture.*

79. *Byakko Shin, attributed to Tankei. Painted wood; height of entire statue, 41.5 cm. About 1225. Kozan-ji, Kyoto.*

was extremely skilled in realistic sculpture, and in that respect he was a worthy successor to Unkei.

In the ways we have noted here, Unkei's sons continued to work in their father's style and created splendid pieces of sculpture. As far as their art was concerned, they were indeed followers of Unkei.

It goes without saying that Unkei had many apprentices besides his own sons. One of these apprentices was Keishun of Tajima Province (now part of Hyogo Prefecture), who was awarded the rank of *hokkyo*. In 1240, he carved a statue of Amida Nyorai (Fig. 78) for the Senju-ji, in Mie Prefecture. In the intricate, free-flowing folds of this statue's robes, we find a conspicuous feature of the Unkei style. The facial expression is naturally calm. The work bears a superficial resemblance to the Amida Nyorai statues of the Kaikei school, which we shall discuss in the following chapter. As a rare Amida Nyorai statue of the Unkei school, it is of great importance.

In the latter half of the thirteenth century, when signs of stagnation began to appear in the world of Japanese sculpture, Koen was one of the most active of Unkei's descendants. He was the son of Unkei's second son, Koun, and in 1254, when his uncle Tankei was working on the Thousand-armed Kannon at the Sanjusangendo, he participated as an apprentice busshi. After Tankei's death in 1256, he became a master busshi. In 1266, he produced six of the thousand smaller statues of the Thousand-armed Kannon at the Sanjusangendo. Other extant statues by Koen are Taizan-o, one of the Ten Kings of Buddhism, at the Byakugo-ji, in Nara Prefecture, produced in 1259; the Followers of the Four Celestial Guardians (Shitenno Kenzoku), including Tamon Ten's follower (Fig. 82), now kept separately in the Atami Art Museum (Shizuoka Prefecture), the Seikado (Tokyo), and private collections, produced in 1267; Fudo Myo-o (Fig. 77) and the Eight Attendants of Fudo Myo-o, or Fudo Hachi Dai Doji (Fig. 81), at the Kannon-ji, Tokyo,

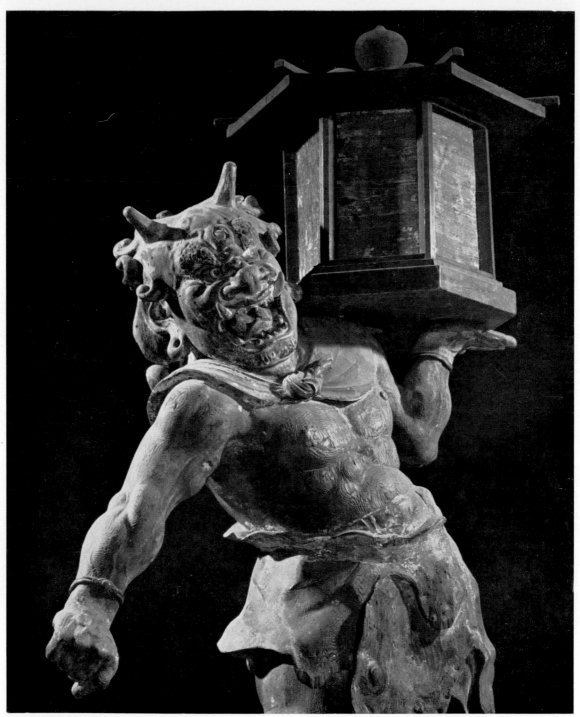

80. *Tentoki, attributed to Koben. Painted wood; height of entire statue (see Figure 163), 77.8 cm. About 1215. Kofuku-ji, Nara.*

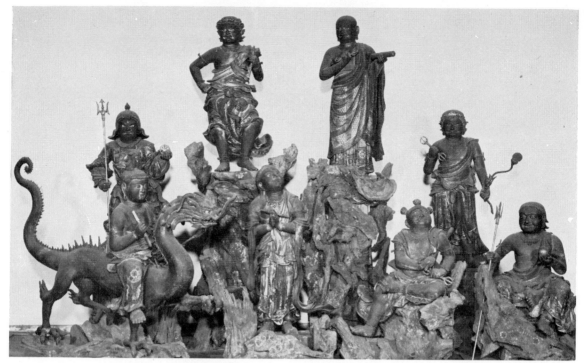

81. *The Eight Attendants of Fudo Myo-o (Fudo Hachi Dai Doji), by Koen. Statues from left to right: Anokudatsu Doji (seated on dragon), Shitoku Doji, Ukubaga Doji, Kongara Doji, Shojobiku Doji, Seitaka Doji, Eko Doji, Eki Doji. Painted wood; average height, 50 cm. Dated 1272. Kannon-ji, Tokyo.*

produced in 1272; Monju Bosatsu and His Four Attendants (Monju Go Son) in the Nakamura Collection, Tokyo, produced in 1273; and Aizen Myo-o (Fig. 76) at the Jingo-ji, in Kyoto, produced in 1275. Since there is accurate evidence that Koen was sixty-eight years old when he produced the last-mentioned statue, we can calculate his birth date as 1207.

If we consider Koen's statues as part of the Unkei line, they appear formalized and weak in expression. Particularly in the Followers of the Four Celestial Guardians and later works, we feel an extreme delicacy in the craftsmanship because of the small sizes and the application of fine colored patterns on the robes. The technical skill evidenced in these sculptures is quite solid, however, and there

is no reason to slight Koen as an artist and direct descendant of Unkei.

Along with Koen we should consider his cousin Kosei, who was the son of Kosho and thus one of Unkei's grandsons. Like his cousin, Kosei worked under his uncle Tankei on the construction of the main image of the Thousand-armed Kannon at the Sanjusangendo. Even earlier in his career, in 1237, he produced a statue of Jizo Bosatsu (Fig. 83) for the Todai-ji's Nembutsudo (Invocation Hall) and dedicated it to the souls of his grandfather, Unkei; his father, Kosho; and others. This stately image shows a talent reminiscent of the earlier followers of Unkei. I should like to note, however, that the carving of the robes shows a certain degree of carelessness.

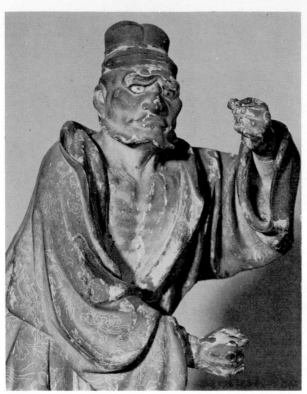

82. *One of the Followers of Tamon Ten, by Koen. Painted wood; height of entire statue, 32.3 cm. Dated 1267. Atami Art Museum, Shizuoka Prefecture.*

83 (opposite page, left). Jizo Bosatsu, by ▷ Kosei, son of Kosho. Painted wood; height, 218.2 cm. Dated 1237. Nembutsudo, Todai-ji, Nara.

84 (opposite page, right). Amida Nyorai, ▷ by Kosho. Bronze; height, 65 cm. Dated 1232. Golden Hall, Horyu-ji, Nara Prefecture.

We must also mention here the father-and-son team of Koshun and Kosei. Although Kosei (康清), the son of Kosho, and Kosei (康成), the son of Koshun, have names of the same pronunciation, we can see that these names are distinguished in Japanese by the use of different characters. Koshun, whose father was Unkei's youngest son, Unjo, was active during the first half of the fourteenth century and produced a large number of works that are extant today. To list them in chronological order, they are as follows: the Jizo Bosatsu at the Hoko-in, in Nara Prefecture, produced in 1315; the Shotoku Taishi (Fig. 85) at the Atami Art Museum, produced in 1320; the Shitenno at the Eiko-ji, in Oita Prefecture, produced in 1321–22; the Monju Bosatsu (Fig. 151) at the Hannya-ji, in Nara, produced in 1324; the Fugen Emmei Bosatsu at the

Ryuden-ji, in Saga Prefecture, produced in 1326; the Shinto god Hachiman represented as a Buddhist priest (Fig. 86) at the Boston Museum of Fine Arts, produced in 1328; the Monju Bosatsu and His Four Attendants at the Daiko-ji, in Miyazaki Prefecture, produced in 1348; and the Fudo Myo-o at the Fukusho-ji, in Hyogo Prefecture, produced in 1369. Among the works of Koshun's son Kosei that survive today are statues of Jizo Bosatsu, formerly in the Hara Collection, Tokyo, produced in 1336; the two temple guardians, or Ni-o (Figs. 89, 155), at the Kimpusen-ji on Mount Yoshino, Nara Prefecture, produced in 1338; and Yakushi Nyorai (Fig. 87), also at the Kimpusen-ji, produced in 1353.

Both father and son preferred to speak of themselves as busshi attached to the Kofuku-ji and thus continued the centuries-old tradition of the Nara

busshi. In reality, however, their stage of activity extended as far as Kyushu, and it is likely that such titles as chief busshi of the Kofuku-ji were useful in the provinces. Since there was very little large-scale production of Buddhist statuary in Kyoto and Nara during this period, there was a tendency for busshi from this area to seek assignments in distant places, and Koshun and Kosei were undoubtedly busshi of this sort. They worked together, and their sculptures are quite similar in style—a style that lacks the delicate craftsmanship of Koen and instead favors heavily fleshed bodies and deeply carved robes. In this sense, Koshun and Kosei correctly preserved the stylistic traditions of Unkei's followers. Artistically, however, their work declined in quality, and the above-noted statues demonstrate all too well the terminal symptoms in Japanese sculpture that seemed to develop almost inevitably as the Kamakura period drew to a close.

As a further demonstration of this unfortunate trend, there is the case of Koyo, a fifth-generation descendant of Unkei and chief busshi of the To-ji. In Koyo's statue of Dainichi Nyorai (Fig. 165) at the Henjo-ji, in Tochigi Prefecture, produced in 1346, there is a suggestion of the Unkei style in the heavy flesh of the body and the elaborately carved robes. The total effect, however, is stiff and conventional, and the work has no true artistic value.

THE TWO JOKEIS During the Kamakura period there were two busshi with exactly the same name who made unique contributions to Japanese sculpture: Jokei I and Jokei II. Unlike Kosei (康清), the son of Kosho, and Kosei

85. *Shotoku Taishi (Prince Shotoku), by Koshun. Painted wood; height of entire statue, 68.2 cm.*
Dated 1320. Atami Art Museum, Shizuoka Prefecture.

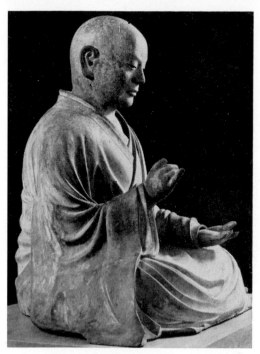

86. *The Shinto god Hachiman represented as a Buddhist priest, by Koshun. Painted wood; height, 81.8 cm. Dated 1328. Museum of Fine Arts, Boston.*

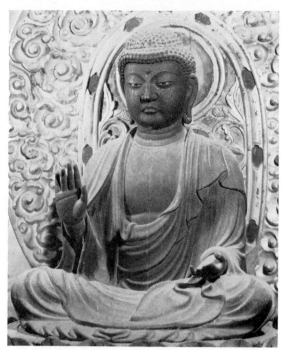

87. *Yakushi Nyorai, by Kosei, son of Koshun. Unpainted wood; height, 53 cm. Dated 1353. Kimpusen-ji, Mount Yoshino, Nara Prefecture.*

（康成）, the son of Koshun, the two Jokeis used the same characters （定慶） for their names. Therefore they are distinguished by Japanese scholars as Jokei I and Jokei II, although there is no evidence that they were in any way related by blood.

It is said that Jokei I may have been Unkei's second son, Koun, working under an assumed name. There is another theory that he was one of Kokei's apprentices. There is no doubt, however, that he was a member of the Kei school. His sculpture shows that instead of blindly following the precedents set by Kokei and Unkei he succeeded in establishing an artistic style all his own. As early as 1184, he created such unusual works as the mask for the Bugaku (court dance) piece *Sanju* (Fig. 88) for the Kasuga Shrine, in Nara. Later works of his include statues of the Indian layman Yuima (Figs. 75, 150) at the Kofuku-ji, produced in 1196; Tai-

shaku Ten, formerly at the Kofuku-ji, produced in 1201; and Bon Ten (Fig. 90) at the Kofuku-ji, produced in 1202. Also, the statues of the two temple guardians, or Ni-o (Figs. 69, 91), at the Kofuku-ji are attributed to Jokei I.

If we observe these statues carefully, we can see that they have a style soundly based on realism, which of course brings to mind the accomplishments of the Kei school. But an even more remarkable point is the strong influence of the artistic style of the Sung dynasty in these works. The unusual shape and decoration of layman Yuima's pedestal and back screen, the rich Chinese-style robes of Bon Ten and Taishaku Ten, and the robust, humanly expressive faces of all the images are clear evidence of this influence. Unkei and his followers were relatively well exposed to the precepts of the Sung style, but Jokei I alone tried to

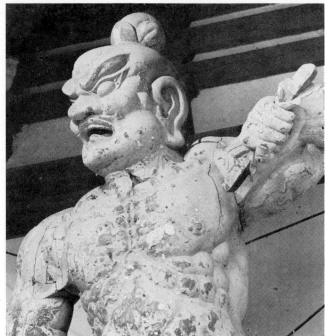

88. Mask for the Bugaku dance Sanju, *by Jokei I. Painted wood; height, 27.3 cm. Dated 1184. Kasuga Shrine, Nara.*

89. Ni-o (Misshaku Kongo), by Kosei, son of Koshun. Painted wood; height of entire statue, 528 cm. Dated 1338. Kimpusen-ji, Mount Yoshino, Nara Prefecture.

make use of them in a positive way. In this respect he made independent progress as an artist.

Here let us digress a bit and touch on the Sung artistic style. The major characteristic of the Chinese art of this period was a lush, vivid realism expressed in heavily fleshed faces and bodies and elaborate decorations. Foldout 3 shows some of the specific features of this style as it was reflected in Kamakura sculpture.

We may cite three different phases in the introduction of the Sung style to the sculptors of the Kamakura period. The first wave of influence came at the end of the twelfth century and centered on the remarkable Buddhist priest Chogen, whose energetic campaign for funds supported the restoration of the Todai-ji after the Great Nara Fire of 1180. Chogen traveled to China several times and introduced the new style of Sung architecture in

the reconstruction of the temple. Jokei I and Unkei's colleague Kaikei, who will be discussed in the next chapter, were quite closely associated with this first phase.

The second wave of influence was initiated by the priest Shunjo (1166–1227) of the Sennyu-ji, in Kyoto, and his disciple Tankai. Both men traveled to China in the early thirteenth century and brought back numerous Sung scrolls, paintings, and documents.

The third phase, covering the entire thirteenth century, is represented by the swiftly growing popularity of a meditative Buddhist sect from China known as Zen (in Chinese, Ch'an). This phase centered on Kamakura, where Zen temples were most concentrated, and the art produced under the new wave of influence had very distinctive features, perhaps because there were few deeply rooted

artistic traditions in the newly established military capital.

In all three instances of the introduction of Chinese ideas, however, Japanese sculptors were mainly interested in special techniques and superficially unusual forms. The influence of the Sung school of sculpture itself was comparatively weak because this school produced few works of great artistic merit. Stylistically speaking, Sung sculpture was capable of giving little or no inspiration to Unkei and the other Japanese sculptors of the Kamakura period. But it is an undeniable fact that the basic Sung style of art did provide a sort of new stimulus for the sculpture of the age.

A very concrete example of the influence of the Sung style on Kamakura sculpture is the Amida Triad (Fig. 13) by Kaikei at the Jodo-ji, in Hyogo Prefecture, a temple founded by Chogen in 1192. This group of statues was produced around the same time as the temple itself and is thought to have been based on a Chinese painting. In corroboration of this theory there are a few Buddhist paintings from Sung China in private Japanese collections and in the Senju-ji, in Mie Prefecture, that closely resemble the Jodo-ji's Amida Triad. The deities in both the paintings and the sculpture are shown floating on white clouds and have the same unusual hand gestures and hair styles so representative of Sung art. There were undoubtedly many cases in which Buddhist paintings brought from China served as models for Kamakura-period statues in the Sung manner.

Jokei II, who was active slightly later in history than Jokei I, was born in 1184. Works from relatively early in his career include the following statues: the Shaka Nyorai in the Suzuki Collection, Tokyo, produced in 1223; the Bishamon Ten (Fig. 92) at the Tokyo University of Arts, produced in 1224; the six manifestations of Kannon (Fig. 154), including the Sho Kannon, the Senju (Thousand-armed) Kannon, the Juichimen (Eleven-headed) Kannon, the Bato (Horse-head) Kannon, the Juntei Kannon (Fig. 74), and the Nyoirin Kannon, at the Daiho-on-ji, in Kyoto, produced in 1224; and a solitary Sho Kannon (Fig. 93) at the Kurama-dera, in Kyoto, produced in 1226. Somewhat later

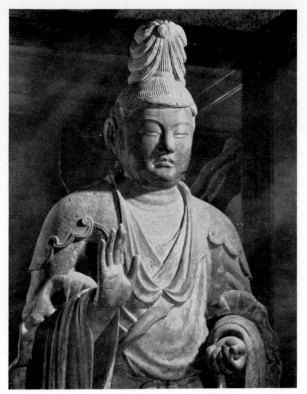

in his career he also produced statues of the Ni-o for the Sekigan-ji, in Hyogo Prefecture, in 1242 and for the Ozo-ji, in Gifu Prefecture, in 1256.

We know that Jokei II was also a busshi of the Kei school. In dynamic statues like the Bishamon Ten and the Ni-o this is particularly evident. In his statues of the Sho Kannon, however, the robes are carved with intricate folds, and the faces have a human freshness—features that point to the strong influence of the Sung style. Jokei II received such honorary titles as *betto* (steward) and *hokkyo* and was often called the *betto* or *hokkyo* of Higo Province (the present Kumamoto Prefecture). He produced many statues for provincial temples like the Sekigan-ji and the Ozo-ji. It is even recorded that he worked for a time in Musashi Province, an area

90. Bon Ten, by Jokei I. Painted wood; height of entire statue, 166.6 cm. Dated 1202. Kofuku-ji, Nara.

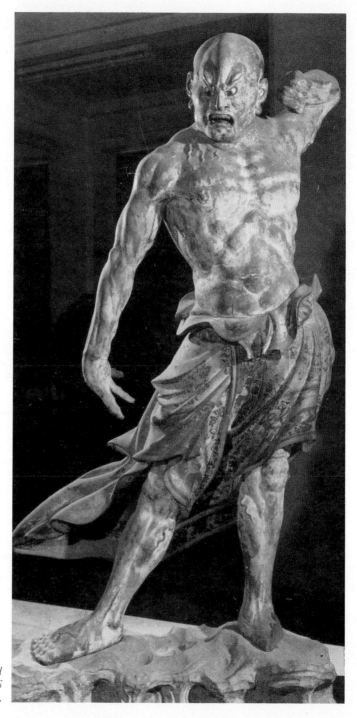

91. Ni-o (Misshaku Kongo), attributed to Jokei I. Painted wood; height, 162.6 cm. Thirteenth century. Kofuku-ji, Nara.

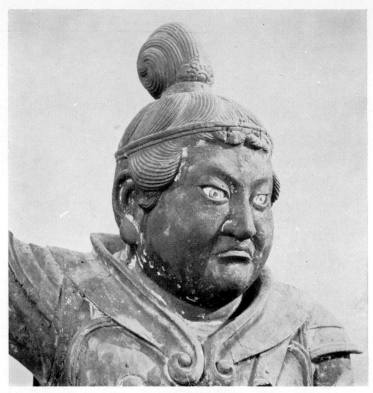

92. Bishamon Ten, by Jokei II. Painted wood; height of entire statue, 86.4 cm. Dated 1224. Tokyo University of Arts.

93. Sho Kannon, by Jokei II. Painted wood; ▷ height, 174 cm. Dated 1226. Kurama-dera, Kyoto.

now consisting of parts of Saitama Prefecture, Kanagawa Prefecture, and Tokyo.

Jokei I and Jokei II had much more in common than their names. Both were quite active in introducing the artistic style of the Sung dynasty into the sculpture of the Kamakura period. It is difficult to ascertain what kind of relationship, if any, the two men had with each other. There is a great gap in their sculptural styles in that Jokei II came to rely on artifice and imbued his works with an excessively delicate air. At any rate, it is important to note that besides those busshi from Tankei onward who faithfully followed Unkei's great style, there were sculptors like Jokei I and Jokei II, who skillfully assimilated the newly imported Sung style and thus demonstrated the extraordinarily wide range of activities enjoyed by the Kei school.

In closing, let us note that still a third sculptor named Jokei lived at the end of the thirteenth century and repaired statuary at the Horyu-ji. Since he is of little importance to our study, there is no need to discuss him further.

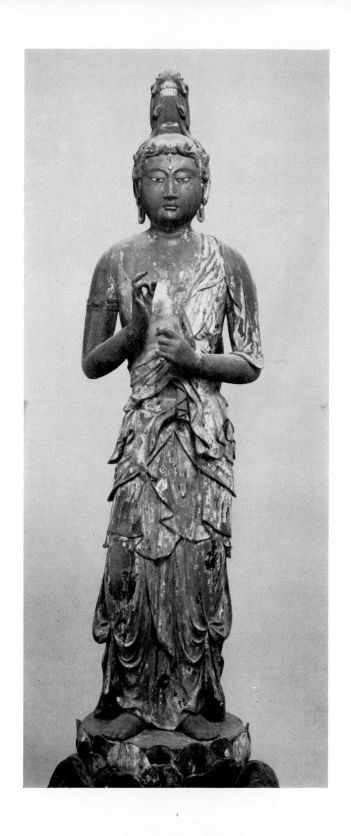

CHAPTER FOUR

The Achievement of Kaikei

KAIKEI'S LIFE AND WORK At the very mention of Unkei's name, the name of Kaikei comes to mind. These two men were the representative sculptors of the Kamakura period, and their lives and works can be contrasted on every level. In order to understand Unkei and his art to the fullest, we should also make a thorough study of Kaikei. Indeed, the genre we call Kamakura sculpture was created with the equal support of these two great artists. For this reason I should like to devote the present chapter to the subject of Kaikei and the many ways in which he can be contrasted with Unkei.

Kaikei learned the techniques of carving Buddhist statuary from Kokei and was a fellow apprentice of Unkei's. Thus in a broad sense he was a member of the Kei school. When we examine the many works by Kaikei that survive today, we can tell that he must have been a rare genius. Moreover, the people of his time hailed him as "a man with almost no equal." Even when he was still only an apprentice, his assignments rivaled in number and importance those of Unkei, the direct successor by birth to the leadership of the Kei school. The accompanying table, showing four projects in the reconstruction of the Todai-ji, clearly demonstrates this. As we study it, we immediately notice that Kaikei was the only busshi to participate in all four projects. Moreover, because Kokei was already quite advanced in years and because Unkei's younger brother Jokaku was still young and inex-

perienced, it would seem that Kaikei assisted Jokaku while Unkei joined forces with his weakening father, Kokei. Thus Kaikei and Unkei were actually competing with each other in a contest of speed and skill. We can imagine how important their positions in the world of Japanese sculpture were at the time.

Although Kaikei had his origins in the Kei school, he later followed a separate career and became as famous as Unkei for a unique, fully developed style of his own. We can therefore surmise that he had a strongly individual character, unusual for a man of his time. We can also learn something of Kaikei's personality from the different signatures he left on his works. If we examine all the statues he produced during his lifetime, we find that these signatures may be divided roughly into three types. The first type, used during his youth before he received any Buddhist rank in recognition of his artistic achievements, reads as follows: "The *kosho* [skilled craftsman] Kaikei of the Buddhist name An [written in Sanskrit] Amida Butsu." After receiving the rank of *hokkyo* in approximately 1203, he changed his signature to read: "The *kosho* Kaikei of the rank *hokkyo*." Again, when he received the rank of *hogen* around 1208–10, the signature came to read: "The *kosho* Kaikei of the rank *hogen*." It is true that these signatures were slightly abbreviated in some cases, but, for the period he lived in, Kaikei signed his works very positively in a clear-cut, regular manner. From this fact we can

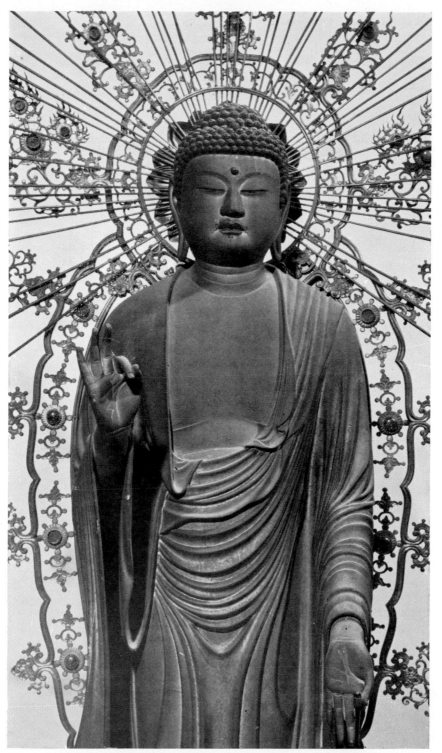

94. *Amida Nyorai, by Kaikei. Painted wood; height of entire statue, 79.5 cm. About 1221. Kodai-in, Mount Koya, Wakayama Prefecture.*

Statuary Group and Date Produced	Statue	Sculptor(s)
Two deities for the Inner Gate, 1194	Jikoku Ten	Jokaku
	Tamon Ten	Kaikei
Two attendants of the Daibutsu, 1196	Kokuzo Bosatsu	Kokei & Unkei
	Nyoirin Kannon	Jokaku & Kaikei
The Shitenno, or Four Celestial Guardians, surrounding the Daibutsu, 1196	Zocho Ten	Kokei
	Jikoku Ten	Unkei
	Tamon Ten	Jokaku
	Komoku Ten	Kaikei
Two temple guardians, or Ni-o, for the South Main Gate, 1203	Misshaku Kongo & Naraen Kongo	Unkei & Kaikei

conclude not only that he had a very methodical nature but also that he was a man of strong convictions and stern pride. Of special note is his use of the word *kosho*, which indicated that he was a busshi. Until Kaikei's time the word had rarely been used for this purpose. Even more unusual was his use of the Sanskrit character pronounced *an* in Japanese. From this particular quirk we somehow sense that Kaikei was always looking for new horizons. That his ability to establish an independent sculptural style was directly related to his highly individual character cannot be denied.

Kaikei's use of the name An Amida Butsu derived from his close relationship with the famous Buddhist priest Chogen. As we have previously noted, Chogen's name has gone down in history because of his fund-raising efforts for the restoration of the Todai-ji after its destruction in the Great Nara Fire of 1180. Originally a priest of the Shingon (in Chinese, Chen-yen) sect of Esoteric Buddhism, Chogen became a zealous missionary for the Jodo (in Chinese, Ching-t'u) sect, which

was established in Japan in the late twelfth century by Chogen's teacher, Honen (also known as Genku). Jodo, or the Pure Land, refers to the Western Paradise of the Buddha Amida, and Honen taught that entrance into this paradise could be obtained merely by repeating Amida's name. Chogen took the Buddhist name of Namu Amida Butsu, and from around 1183 he began to give his friends Buddhist names that contained the word Amida. Kaikei, who was a sculptor of Buddhist images and a firm believer in the tenets of the Jodo sect as well, received his Buddhist name of An Amida Butsu from Chogen in this manner. It goes without saying that his friendship with Chogen was based not only on religious affinities but also on his important role in the production of statuary for the Todai-ji and other temples.

Other important Buddhist priests with whom Kaikei was intimate included Myoe (also called Koben) of the Kozan-ji, in Kyoto; Jokei (Gedatsu) of the Kasagi-dera, in Kyoto Prefecture; and Myohen (Ku Amida Butsu) of the Rengezammai-in on

◁ 95. Four projects in the reconstruction of the Todai-ji.

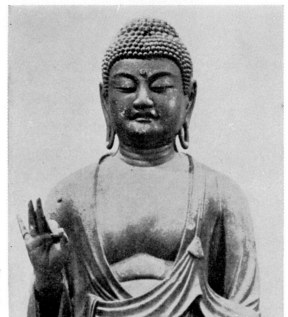

96. Amida Nyorai, by Kaikei. Painted wood; height of entire statue, 98.5 cm. Late twelfth century. Saiho-ji, Nara Prefecture.

Mount Koya, in Wakayama Prefecture. Since we also know that his contemporaries described him as "indeed a purified person," we may judge that Kaikei must have been a pious believer in Buddhism. Because of his fervent faith, he was able to increase the depth and brilliance of his art.

KAIKEI'S ARTISTIC STYLE The completely independent sculptural style that Kaikei established came to be known as the Annami style, after his Buddhist name of An Amida Butsu. When we consider his strongly individual character and his thirst for the new and different, it seems only natural that he should have developed such a distinct style. Here let us examine the various stages he passed through in perfecting it.

Among Kaikei's earliest works are the Miroku Bosatsu (Fig. 97) at the Boston Museum of Fine Arts, produced in 1189; the Miroku Bosatsu (Fig. 110) at the Sambo-in of the Daigo-ji, in Kyoto, produced in 1192; the Amida Triad (Fig. 13) at the

Jodo-ji, in Hyogo Prefecture, produced in 1197; and the Shaka Nyorai at the Empuku-in, in Shiga Prefecture, produced in 1197. All of these works display a conspicuously realistic trend and are distinguished by their free-flowing robes. In this respect they follow the new style that was then being created by Kokei and Unkei, and the delicate beauty that eventually became the hallmark of Kaikei's sculpture is not very apparent. But it is significant that Kaikei began his career with realism. During the last decade of the twelfth century he was participating with all his might in the critical reconstruction of the Todai-ji, and we can imagine what powerful, animated sculpture he must have produced for the Daibutsuden and the Inner Gate.

But Kaikei could not remain satisfied with the realism of the Kei school indefinitely. During the closing years of the twelfth century, in what might be called his middle period, he began to experiment with a number of different sculptural styles. To be sure, he did produce works at this time that re-

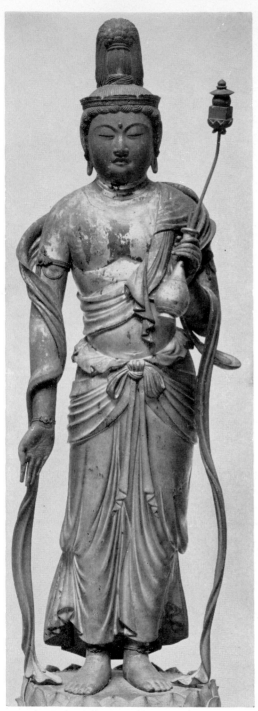

97. *Miroku Bosatsu, by Kaikei. Lacquer and gold leaf over wood; height, 107 cm. Dated 1189. Museum of Fine Arts, Boston.*

98 (opposite page, left). *Miroku Bosatsu, attributed to Kaikei. Lacquer and gold leaf over wood; height of entire statue, 102.8 cm. About 1190–98. Chujo-in, Todai-ji, Nara.* ▷

99 (opposite page, right). *Shaka Nyorai, attributed to Kaikei. Painted wood; height of entire statue, 51.3 cm. Dated 1199. Bujo-ji, Kyoto.* ▷

tained some of the vivid realism of his early years—for example, the Fudo Myo-o at the Shoju-in, in Kyoto Prefecture; the Amida Nyorai (Fig. 96) at the Saiho-ji, in Nara Prefecture; and the Amida Nyorai (Figs. 116, 157) at the Matsuno-o-dera, in Kyoto Prefecture. But he also carved images with fluttering robes in the Sung manner—for example, the Miroku Bosatsu (Fig. 98) at the Chujo-in of the Todai-ji, produced in the 1190s; the Shaka Nyorai (Fig. 99) at the Bujo-ji, in Kyoto, produced in 1199; and the Shaka Nyorai (Fig. 102) at the Kengo-in, in Kyoto, produced around 1194–99. (We must note that the first two of these three statues are only attributed to Kaikei.) He also created pieces reminiscent of the early years of the Fujiwara period (897–1185), such as the Amida Nyorai (Fig. 101) at the Kengo-in, produced around 1194–99. His statue of the guardian deity Shikkongo Shin (Fig. 112), which is enshrined together with a

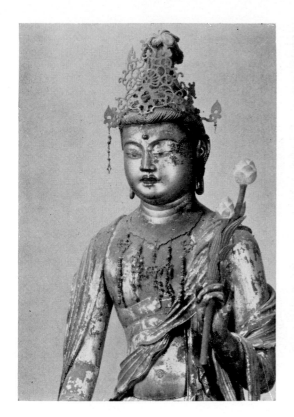
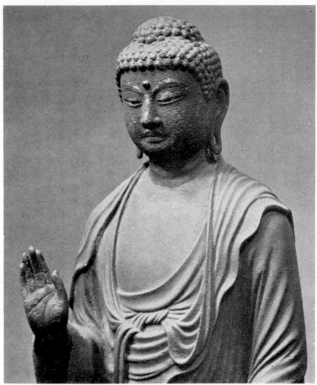

grotesque image of Jinja Taisho (Fig. 111) at the Kongo-in, in Kyoto Prefecture, is probably a copy of the late-Nara statue of the same deity at the Todai-ji's Hokkedo.

Thus we see how Kaikei, during this period when he worked in the styles of the Sung dynasty, the early Fujiwara period, and the late Nara period, continued to grope for a style of his own. In trying to escape from the realism of the Kei school, which he had followed up to this point in his career, Kaikei was in the throes of creating his own individual style. Also, we should recall here that in 1196 the two most important structures at the Todai-ji, the Daibutsuden and the Inner Gate, had just been completed, and we can imagine that all the Nara busshi experienced a feeling of relief as the tensions of these demanding projects were eased. While Unkei took advantage of this pause in the restoration work to go to Kyoto and become

involved in assignments for the Jingo-ji and the To-ji, Kaikei experimented with various sculptural styles and accumulated more and more knowledge of his art.

In due time an extraordinarily beautiful and elegant style began to appear in Kaikei's sculpture. Going beyond mere prettiness, this unique style overflowed with an intellectual beauty based on the concepts of realism. It was created from an exceptional combination of elements that Kaikei had assimilated over the years and, as we have already noted, came to be called the Annami style.

The earliest appearance of the Annami style can be seen in Kaikei's statue of Kujaku Myo-o, the Peacock King (Fig. 109), produced in 1200 and enshrined at the Kongobu-ji on Mount Koya, in Wakayama Prefecture. We can also note the appearance of the style in Kaikei's statues of Amida Nyorai (Fig. 103) at the Kozo-ji, in Hiroshima Pre-

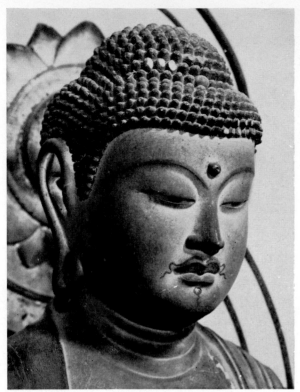

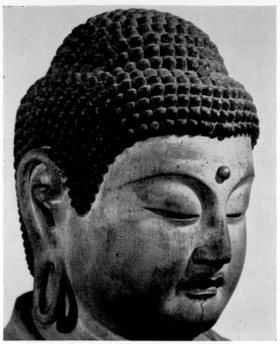

101. *Amida Nyorai, by Kaikei. Painted wood; height of entire statue, 99.6 cm. About 1194–99. Kengo-in, Kyoto.*

100. *Amida Nyorai, by Kaikei. Painted wood; height of entire statue, 100 cm. Dated 1202. Shunjodo, Todai-ji, Nara.*

fecture, produced in 1201; the Shinto god Hachiman represented as a Buddhist priest (Fig. 108) at the Todai-ji, also produced in 1201; Amida Nyorai at the Henjoko-in on Mount Koya; Amida Nyorai (Fig. 100) at the Shunjodo of the Todai-ji, produced in 1202; Fudo Myo-o (Fig. 105) at the Sambo-in of the Daigo-ji, produced in 1203; and Dainichi Nyorai at the Tokyo University of Arts.

Finally, in Kaikei's Jizo Bosatsu (Figs. 15, 152) at the Kokeido of the Todai-ji, we find a work of art in which the Annami style has reached the point of perfection. This statue dates from the sculptor's *hokkyo* period (c. 1203–8) and is extremely well preserved. More striking than anything else to the viewer of this lovely work are the brilliant carving

of the robes and the expression on the face, which mixes dignity with a graceful beauty. We can see here the achievement of the goal toward which Kaikei had been working.

The years of groping in the development of the Annami style were now over, and new doors opened for Kaikei. As the restoration work at the Todai-ji began anew, he entered on the most intensely active period of his entire career. During the years that followed, he produced such ambitious works as the statues of Monju Bosatsu (Fig. 120) and His Four Attendants at the Monju-in, in Nara Prefecture, in 1201–3; Amida Nyorai at the Shin Daibutsu-ji, in Mie Prefecture, in 1202; and, together with Unkei, the celebrated Ni-o (Figs. 41–43, 53) in the South Main Gate of the Todai-ji, in 1203. The statues at

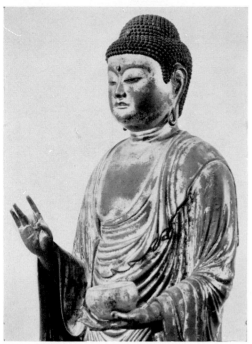

102. *Shaka Nyorai, by Kaikei. Lacquer and gold leaf over wood; height of entire statue, 98 cm. About 1194–99. Kengo-in, Kyoto.*

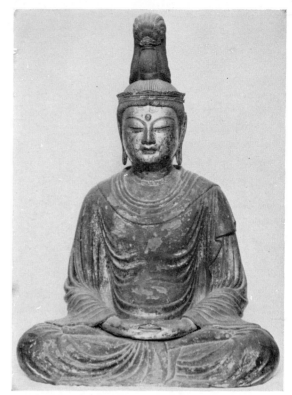

103. *Amida Nyorai, by Kaikei. Lacquer and gold leaf over wood; height, 75 cm. Dated 1201. Kozo-ji, Hiroshima Prefecture.*

the Monju-in and the Shin Daibutsu-ji show the strong influence of the Sung style and reveal Kaikei's deepening interest in this new art form. On the other hand, the Ni-o are heroic statues that recall his early period of realism.

The final period of Kaikei's artistic career began around 1208, when he received the rank of *hogen*, and continued into the 1220s. (The exact date of his death is unknown, but the last record containing his name is dated 1223.) As the great sculptor grew older, he could not hope to continue the vigorous pace of his prime. One of the few large statues that he produced during his last years was the Juichimen (Eleven-headed) Kannon, carved in 1219 for the Hase-dera, in Nara Prefecture, and no longer extant. (There are indications, however,

that Kaikei's apprentice Gyokai made this statue in his master's stead.) Other than this one example, most of the works Kaikei produced after 1208 are no taller than a meter or so. The first thing one notices about these small statues is that an overwhelming number of them are images of Amida Nyorai, including statues at the Toju-in, in Okayama Prefecture, produced in 1211; at the Korin-ji, in Nara Prefecture, produced in 1221; at the Kodai-in (Fig. 94), in Wakayama Prefecture, produced about 1221; at the Saiho-in (Fig. 106), in Nara; and at the Daigyo-ji, in Kyoto.

Kaikei had already begun to carve statues of Amida Nyorai in his middle period, but the later ones, in comparison with these, lack the radiance that once characterized his art. A shadow seems to

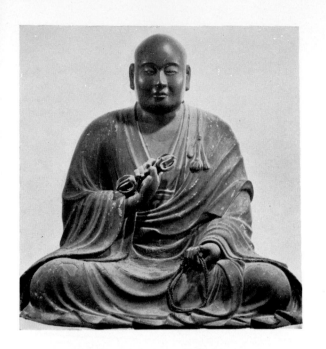 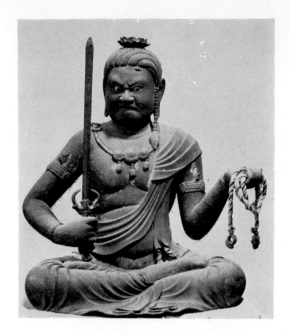

have fallen over the formerly sharp and graceful sculpturing of the robes, and there is a growing tendency toward busy detail. The statues of the Ten Great Disciples of the Buddha—the Ju Dai Deshi, as they are called in Japanese (Figs. 113, 114, 121, 122, 126)—at the Daiho-on-ji, in Kyoto, and of Kongo Satta at the Zuishin-in (Kyoto) belong to this period. Although they are full of the charming daintiness so typical of Kaikei, they lack freedom of expression and are extremely formalized. We might even say that because the basic aim of the Annami style was a very low-keyed beauty, it was fated to become quickly stereotyped once it had passed a step beyond its goal. All the statues produced by Kaikei during his last years exhibit the unfortunate artistic limitations inherent in the Annami style.

Although Kaikei's sculptural style had some basic weaknesses, his images of the Buddha had a beauty that anyone could appreciate and feel intimate with. Consequently, he was supported by every rank of society, including the priesthood, the warrior class, the aristocracy, and the common people.

Understandably, a great many apprentices flocked to him to learn the Annami style. His senior apprentice, Gyokai, produced two statues that survive today: the Shaka Nyorai (Figs. 107, 115) at the Daiho-on-ji and one of the thousand smaller statues of the Thousand-armed Kannon (Fig. 71) at the Sanjusangendo. Although much influenced by the Annami style, Gyokai's statues have a firm strength that causes us to feel that he was more than a mere imitator.

Eikai, who carved the Jizo Bosatsu at the Cho-mei-ji, in Shiga Prefecture, in 1254, and Chokai, who produced the statue of Kukai (Fig. 104) at the Rokuhara Mitsu-ji, were also apprentices of Kaikei. Both demonstrate a steady carving technique that is unhappily somewhat lacking in spirit. Besides the three apprentices mentioned here, one could name many other busshi who continued the Kaikei school for the next several centuries. Unfortunately, however, none of them showed any signs of artistic development but simply kept to the prescribed formula that Kaikei created for carving Buddhist statuary.

◁ *104 (opposite page, left). The priest Kukai (Kobo Daishi), by Chokai. Painted wood; height, 69.4 cm. Thirteenth century. Rokuhara Mitsu-ji, Kyoto.*

◁ *105 (opposite page, right). Fudo Myo-o, by Kaikei. Painted wood; height, 54 cm. Dated 1203. Sambo-in, Daigo-ji, Kyoto.*

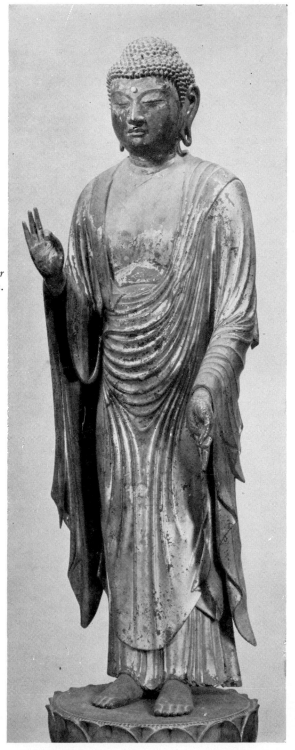

106. Amida Nyorai, by Kaikei. Lacquer and gold leaf over wood; height, 100 cm. Thirteenth century. Saiho-in, Nara.

A COMPARISON OF UNKEI AND KAIKEI

As the two artists most representative of those who created Kamakura-period sculpture, Unkei and Kaikei can be compared and contrasted in many ways. Unkei was the direct successor, by birth, to the leadership of the Kei school and perfected a strong style of sculpture soundly based on realism. We have noted that this genre was particularly well received and favored by the new holders of power. In contrast, Kaikei, although he came from the same Kei school, was not a direct descendant of this line of busshi. Thus the school he established is considered only a branch of the main one. His style of sculpture was characterized by an intellectual beauty based on realism. He was supported by no specific class but by the people in general, with no distinction among warriors, priests, aristocrats, or commoners. In contrast with Unkei's masculine style, his style was decidedly feminine. We might even compare the two with Michelangelo and Raphael, two of the greatest artists of the Italian Renaissance. As we all know, Michelangelo created paintings and sculp-

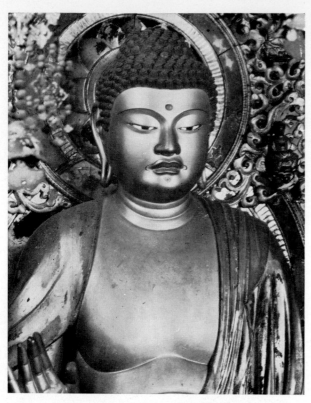

107. *Shaka Nyorai, by Gyokai. Lacquer and gold leaf over wood; height of entire statue (see Figure 115), 91 cm. Thirteenth century. Daiho-on-ji, Kyoto.*

108. *The Shinto god Hachiman represented as a Buddhist priest, by Kaikei. Painted wood; height, 87 cm. Dated 1201. Hachimanden, Todai-ji, Nara.* ▷

ture overflowing with power and passion, while Raphael skillfully blended the styles of many artists to paint pictures that glowed with harmonious beauty. Raphael is especially famous for his perfection of the image of the Madonna, a figure not unlike that of Amida Nyorai in Buddhism. Perhaps this is merely a historical coincidence, but there is indeed a striking resemblance between the two pairs of artists: Unkei and Kaikei in the East and Michelangelo and Raphael in the West.

Sculpture in the Kamakura period tended to be controlled by two divisions of the Kei school, one led by Unkei and the other by Kaikei. In addition to these two major schools, the two Jokeis established a group with distinct characteristics. The traditional In and En schools in Kyoto, which were continuations of the Fujiwara-period busshi groups, were also active. But all the sculptors of these dif-

ferent schools eventually absorbed the style of either the Unkei or the Kaikei school or a blend of the two. Japanese sculpture came to be completely dominated by these two styles, and it was undoubtedly for this reason that the successors of the two Jokeis did not develop as a separate school.

It is difficult to classify the Kamakura sculpture created by the busshi of the two Kyoto schools as being either in the Unkei style or in the Kaikei style, for most of these works display a mixture of the characteristics found in the style of the Kei school, from which Unkei and Kaikei sprang. One example is the Amida Nyorai (Figs. 118, 123) at the Kongorin-ji, in Shiga Prefecture. Kyoen, a busshi of the En school, carved this statue between 1222 and 1226. In spite of its tranquil expression, the image has a feeling of tenseness. It also displays a realistic technique in such details as the folds of

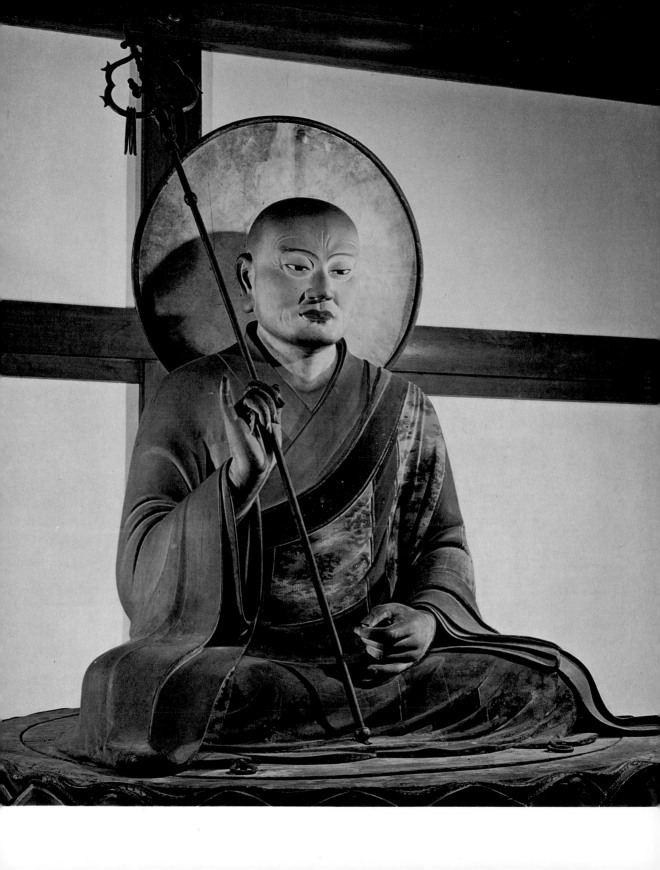

109. Kujaku Myo-o, by Kaikei. Painted wood; height, 78.5 cm. Dated 1200. Kongobu-ji, Mount Koya, Wakayama Prefecture.

110. Miroku Bosatsu, by Kaikei. Painted wood; height, 112.5 cm. Dated 1192. Sambo-in, Daigo-ji, Kyoto.

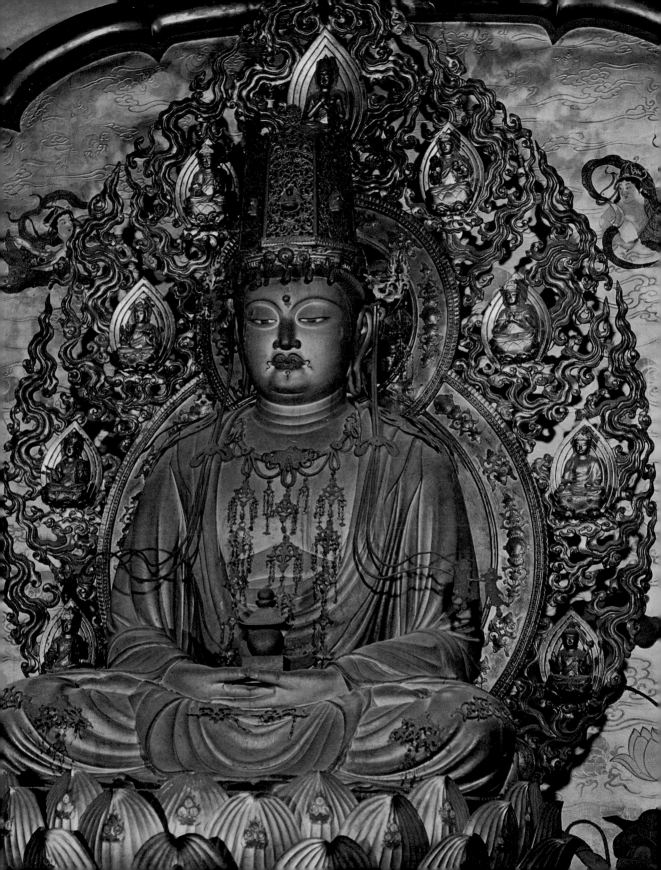

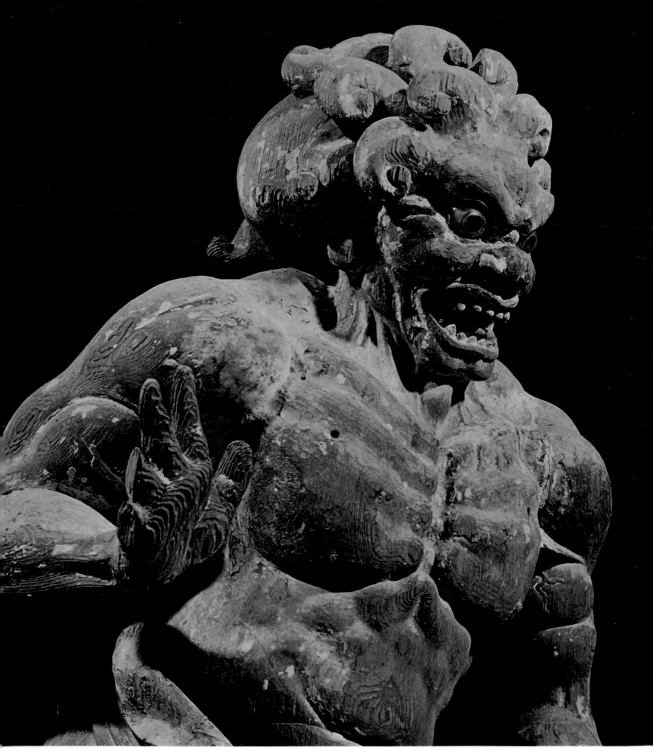

111. *Jinja Taisho, by Kaikei. Painted wood; height of entire statue, 85.8 cm. Late twelfth century. Kongo-in, Kyoto Prefecture.*

112. *Shikkongo Shin, by Kaikei. Painted wood; height of ▷ entire statue, 87 cm. Late twelfth century. Kongo-in, Kyoto Prefecture.*

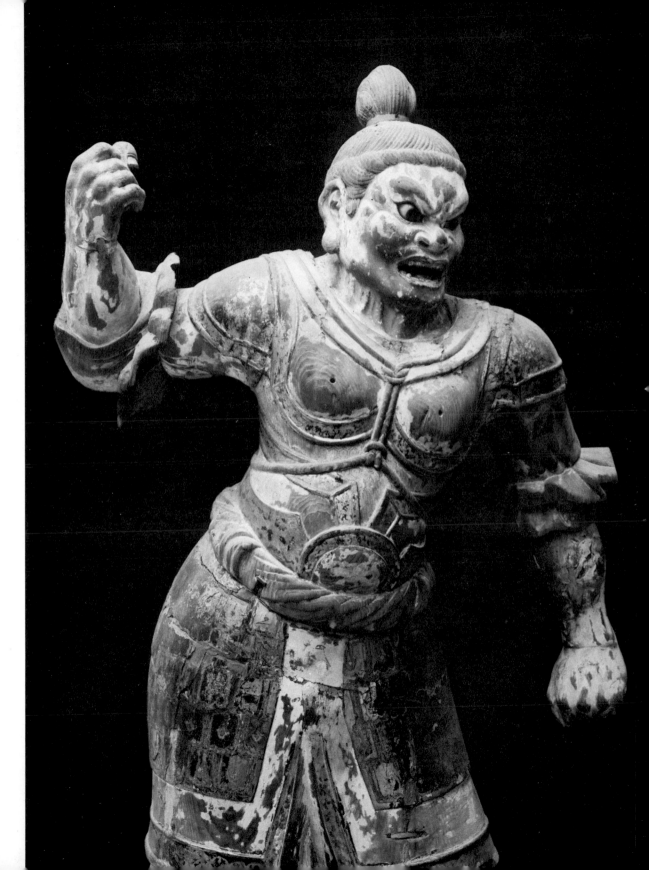

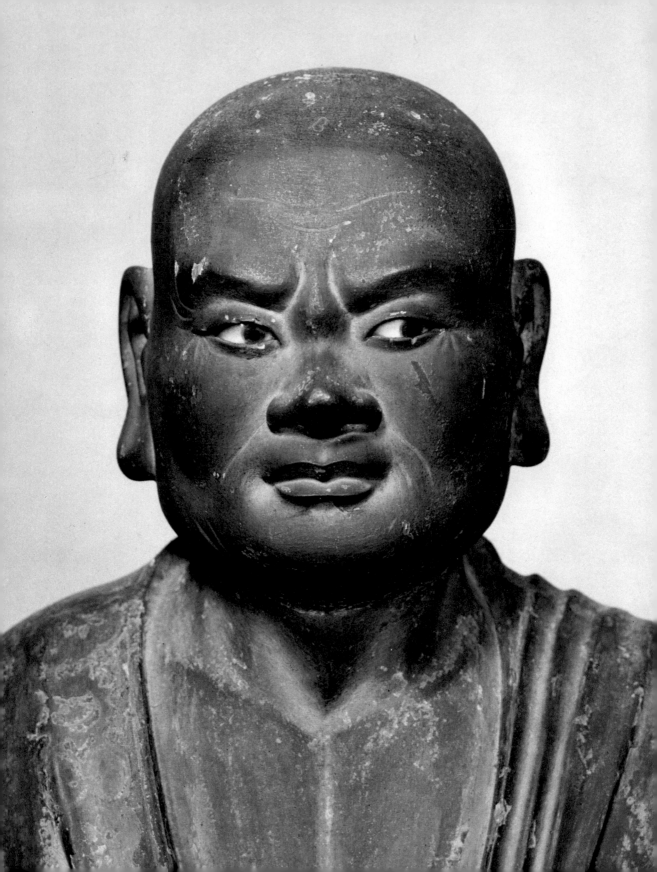

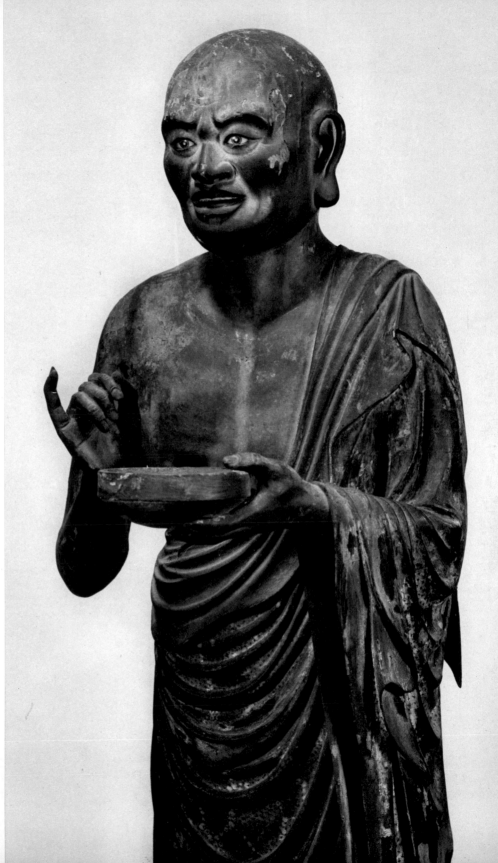

113. Furuna, one of the Ten Great Disciples of the Buddha, by Kaikei. Painted wood; height of entire statue, 96.9 cm. Thirteenth century. Daiho-on-ji, Kyoto.

114. Ubari, one of the Ten Great Disciples of the Buddha, by Kaikei. Painted wood; height of entire statue, 95.4 cm. Thirteenth century. Daiho-on-ji, Kyoto.

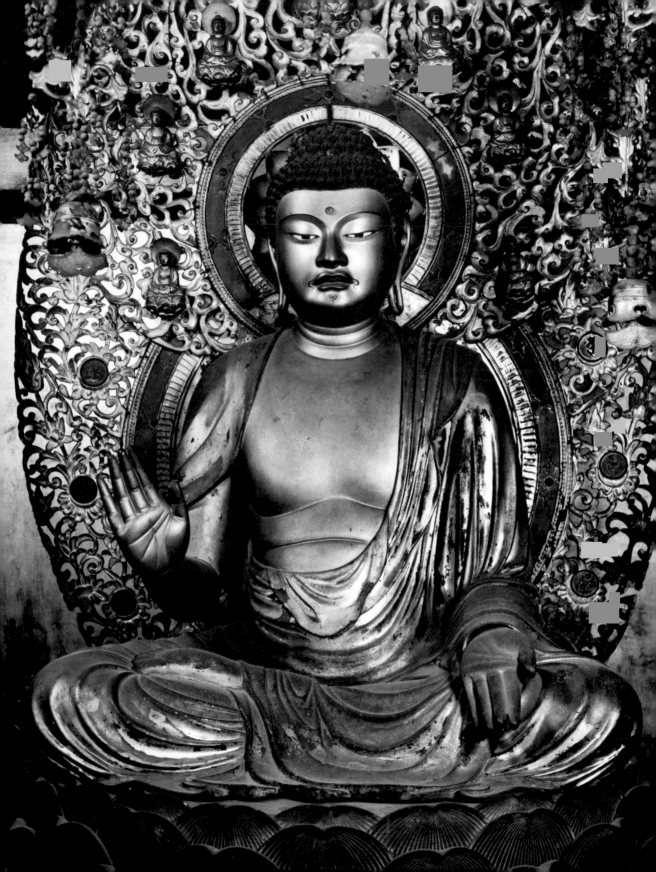

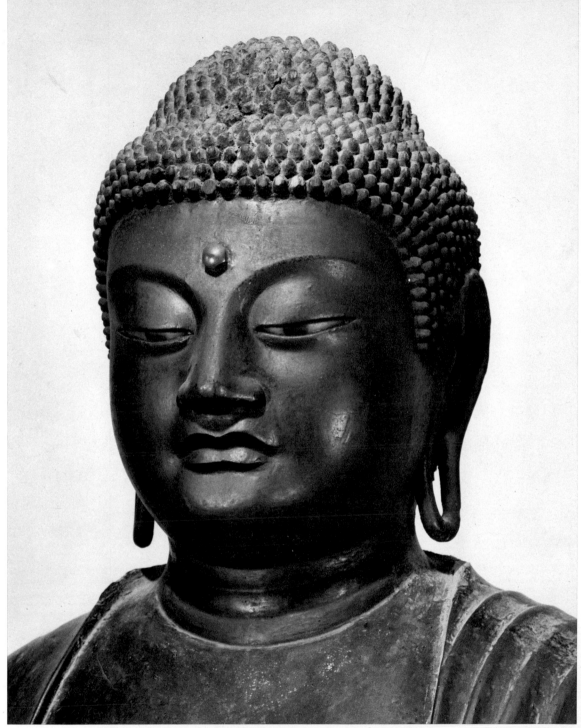

116. *Amida Nyorai, by Kaikei. Painted wood; height of entire statue (see Figure 157), 89 cm. Late twelfth century. Matsuno-o-dera, Kyoto Prefecture.*

◁ 115. *Shaka Nyorai, by Gyokai. Lacquer and gold leaf over wood; height, 91 cm. Thirteenth century. Daiho-on-ji, Kyoto. (See also Figure 107.)*

117. *Juichimen (Eleven-headed) Kannon, by Impan and In'un. Lacquer and gold leaf over wood; height of entire statue, 225 cm. Dated 1233. Hoshaku-ji, Kyoto Prefecture.*

118. *Amida Nyorai, by Kyoen. Lacquer and gold leaf over wood; height of entire statue (see Figure 123), 140.5 cm. Dated 1226. Kongorin-ji, Shiga Prefecture.*

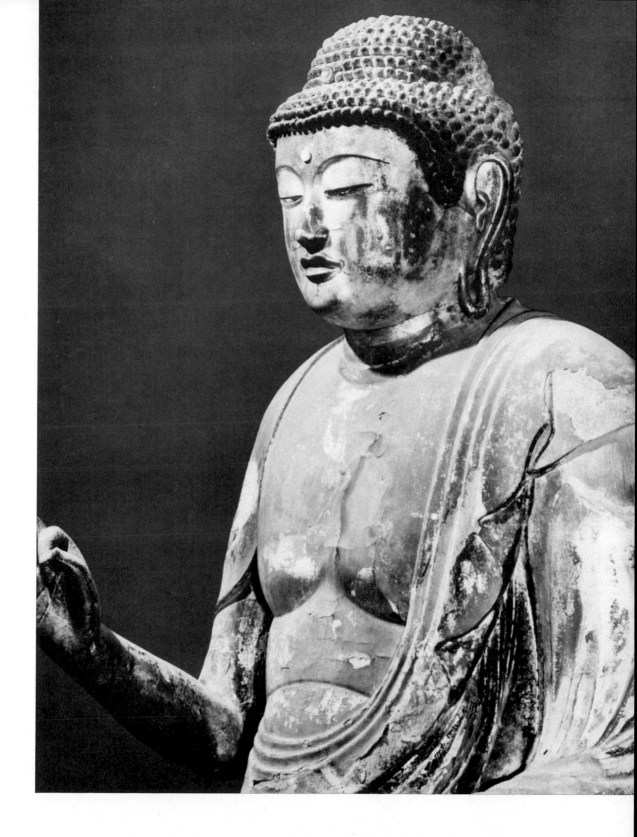

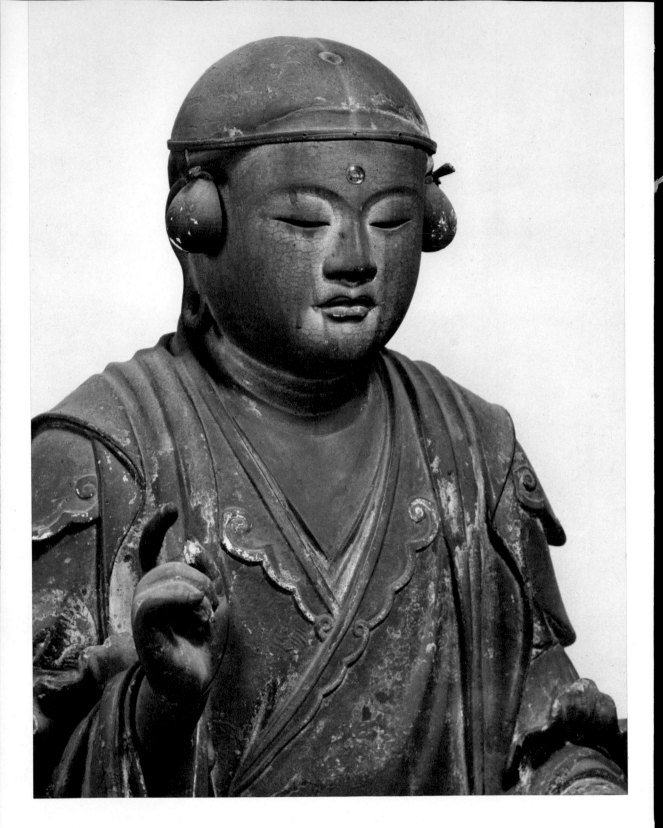

119. Shitta Taishi (Prince Siddhartha), by Inchi. Painted wood, height of entire statue (see Figure 124), 71 cm. Dated 1252. Ninna-ji, Kyoto.

120 (right). Monju Bosatsu, by Kaikei. Painted wood; height, 199.2 cm. About 1201–3. Monju-in, Nara Prefecture.

121 (below, left). Ragora, one of the Ten Great Disciples of the Buddha, by Kaikei. Painted wood; height of entire statue, 98.5 cm. Thirteenth century. Daiho-on-ji, Kyoto.

122 (below, right). Shubodai, one of the Ten Great Disciples of the Buddha, by Kaikei. Painted wood; height of entire statue, 95 cm. Thirteenth century. Daiho-on-ji, Kyoto.

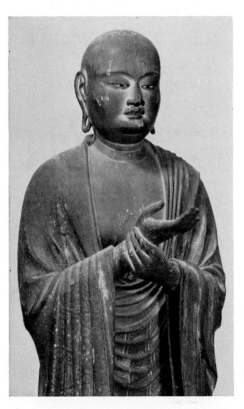

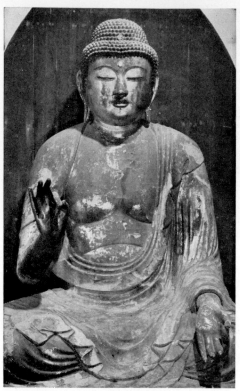

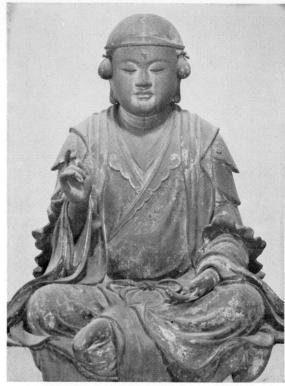

123. Amida Nyorai, by Kyoen. Lacquer and gold leaf over wood; height, 140.5 cm. Dated 1226. Kongorin-ji, Shiga Prefecture. (See also Figure 118.)

124. Shitta Taishi (Prince Siddhartha), by Inchi. Painted wood; height, 71 cm. Dated 1252. Ninna-ji, Kyoto. (See also Figure 119.)

the robes. Thus we can see that Kyoen, to a great extent, adopted the new style of the Kei school. As for the Kamakura-period sculpture of the In school, the statue of Shitta Taishi (Figs. 119, 124) at the Ninna-ji, in Kyoto, serves as a good example. This image, carved by Inchi in 1252, has robes that in basic conception represent the Kei-school style. In addition, the influence of the Sung style can be seen in the fluttering folds of the sleeves. At any rate there is hardly a trace of the Fujiwara-period style to be found here.

At the end of the Kamakura period the schools established by Unkei and Kaikei, as well as the In and En schools of Kyoto, still existed as separate entities as far as the genealogies of the busshi were concerned. But this did not mean that each of the schools worked within the framework of its own style or made any artistic progress. Sculptors of the traditional Kyoto schools, for example, undertook to carve statues in the style of the Unkei school, and busshi of the Unkei school were equally willing to create works in Kaikei's Annami style. Under such conditions the distinctive styles of the different schools lost all significance, and the styles established by Unkei and Kaikei were merely imitated by all the busshi as set formulas. In such an atmosphere, there could be no creative development, and therein lies one of the main reasons for the decline of Japanese sculpture toward the end of the Kamakura period. Still, inasmuch as the sculptural styles created by Unkei and Kaikei were regarded by their respective schools as the absolute foundation, we can recognize the true greatness of these two sculptors.

CHAPTER FIVE

Realism and Portraiture

PORTRAITS OF
ANCIENT BUDDHIST
PATRIARCHS

Realism penetrates every aspect of the sculpture of the Kamakura period. Whether a work of that period is classified as representing the Unkei school or the Kaikei school, realism is always the basic artistic principle, and only the treatment of the subject and the method of expression differ. It goes without saying that Buddhist statuary was of prime importance during Kamakura times, just as it had been in the past, but portrait sculpture also came to enjoy an unprecedented popularity. Since portraiture is one of the most apt mediums for realism in art, it is only logical that we should find so many portrait statues produced in the Kamakura age, when realism flourished in art as never before. In one sense, it is only in portraiture that we discover the real nature of Kamakura sculpture. This was an age when even the Buddha was portrayed in realistic and human fashion.

The most famous portrait statues by Unkei are of course those of Mujaku and Seshin at the Ko-fuku-ji. Before we discuss these two works, however, let us examine the statues of the Six Patriarchs of the Hosso Sect (Figs. 33–35, 55, 146, 147), also at the Kofuku-ji, which is one of the main temples of the Hosso sect in Japan. Unkei's father, Kokei, carved these statues of six Japanese priests who lived during the Nara period, hundreds of years before his time. In painting as well as in sculpture, portraits of famous priests of old like the Hosso

patriarchs were copied and handed down for generations, and the copies served as models for new artists. Portraits of such patriarchs were used mainly as objects of worship, and for this reason the expressions given their faces were idealized rather than individualized. Indeed, the figures often came to be identified by some peculiarity of dress, posture, or gesture rather than by their facial features.

In the light of this tradition, Kokei's statues of the Six Patriarchs of the Hosso Sect are somewhat different, for each face has its own distinct personality and special characteristics. The poses of the patriarchs are quite unrestrained, and their robes fall about them in intricate folds. Kokei has clearly tried to capture each figure impressionistically at an instant of movement, and we can tell that the unique spirit of Kamakura-period realism was already at work here. In a word, Kokei tried to portray the patriarchs as real human beings, to break away from tradition and give a new interpretation to this type of portraiture. Unfortunately his efforts did not lead to the establishment of a perfected style, and this group of statues gives a definite impression of disorganization. As a lone pioneer in a new genre of sculpture, Kokei himself must have felt great distress over this very problem.

We come now to Unkei's portrait statues of Mujaku (Figs. 16, 48, 149) and Seshin (Figs. 54, 59, 148), works of art that represent the apotheosis of portrait sculpture in the Kamakura period. The subjects of Unkei's masterpieces were brothers born

125. The priest Honen (Genku). Colors on silk; height, 113.7 cm.; width, 83.3 cm. Fourteenth century. Konkaikomyo-ji, Kyoto.

126 (opposite page, left). Mokuken- ▷ ren, one of the Ten Great Disciples of the Buddha, by Kaikei. Painted wood; height of entire statue, 96.7 cm. Thirteenth century. Daiho-on-ji, Kyoto.

127 (opposite page, right). The priest ▷ Ryogen (Jie Daishi). Painted wood; height of entire statue, 83.5 cm. Dated 1288. Kongorin-ji, Shiga Prefecture.

around the early fifth century A.D. in the ancient province of Gandhara in northwestern India—an area made up of parts of present West Pakistan, Kashmir, and Afghanistan, with the Pakistani city of Peshawar at its center. Both were theologians who preached the doctrines of Mahayana Buddhism, and they are known in Japan as the legendary founders of the Hosso sect.

Through Unkei's genius these priests, who lived so far away and so long ago, have been vividly pictured as real human beings. When we look at the statues, we instinctively feel that this is what Mujaku and Seshin actually looked like. Unkei has brought out the spirit of individuality inherent in the two men and expressed it in the most fitting way possible. The facial features and the robes are not carved with any great attention to detail, how-

ever, and there is no attempt to capture the subjects at an instant of movement as there is in Kokei's Six Patriarchs of the Hosso Sect. Rather, Unkei's method of representation harks back to that of the dry-lacquer statues of the late Nara period. Indeed, his inspiration could only have come from the realism of that age, when artists searched for something essential and enduring within the subject itself instead of employing superficial variations in facial expressions and poses. With Unkei as their creator, these statues of Mujaku and Seshin reached a new plateau in art. Beyond doubt they are the finest examples of portrait sculpture produced in the Kamakura period.

Among other statues whose sculptors attempted to represent patriarchs of ancient times as real people, we should mention the Ten Great Disci-

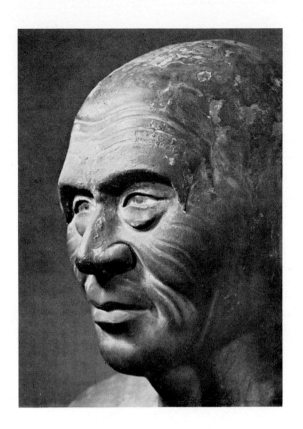
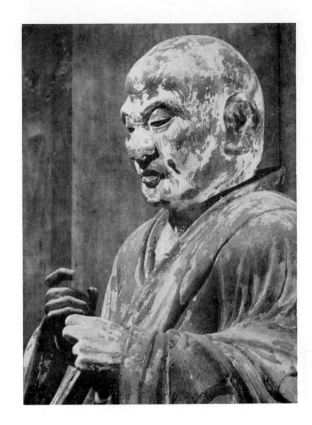

ples of the Buddha (Figs. 113, 114, 121, 122, 126) produced by Kaikei and his apprentices for the Daiho-on-ji, as well as statues of the tenth-century priest Ryogen (or Jie Daishi; Fig. 127) at the Hongaku-in and the Kongorin-ji, in Shiga Prefecture, and of the eighth-century priest Gyoki (Fig. 128) at the Toshodai-ji, in Nara. At the same time, however, along with such realistic portrait statues, stereotyped images of patriarchs that merely held to the traditions handed down from past ages continued to be produced. Most of these stereotyped works were statues of Kukai (Kobo Daishi), Shotoku Taishi, and other historical figures who became popularized as objects of worship quite early in the history of Japanese Buddhism. Needless to say, such pieces are of little or no importance to our study of portrait sculpture.

To digress a bit, let us note here that this new, realistic method of representing Buddhist patriarchs was also employed in painting during the Kamakura period. We find a good example of such realistic painting at the Konkaikomyo-ji, in Kyoto: a portrait of Honen (Fig. 125), the priest who established the Jodo sect in Japan in the early thirteenth century. (Still another portrait of Honen can be seen at the Nison-ji, also in Kyoto.) Honen is pictured with a rosary in his hands and his eyes slightly cast down as if to represent some sort of movement. He has a round face and puffy cheeks, and the top of his head is slightly flattened. The portrait was painted in the fourteenth century and thus postdates the patriarch by many years, for he died in 1212. But the artists of the Kamakura period, with their great descriptive powers, were

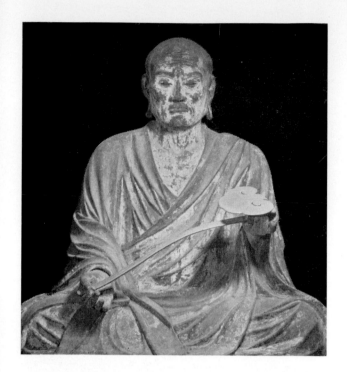

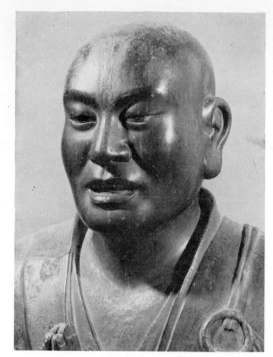

more than capable of creating animated, lifelike portraits, even without living models.

Kamakura-period portrait statues of priests of ancient times expressed the spirit of realism in still another way, which is best exemplified by Kosho's statue of Kuya (Figs. 72, 131, 153) at the Rokuhara Mitsu-ji. Kuya (903–72), the founder of this temple, was called the Saint of the Common Folk because he traveled throughout Japan constantly reciting the prayer Namu Amida Butsu (All hail, the Buddha Amida) for the salvation of all men. The statue shows Kuya's unusual traveling costume down to the last detail, but most striking of all are the six small images of Amida that emerge from his mouth and represent the six characters that form the prayer: *na, mu, a, mi, da, butsu*. Kosho has done nothing less than carve the sound of the voice of invocation.

In contrast with Kuya's minutely detailed body, his facial features seem rather bland and lacking in any strong individuality. Instead, his personality has been expressed through the strangeness of his outward appearance. This method of portraiture was especially suited to the tastes of the common man.

In connection with this portrayal of Kuya, let us examine the seated statue of Zendo (Fig. 129) at the Raigo-ji, in Nara. (There is a standing statue of Zendo at the Chion-in, in Kyoto.) Zendo (in Chinese, Shan-tao) was a celebrated priest of the T'ang dynasty (618–907) who made important contributions to the formation of the Jodo sect in China. Legend has it that whenever he recited prayers to Amida, a halo of light would issue from his mouth. As might be expected, this portrait statue shows Zendo with hands piously clasped together and lips parted in prayer. But of most importance is the small hole inside the mouth of the statue. Since the unknown sculptor could not depict a halo of light emerging from the mouth, it

128 (opposite page, left). The priest Gyoki. Painted wood; height, 115.4 cm. Thirteenth century. Tosho-dai-ji, Nara.

129 (opposite page, right). The priest Zendo. Painted wood; height of entire statue, 86.4 cm. Thirteenth century. Raigo-ji, Nara Prefecture.

130. The priest Myoe (detail), by Enichibo Jonin. Colors on paper; dimensions of entire painting: height, 145.7 cm.; width, 58.8 cm. Early thirteenth century. Kozan-ji, Kyoto.

is more than likely that he commemorated Zendo's miracle by attaching a row of tiny Amida images by means of this hole. Indeed, there are Sung paintings that show just such a row of Amidas emerging with the halo of light from Zendo's mouth. At any rate, it would seem safe to assume that Kosho was inspired by portraits of Zendo when he produced his statue of Kuya.

A painting of Zendo (Fig. 134), said to be a copy of a Sung work, is stored at the Chion-ji. The priest is shown in an attitude quite similar to that of the statues. He stands on a rooftop, his hands joined and his mouth open in prayer. A halo of light and a row of Amida images also emerge from his mouth, but unfortunately this painting has so faded that the phenomenon is not visible in the photograph shown here. The feeling of reality is heightened by the depiction of such details as the roof tiles and the elaborately carved balcony in a manner that would be impossible in a piece of sculpture. It is also quite

interesting to note that Zendo's robes are decorated with patterns in finely cut gold leaf—a practice quite common in earlier Buddhist paintings of deities used for devotional purposes. Here we can observe that the custom of using portraits of ancient patriarchs as objects of worship still survived in the Kamakura period.

Portrait painters of Kamakura times were quite skillful in using the depiction of the subject's environment to increase the feeling of reality. Such paintings had a great appeal for the common man, just as the statue of Kuya had. One fine example of this type of painting is the portrait of the priest Myoe (Fig. 130) at the Kozan-ji, in Kyoto. Since Myoe (1173–1232) undoubtedly posed for the painting, it perhaps more properly belongs in the following section, which deals with portraits of contemporary subjects. But I should like to include it here, together with the portrait of Zendo, because of its striking portrayal of background. Myoe is

131. *The priest Kuya, by Kosho. Painted wood; height of entire statue (see Figure 153), 117.5 cm. Thirteenth century. Rokuhara Mitsu-ji, Kyoto. (See also Figure 72.)*

shown seated quietly in meditation, alone in a deep mountain forest of pines. The pious devotion of the priest blends with his natural surroundings to make an unforgettable impression on the viewer.

PORTRAITS OF CONTEMPORARY SUBJECTS

Now let us study several portraits of subjects who were contemporaries of the sculptors and painters of the Kamakura period. Portraiture was especially popular in such humanistic, newly formed Buddhist sects as Jodo, Jodo Shin, Ji, Nichiren, and Zen. Even among the older, more established sects there were quite a few cases in which famous contemporary priests served as subjects for religious art. Because the creators of these contemporary portraits had the images of their subjects freshly in mind, they were able to produce highly individual, animated likenesses.

The statue of Shunjobo Chogen (Figs. 10, 137) at the Todai-ji's Shunjodo was no doubt carved by a sculptor who had been able to observe Chogen well. When we look at the highly individual features of the emaciated face, with its high cheekbones and tightly pursed, down-turned mouth, we feel sure that this is a faithful portrait of the actual man. The strong faith and even stronger will of this aged priest, who bent every effort toward the restoration of the Todai-ji after the Great Nara Fire of 1180, can be comprehended with no hesitation at all after one glance at this statue. The folds of the robes are thickly and deeply carved, and they give the impression of a certain sort of simplicity that matches quite well with Chogen's face.

132. The priest Shinran, by Sen Amida Butsu
(Fujiwara Tametsugu). Ink on paper; height,
39.7 cm.; width, 32.7 cm. Thirteenth century.
Nishi Hongan-ji, Kyoto.

133. The priest Eison, by Zenshun. Painted wood; height of
entire statue (see Figure 158), 89.4 cm. Dated 1280. Saidai-
ji, Nara.

If we cite the statue of Chogen as one of the masterpieces among portraits of contemporary figures in the early Kamakura period, the statue of Eison (Figs. 133, 158), a noted priest of the Ritsu sect, is the corresponding work for the late Kamakura period. This statue was carved by the busshi Zenshun in 1280 for the Saidai-ji, in Nara, where Eison resided. Eison was seventy-nine years old at the time, and there is something in the unique expression of the statue's face that urges us to accept this as a faithful portrait of the real man.

There are a number of paintings that fall into the category of portraits of contemporary figures. Let us look first at a portrait of Shinran (Fig. 132), the controversial founder of the Jodo Shin sect. This painting is owned by the Kyoto temple Nishi

Hongan-ji and is known by the title *Kagami no Miei* (Mirror Image). It is the work of an artist who called himself Sen Amida Butsu (he was one of the sons of the famous portrait painter Fujiwara Nobuzane) and was painted at some time before Shinran's death in 1262. Executed in black ink, it is rather more like a sketch, but the portrayal of the priest's features is expertly done. Shinran has been candidly captured on paper as a real human being.

The practice of painting or sculpturing portraits of contemporary personalities during the Kamakura period showed an even more extraordinary and specialized development in the Zen sect, which was newly introduced into Japan by Eisai at the close of the twelfth century and spread rapidly thereafter. In Zen, the character of the great priests

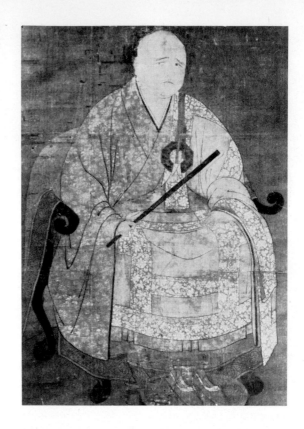

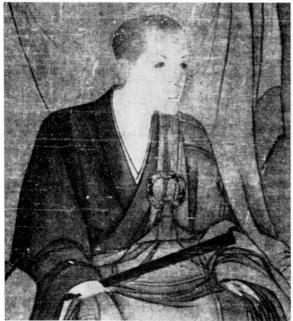

134 (above, left). The priest Zendo. Colors on silk; height, 141.2 cm.; width, 55.1 cm. Thirteenth century. Chion-ji, Kyoto.

135 (above, right). The priest Shuho Myocho (Daito Kokushi). Colors on silk; height, 115.7 cm.; width, 56.7 cm. Dated 1334. Daitoku-ji, Kyoto.

136 (left). The priest Rankei Doryu (detail). Colors on silk; dimensions of entire painting: height, 104.6 cm.; width, 46 cm. Dated 1271. Kencho-ji, Kamakura.

137. The priest Shunjobo Chogen. Painted ▷ wood; height, 82 cm. Early thirteenth century. Shunjodo, Todai-ji, Nara. (See also Figure 10.)

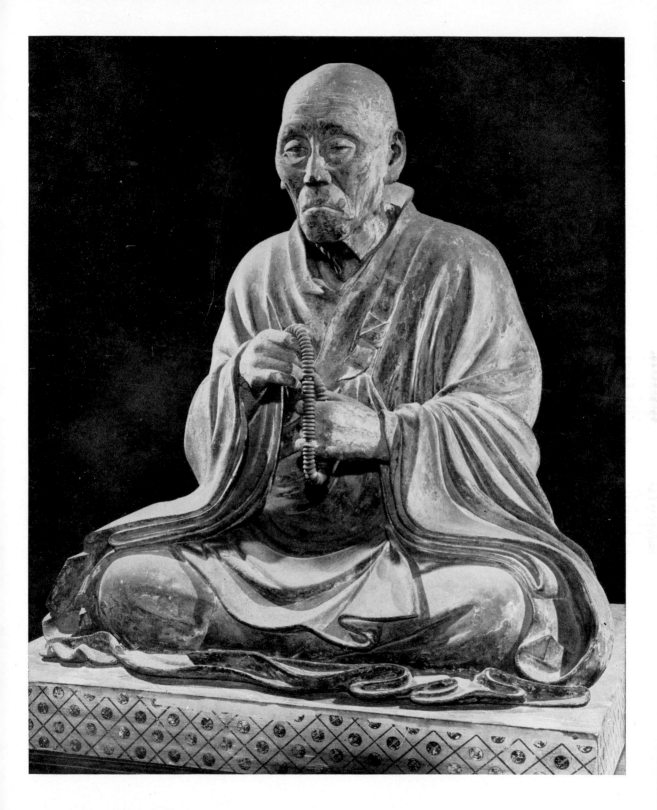

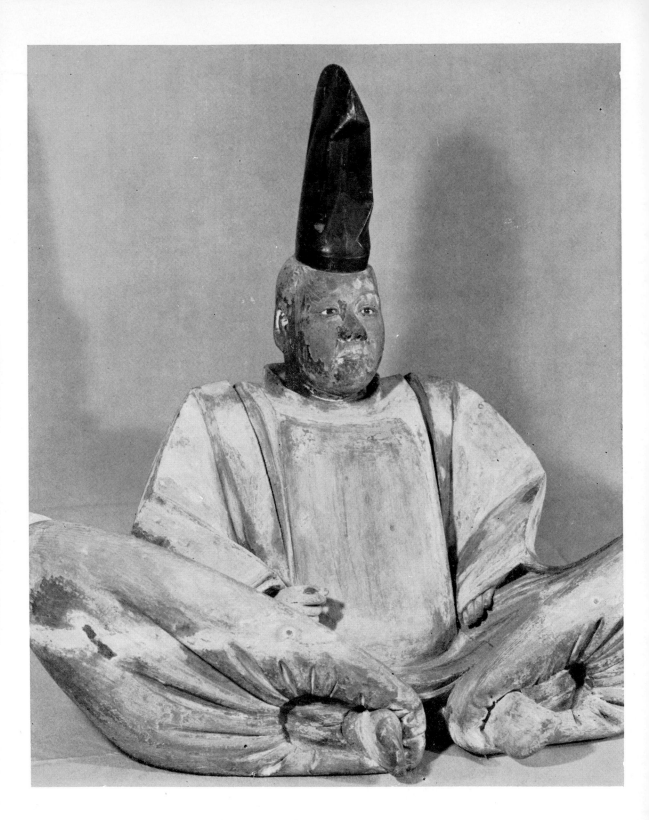

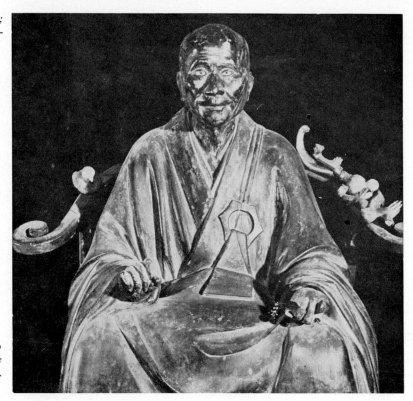

◁ *138. Hojo Tokiyori. Painted wood; height, 70 cm. Thirteenth century. Kencho-ji, Kamakura.*

139. The priest Mugaku Sogen (Bukko Kokushi). Painted wood; height of entire statue, 111.5 cm. Late thirteenth century. Engaku-ji, Kamakura.

and masters was given much importance. Indeed, a great master was looked upon as the embodiment of the holy law of Buddhism. When a disciple became qualified to be a Zen master himself, he was awarded a portrait of his own master as a kind of certificate of his adherence to the doctrine and his capability to teach. These paintings were called *chinzo,* and it was customary for the master portrayed to inscribe his *chinzo* with an epigraph. In some cases, wooden statues made by the disciples were preferred.

The majority of the *chinzo* show the master seated in a carved wooden temple chair and dressed in long robes that reach to the floor. Absolute fidelity to the master's features was the prime requisite of these portraits. The paintings, in particular, were directly influenced by the artistic styles of the Sung and the Yuan (1279–1366) dynasties, with the

result that the majority of them reflect the very detailed, intellectual spirit of realism so typical of those styles.

A number of these portraits of Zen priests still exist. To begin with the sculpture, let us mention the statue of Shinchi Kakushin (also known as Hotto Kokushi) at the Kokoku-ji, in Wakayama Prefecture. Kakushin, who established the Fuke branch of the Zen sect, died in 1298 at the age of ninety-one, and the statue, carved around 1286, shows him already well advanced in years. The face is thin and aged, with thick eyebrows that curve downward and an apparently toothless mouth. The stern appearance of this great Zen priest has been captured so skillfully that the statue seems almost to breathe with life.

At the Engaku-ji, in Kamakura, there is a statue of the temple's founder, the priest Mugaku Sogen

140. *Minamoto Yoritomo. Colors on silk; height, 139.4 cm.; width,*
111.8 cm. Late twelfth to early thirteenth century. Jingo-ji, Kyoto.

141. *Detail from picture scroll* Zuishin Teiki Emaki *(The Imperial Guard Cavalry). Colors on paper; height of scroll, 28.8 cm. About 1247. Okura Cultural Foundation, Tokyo.*

142. *Taira Shigemori (detail). Colors on silk; dimensions of entire painting: height, 139.3 cm.; width, 111.8 cm. Late twelfth to early thirteenth century. Jingo-ji, Kyoto.*

(in Chinese, Wu-hsueh Tsu-yuan), also known as Bukko Kokushi (Fig. 139). Sogen's face has the penetrating look so characteristic of Zen priests, and his robes are carved in deep, free-flowing folds. Undoubtedly this statue was produced not long after his death in 1286.

Later examples of portrait sculpture in the Zen sect include statues of the two abbots Enin and Yuisen at the Anraku-ji, in Nagano Prefecture. These two works, produced in 1329, exhibit a realism slightly tinged with naïveté.

In the field of painting, there are numerous *chinzo* of the Zen masters. One famous example is the portrait of Rankei Doryu (in Chinese, Lan-ch'i Tao-lung), also known as Daikaku Zenji (Fig. 136). Doryu, born in China in 1213, came to Japan

in 1246 and founded the Kencho-ji in Kamakura, where he died in 1278. This portrait exquisitely depicts the highly individual expression of the priest's mouth and eyes. The lines of the robes are drawn with quick brush strokes in light and dark tones, showing a fresh, innovative style strongly influenced by Sung art. The epigraph, written by Doryu himself, is dated 1271.

The Sung style of *chinzo* painting was gradually assimilated into the elegant style of the *yamato-e*, or traditional Japanese painting, and eventually a Japanese *chinzo* form was established. A good example among paintings that demonstrate this trend is the portrait of Shuho Myocho, also known as Daito Kokushi (Fig. 135), the founder of the Dai-toku-ji, in Kyoto, where the painting is kept today.

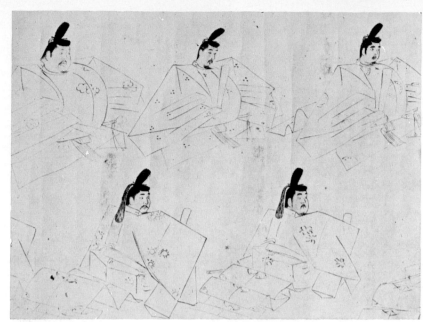

143. Detail from picture scroll Kuge Retsuei Zukan (Portraits of Courtiers). Colors on paper; height, 37 cm. Thirteenth century. Kyoto National Museum.

144. Suigetsu Kannon (Kannon of ▷ Water and Moon). Painted wood; height, 54.5 cm. Fourteenth century. Tokei-ji, Kamakura.

The lines and colors are very subdued in this portrait, but in the unusual expression of the priest's face and the dignity of his large body the special qualities of realism found in earlier *chinzo* have been preserved. The inscription on the painting is dated 1334, three years before Myocho's death.

We also find a great many portraits of Kamakura-period laymen. While the portraits of Buddhist priests and patriarchs were often made as objects of worship, those of laymen were meant to be memorials. Once again we see how much concern was felt for the individual during Kamakura times. The statues of Uesugi Shigefusa (Fig. 37) at the Meigetsu-in, in Kamakura, and of Hojo Tokiyori (Fig. 138) at the Kencho-ji, also in Kamakura, are among the most representative works of this type. Both men wear the high lacquered-paper headgear (*eboshi*) and the starched, sharply creased garments affected by court nobles of the time, and each once held a wooden scepter in his right hand. Their faces are extremely realistic, but their clothes are quite simply and almost geometrically carved.

The contrast between simple garments and detailed facial expressions is also found in painted portraits of laymen. At the Kyoto temple Jingo-ji, for example, we have the famous portraits of Taira Shigemori (Fig. 142), Minamoto Yoritomo (Fig. 140), and Fujiwara Mitsuyoshi. In all three of these the faces have been vividly drawn with a fine brush. The eyes, in particular, are so carefully done that we feel as though the subjects had just blinked. The black, sharply creased garments are composed in straight lines, but the terseness in line and color only serves to emphasize the realism of the faces.

Still another genre among Kamakura-period portraits of laymen should be cited: the *nise-e*, or "likeness pictures." These small pictures employed light, feathery brush strokes to depict people in various attitudes of movement or rest and at the same time captured their individual features with consummate skill. Examples of *nise-e* are to be found in the picture scroll *Zuishin Teiki Emaki* (The Imperial Guard Cavalry) at the Okura Cultural Foundation, in Tokyo (Fig. 141); the picture scroll

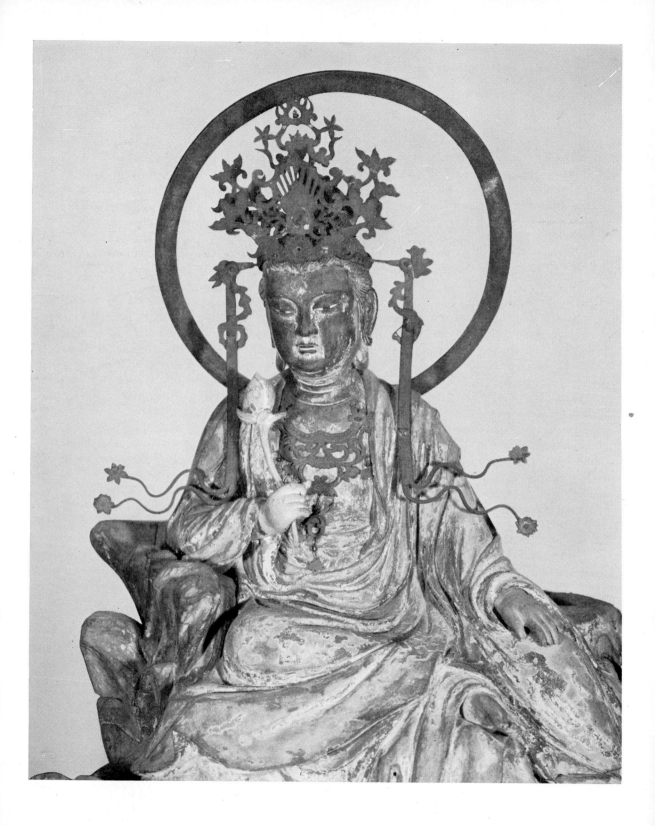

Kuge Retsuei Zukan (Portraits of Courtiers) in the Kyoto National Museum (Fig. 143); and the portrait of Emperor Gotoba at the Minase Shrine, in Osaka. Although the two picture scrolls deal with groups of persons, the artists have sharply portrayed the individual qualities of each face. The *nise-e* were characterized by a light and simple realism, and in one sense they might be called the most Japanese of all the types of portraiture that we have discussed so far. Certainly they have a realistic feeling quite different from that of the *chinzo*.

FROM BUDDHIST STATUARY TO PORTRAITURE AND NOH MASKS

Once the realism of Kamakura art had reached its peak, sculptors began to give human qualities even to images of Buddhist deities, which were supposed to express only the ideal nature of an object of worship. To cite one example of such humanization, the statue of the Suigetsu Kannon, or Kannon of Water and Moon (Fig. 144), at the Tokei-ji, in Kamakura, has an extremely casual pose and a facial expression full of a freshness that brings to mind the human face. Undoubtedly this statue was produced at the end of the Kamakura period or later. Such Buddhist images were no longer meant to be objects of worship but were only made to be appreciated as lovely works of art. There was obviously almost no hope that Buddhist statuary representing a truly religious quality of art would ever be produced again. In fact, as the Kamakura period came to an end, Buddhist sculpture and painting went into a rapid decline.

Although the development of realistic expression and keen observation of human beings spelled misfortune for the production of Buddhist statuary, it brought great benefits to portraiture, in which the subjects were depicted in lifelike fashion. In particular, the *chinzo* and their counterpart portrait statues, which originated in the Zen sect, evolved along distinctive lines. This school of portraiture continued into the Muromachi period (1336–1568) and, in keeping with the prosperous state of Zen itself, produced many great works of art. Even though the Muromachi period was marked by the deterioration of Buddhist sculpture in general, it was distinguished by the successful expression of individuality in Zen portrait sculpture. In a word, humanistic realism was given continued life through the creation of portrait sculpture.

This trend in portrait sculpture can be linked with the production of masks for the Noh drama, which developed as an art form during the Muromachi period. Noh masks are generally divided into five major categories: gods, men, women, mad people, and demons. Each mask, however, is designed to express a complexity of human emotions, depending on the intention of the play itself. Noh masks do not necessarily make a point of being purely realistic. Instead, they transcend the realism of human faces to become symbolic and mystical, and in this manner they demonstrate their own peculiar artistic quality. The birth of this art of the mask during the Muromachi period could only have been the result of an escape from the restrictions of religion and a turning toward the clear-eyed observation of man. From this point on, in the history of Japanese sculpture, there was a departure from Buddhist statuary, and new horizons were explored in such art forms as Zen portraiture and Noh masks.

CHAPTER SIX

Perspectives
and Commentaries

THE REGIONAL ASPECTS OF KAMAKURA SCULPTURE

If we consider the culture of the Kamakura period by regional divisions, the three major cities concerned are undeniably Kyoto, Nara, and Kamakura. Kyoto, of course, had been the capital since 794, when Emperor Kammu transferred the seat of government there, having moved it first from Nara to the temporary capital of Nagaoka in 784. Even after political power had shifted to the warrior class in the twelfth century, Kyoto continued to shine unwaveringly as a center of cultural achievement. Nara, in contrast with Kyoto, was only the former capital, but even so it remained a center of deep-rooted religious and cultural traditions long after it had been supplanted as the seat of government. Kamakura, the hub of the military government that Minamoto Yoritomo established at the end of the twelfth century, was a completely new city without cultural traditions. Once the warrior class had come to power, however, it began to show signs of lively activity in religion and the arts. In the end, it developed a culture with a flavor all its own, quite different from that of Kyoto and Nara.

It is impossible to disregard these three cities when we study the sculpture of the Kamakura period. As we have noted in previous chapters, this new genre of sculpture was created in the Nara region, and Unkei, the greatest genius to work in the genre, spent his formative years there. As a young man, he traveled to Kamakura, where he received commissions from the warrior class to carve Buddhist statuary. He then returned to Nara to play an important role in the restoration of the Todai-ji and the Kofuku-ji. He also went to Kyoto and established his workshop there. In his last years Unkei was again very active in producing statuary for members of the warrior class in the Kamakura region. Looking over this brief outline of his life, we can see just how important the three cities of Nara, Kyoto, and Kamakura were in his artistic career. From this viewpoint alone, much can be gained by studying Kamakura sculpture in these three regional divisions.

What happens when the development of a genre of sculpture becomes involved with three different cities, each with its own personality? Since the schools of busshi active in each region all sprang from the same source, it is true that they produced fairly similar works. But there are also numerous statues that express the special qualities of their region. Kamakura, in particular, has unusual features of geography, history, and most of all, cultural climate that set its sculpture quite far apart from the sculpture of Kyoto and Nara. It has been said

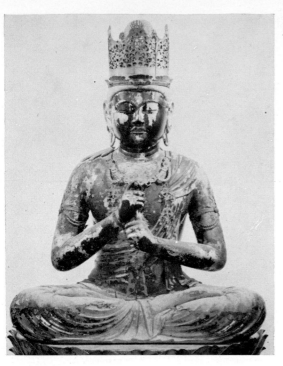

145. *Dainichi Nyorai, by Unkei. Lacquer and gold leaf over wood; height, 101 cm. Dated 1176. Enjo-ji, Nara. (See also Figures 17, 49, 60, 61.)*

146 (*opposite page, left*). *Joto, one of the Six* ▷ *Patriarchs of the Hosso Sect, by Kokei. Painted wood; height, 78.2 cm. Dated 1189. Nan'endo, Kofuku-ji, Nara.*

147 (*opposite page, right*). *Shin'ei, one of the* ▷ *Six Patriarchs of the Hosso Sect, by Kokei. Painted wood; height, 82.7 cm. Dated 1189. Nan'endo, Kofuku-ji, Nara.*

that art history should be studied not only vertically —that is, chronologically—but also horizontally— that is, by the various schools. I think it necessary in this case to go even one step further and to consider art history spatially—that is, by different geographic regions. Consequently, in this chapter I should like to discuss in depth the special characteristics of the three cities that played an important role in the development of Kamakura sculpture—Nara, Kyoto, and Kamakura—and to comment upon the major works of sculpture produced in each of them.

THE NARA BUSSHI AND THEIR WORKS

Nara is the birthplace of Japanese sculpture. The late Nara period (710–94), when the city was the capital, is regarded as the golden age of Japanese sculpture, and many famous works from that time survive, including the statuary in the Todai-ji's Hokkedo (Lotus Hall).

The glorious genre of sculpture created in the late Nara period was immortal, and it exerted its influence as *the* classic style, sometimes tangibly, sometimes intangibly, over the sculpture of each following period. It was no accident that the new genre of sculpture that developed during the Kamakura period came to flower in the Nara region amid the traditions of late-Nara sculpture. Unkei and Kaikei, the two representative sculptors of the Kamakura age, both came from Nara, and it was the reconstruction of the Todai-ji and the Kofuku-ji that allowed them to give free rein to their creative activities. Thus it is not surprising that we find many truly great works of art by Unkei, Kaikei, and their followers in the Nara region.

As Unkei's school, which represented the main branch of the Nara busshi, came to dominate the world of Japanese sculpture, Unkei moved his workshop to the more central location of Kyoto. Undoubtedly, many busshi who had been living in

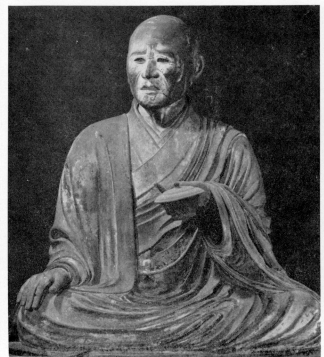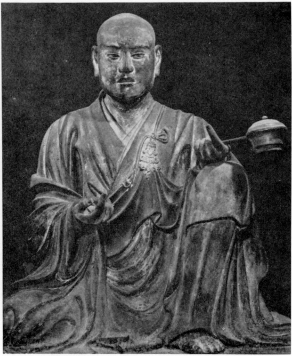

Nara moved to Kyoto with Unkei, but even so a strong sculptural tradition continued in Nara. Of the busshi who stayed there after Unkei's departure, Zen'en, Zenkei, and Zenkei's son Zenshun should be mentioned as men of importance. They belonged to the Kei school, but for the sake of convenience we may also label them as the Zen school (after the character *zen* in their names).

Even after Unkei and his followers moved to Kyoto, they preserved their close relationship with Nara and continued to make statuary for temples there. Of special note are Unkei's grandson Koshun and Koshun's son Kosei, who both called themselves chief busshi of the Kofuku-ji. No doubt they simply inherited this title, which had been traditionally awarded to Nara busshi for generations. A number of statues by these two sculptors can be seen in the Nara region today. Again, one of Kaikei's apprentices, Eikai, called himself by such titles as chief busshi of the Todai-ji, the Kofuku-ji, and

the Yakushi-ji and actually did carve statuary for the Todai-ji's Lecture Hall.

In summary, the three powerful groups of busshi who were active in the Nara region during the Kamakura period were the Unkei school, the Kaikei school, and the Zen school. These three can be brought together under the general heading of the Kei school, and we may note that all the busshi of this school left behind very distinguished works of art.

THE UNKEI SCHOOL AND THE KAIKEI SCHOOL IN NARA It goes without saying that we can find many statues by Unkei, Kaikei, and their followers in the Nara region. Here I wish to comment on representative works by Kokei, Unkei, Kaikei, Jokei I, Koben, Kosho's son Kosei, Koshun, and Koshun's son Kosei.

FIGURE 49. Dainichi Nyorai, by Unkei. (See

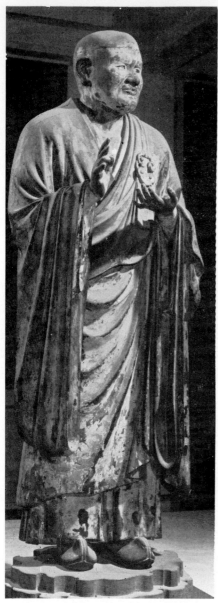

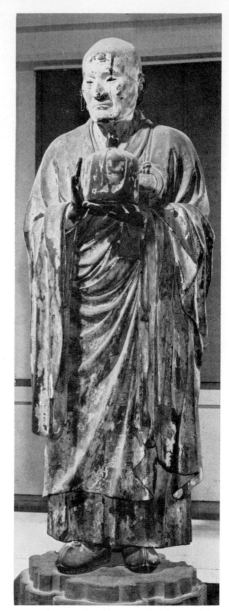

148. *The Indian patriarch Seshin, by Unkei. Painted wood; height, 189.5 cm. About 1208–12. Hokuendo, Kofuku-ji, Nara. (See also Figures 54, 59.)*

149. *The Indian patriarch Mujaku, by Unkei. Painted wood; height, 194 cm. About 1208–12. Hokuendo, Kofuku-ji, Nara. (See also Figures 16, 48.)*

also Figures 17, 60, 61, 145.) This magnificent work portrays Dainichi Nyorai, the Buddha of the Diamond World (Kongokai), making a mudra (hand gesture) symbolic of spiritual action and will. The statue belongs to the Enjo-ji, a small temple in a country village a few miles northeast of Nara, and was originally enshrined in the temple's Taho Pagoda. Of all authenticated works by Unkei, it is the oldest. An inscription on the pedestal states that Unkei, the "true apprentice" of Kokei, began work on the statue on the twenty-fourth day of the eleventh month, 1175, and completed it on the nineteenth day of the tenth month, 1176.

At first glance, the calm, unruffled face and the widely spread knees of this statue bring to mind the sculpture of the Fujiwara period. But the firm and youthful quality of the cheeks and the jaw, in addition to reminding us of the sculptor's own youth, gives the impression of a new modeling technique. The waves in the hair piled about the head are cleanly carved, the topknot and the crown are extremely high, and crystal has been set in from the inside for the eyes. These are all features that cannot be found in Fujiwara-period sculpture.

Next, we should pay careful attention to the carving of the folds in the robes. Most of these folds run in roughly parallel lines, especially those that go down the back on the swath of robe flung over the left shoulder (Fig. 61). The body is quite plump, however, and these folds do not give a smoothly flowing impression. In particular, the sections of robe around the knees and on the left shoulder show not only thick and thin lines but also very deep carving. This is still a far cry from the free and realistic swell found in the robes of some of Unkei's later masterpieces, but it is unmistakably a step in a new direction.

FIGURES 33–35, 55, 146, 147. The Six Patriarchs of the Hosso Sect, by Kokei. These six statues in the Nan'endo of the Kofuku-ji were begun by Kokei on the eighteenth day of the sixth month, 1188, and finished on the twenty-eighth day of the ninth month, 1189, together with the Nan'endo's Fukukenjaku Kannon (its main image) and statues of the Shitenno. The six patriarchs' names are given by the Kofuku-ji as Zenju (Fig. 55), Gyoga (Fig. 33), Gempin (Fig. 34), Gembo (Fig. 35), Joto (Fig. 146), and Shin'ei (Fig. 147), but these names are not necessarily correct in a historical sense. In any case, here let us follow the tradition of the temple.

The six statues, all seated and all life size, show much diversity in their features and postures. Kokei must have deliberated long hours as he tried to decide how to give variety to these figures and, at the same time, preserve their unity as a group. If we observe them carefully, we can see that there are three different ways in which the patriarchs are seated: with one leg bent at the knee and the other extended (Gyoga and Shin'ei), with the legs crossed (Zenju and Joto), and kneeling on both knees (Gempin and Gembo). This must have been done with the intention of grouping the statues into three pairs.

The most important sculptural feature of these statues is their robes, which have very intricate, free-flowing folds. The carving is sometimes deep, sometimes shallow, and really quite lively in total effect. The realism of Kamakura-period sculpture was already being shaped by Kokei, although, as we have noted earlier, he did not succeed in mastering it completely. As a group, the Six Patriarchs are overdetailed and awkward, for intention has exceeded ability. In the faces, there has been an attempt to bring out each man's personality, but the wrinkles, especially in the faces of Gyoga, Gembo, and Joto, are excessively graphic. It is most interesting that this unrealistic feature should coexist with the realistic carving of the robes, for we can see here a reflection of the stylistic change that was taking place in Kokei's time.

FIGURES 16, 54. Mujaku and Seshin, by Unkei. (See also Figures 48, 59, 148, 149.) These two famous statues in the Kofuku-ji's Hokuendo, together with the Miroku Butsu (Figs. 46, 47, 51), which is the main image in the same hall, represent the pinnacle of Unkei's art. Production of the nine statues in the Hokuendo (the other six are no longer extant) began on the seventeenth day of the twelfth month, 1208, and ended around 1212. Unkei was in charge of the entire project, with ten full-fledged busshi and numerous minor busshi

working under him. An inscription on the pedestal of the Miroku Butsu lists the names of the busshi in charge of each statue. Unfortunately, the name of the sculptor of Mujaku has been obliterated, but that of the sculptor of Seshin is given as the *hokkyo* Unga. (Unga, it will be recalled, was Unkei's fifth son.) It appears that each statue in the Hokuendo was assigned to a full-fledged busshi; so we may assume that the images of Mujaku and Seshin were produced by two different men. But under Unkei's personal direction the personalities of these two sculptors were not allowed to surface in their work. The style that unites the statues of Mujaku and Seshin is none other than that of Unkei, and here we can appreciate to the full his outstanding abilities in leadership.

According to Buddhist tradition, Mujaku was Seshin's older brother, and these two statues reflect quite well the difference in their ages. Mujaku has a thinnish, elderly face, while Seshin has a plump, younger-looking one. Although they are made of wood, the statues look as if they had been molded from clay rather than carved. The reason for this impression is that Unkei did not become over-involved in carving the details but, instead, grasped the major points of his composition in order to bring out the contrasts between the two brothers. This is true of their faces and their garments as well. As we have noted before, the statues show the strong influence of late-Nara sculpture.

FIGURE 15. Jizo Bosatsu, by Kaikei. (See also Figure 152.) The inscription "the skilled craftsman Kaikei of the rank *hokkyo*," engraved on a tenon in the right leg of this statue, establishes that it was produced during Kaikei's *hokkyo* period (c. 1203–8). We have no other examples of Kaikei's work bearing his *hokkyo* signature, and in this respect alone the statue is an extremely valuable work. Moreover, it is exceedingly well preserved, and the lovely colors can be readily discerned.

Jizo Bosatsu stands on a lotus pedestal that floats on trailing white clouds. In his right hand he once grasped a pilgrim's staff; in his left, he still holds a sacred jewel. The robes and the surplice are decorated with beautiful patterns in finely cut gold leaf. Surely this is a figure the faithful could readily

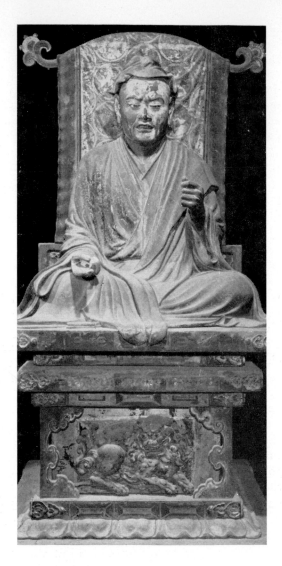

picture greeting them at the gates of the Buddha's paradise.

It should be noted that although the statue has been constructed by means of the more up-to-date *yosegi* (assembled blocks of wood) technique, the eyes are not inlaid with crystal from the inside— a very unusual deviation in Kamakura sculpture. The use of copper for the necklace, the bracelets, and the ties of the surplice is also of interest. The body is well balanced, and the beauty of the face is

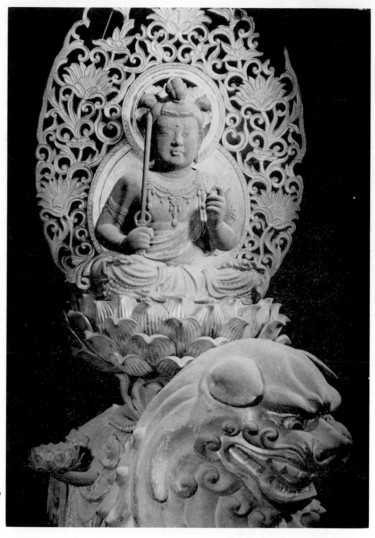

151. Monju Bosatsu, by Koshun. Unpainted wood with gold-leaf patterns; height, 45.2 cm. Dated 1324. Hannya-ji, Nara.

imbued with a quiet solemnity and purity. The carving of the robes has a perfect flow, neither too simple nor too complex. Here we can see an actual example of the perfection of Kaikei's Annami style and, at the same time, clear-cut proof that Kaikei brought this style to completion during his *hokkyo* period.

FIGURE 75. Yuima Koji (Layman Yuima), by Jokei I. (See also Figure 150.) This statue, together with a statue of Monju Bosatsu, was produced for

the Tokondo at the Kofuku-ji. According to a long inscription on the inside of the body, production began on the twenty-second day of the third month, 1196. The actual carving required fifty-three days, while the application of the colors took another fifty days. The sculptor was Jokei I; the painter, Koen (not to be confused with the sculptor Koen).

Buddhist legend tells us that Yuima, a wealthy merchant from the Indian city of Vaisali (located in the area around the present city of Patna), heard

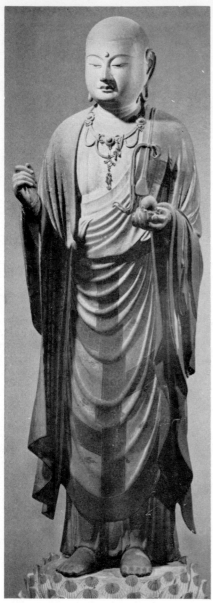

152. Jizo Bosatsu, by Kaikei. Painted wood; height, 90.6 cm. Early thirteenth century. Kokeido, Todai-ji, Nara. (See also Figure 15.)

the teachings of the Buddha and, although he was only a layman, became a most eloquent orator for the faith. This statue can also be considered in the category of portrait sculpture, for there is evidence that the sculptor took great pains to bring out the human qualities of the face. But the truly noteworthy feature of the work is the rather odd air of robustness in the facial expression. After observing other works by Jokei I, we can only conclude that this feature arises from the influence of the Sung style. Although the folds of the robe wrapped about Yuima's body are characteristic of the Kei school in their realistic and skillful carving, the long sleeves that hang over the edge of the pedestal are a feature quite common in Sung statuary and painting. In addition, the pedestal, decorated with a very lively bas-relief of a mythical Chinese lion, and the unusually shaped back screen are related to the Sung style. In the sculpture of Jokei I the Kei school took in new stylistic elements from Sung art—a significant development well represented in this statue.

FIGURES 67, 80. Ryutoki (Demon Carrying a Lantern on His Head) and Tentoki (Demon Shouldering a Lantern), by Koben. (See also Figure 163). This unusual pair of statues, now displayed in the Kofuku-ji Treasure Hall, were originally enshrined in the same temple's Saikondo (West Golden Hall), a building that no longer exists. They represent demons who hold up glowing lamps as offerings to the Buddha. An inscription inside the Ryutoki gives the date of production as 1215 and the sculptor as Koben, and both statues are usually attributed to Koben. If one examines the pair quite closely, however, a number of differing stylistic points can be found. For example, the Ryutoki is a very solid piece of sculpture, executed in a powerful style and with a humorous facial expression, whereas the flesh of the Tentoki looks somewhat flabby, and the facial expression could almost be called vulgar. There are differences in technique as well. The eyebrows of the Ryutoki are made of serrated copper, and one of his tusks is crystal, while the Tentoki's eyebrows were probably made of hair, and the tusks are merely carved from wood. On the basis of such an analysis, some scholars believe that the sculptors of these works were two

different men, although there is no doubt that both were members of the Unkei school. But no matter which opinion we choose to believe, the two statues are excellent reflections of the free, heroic spirit of the Kamakura period. The lanterns borne by the demons are later replacements.

FIGURE 83. Jizo Bosatsu, by Kosei (son of Kosho). Near the famous belfry on a hill west of the Todai-ji's Daibutsuden stands an elegant little building called the Nembutsudo (Invocation Hall). Its main image is this statue of Jizo Bosatsu. According to an inscription on the inside of the statue, it was produced by the chief busshi and *hokkyo* Kosei toward the end of the eleventh month of 1237 in memory of the "great solicitor of contributions" (probably Chogen), the *hoin* Unkei, the *hokkyo* Kosho, and a number of others. Since Kosei carved the statue as a memorial to his departed father, Kosho, and grandfather, Unkei, as well as to Chogen, the project had important significance for the Unkei school in many ways. It is also important to note the use of the character meaning "cloud" to write the syllable *un* in Unkei's name instead of the more widely used character meaning "good fortune." In a number of historical documents, including the *Azuma Kagami*, a chronicle written toward the close of the thirteenth century, the *un* of the name Unkei is written with the character for "cloud." Certain scholars have argued that the Unkei whose name was so written was yet another sculptor, but the recent discovery of the inscription inside the Jizo Bosatsu has effectively cleared up such doubts.

This Jizo Bosatsu is seated and holds a pilgrim's staff in his right hand and a sacred jewel in his left—a most ordinary representation. The emphatic realism displayed in the carving of the folds in the robes makes it clear that this is the work of one of Unkei's descendants, but here, in the grandson's generation, the lines of the robes have become rather slack. Moreover, the mild, sweet expression of the face quite strongly suggests the style of the Kaikei school rather than that of the Unkei school.

FIGURE 151. Monju Bosatsu, by Koshun. This statue, enshrined at the Hannya-ji, in Nara, has an

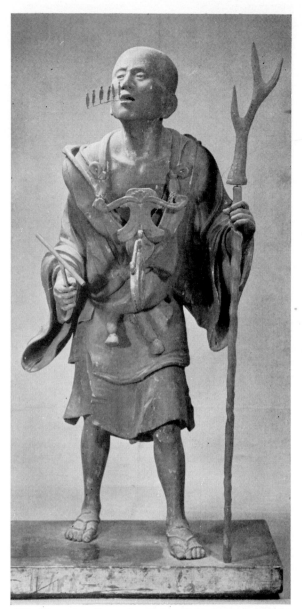

153. The priest Kuya, by Kosho. Painted wood; height, 117.5 cm. Thirteenth century. Rokuhara Mitsu-ji, Kyoto. (See also Figures 72, 131.)

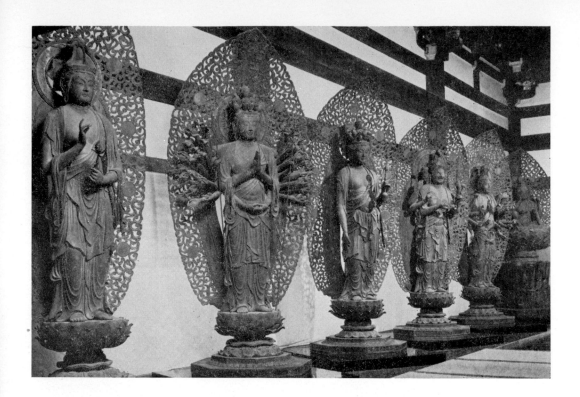

inscription on its knee from which we learn that it was completed on the seventh day of the third month, 1324, by the chief busshi and *hogen* Koshun with the assistance of his son Kosei and other minor busshi. The face and the body are childishly plump, and the hair is drawn up into eight topknots, signifying that this Monju Bosatsu is the embodiment of an eight-syllable mantra (a word or words revealed by the Buddha during meditation). The work is quite unusual because it was created by means of the old-style *ichiboku* (single wood block) technique. Even the necklace and the armlets have been carved out of the wooden body. The wood is unfinished, and there are only a few decorative patterns in gold leaf on the robes. The deep carving of these garments brings to mind the Unkei school, but the rippling of their edges is definitely a characteristic of the Sung style. The statue is not what one would call a great work of art, but it is a good example of the sculpture of the latter-day Unkei school.

FIGURES 89, 155. Ni-o, by Kosei (son of Koshun). These two temple guardians are enshrined in either side of the Main Gate at the Kimpusen-ji, the famous temple on Mount Yoshino in Nara Prefecture. Inscriptions discovered inside the statues during recent repair work state that they were completed on the nineteenth day of the twelfth month in 1338 by the chief busshi and *hokkyo* Kosei with the assistance of Ryoen, Kozen, and other minor busshi. Kosei was one of Unkei's great-grandsons, and it would be precisely in a subject like the Ni-o —mighty figures full of movement—that a busshi of his lineage would be expected to do his best work. Unfortunately, although Kosei's statues are indeed giants with a driving force, these very qualities of great size and power have been exaggerated almost to the point of grotesqueness.

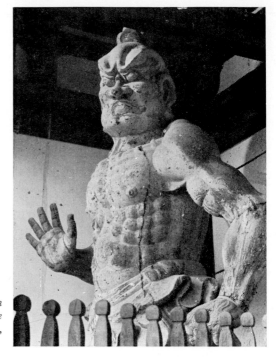

154. Six manifestations of Kannon, by Jokei II. Statues from left to right: Sho Kannon, Senju (Thousand-armed) Kannon, Juichimen (Eleven-headed) Kannon, Batō (Horse-head) Kannon, Juntei Kannon, Nyo-irin Kannon. Unpainted wood; average height, 180 cm. Dated 1224. Daiho-on-ji, Kyoto. (See also Figure 74.)

155. Ni-o (Naraen Kongo), by Kosei, son of Koshun. Painted wood; height of entire statue, 527 cm. Dated 1338. Kimpusen-ji, Mount Yoshino, Nara Prefecture.

THE ACHIEVEMENTS OF THE ZEN SCHOOL

After Unkei and his followers moved their workshops to Kyoto, it was the Zen school of busshi, including Zen'en, Zenkei, and Zenshun, who produced outstanding works of sculpture in the Nara region. (The name of the school, taken from the first character of the sculptors' names, is written differently in Japanese from that of the Zen sect of Buddhism, and no relationship between the two is implied.) There is no clear historical evidence that indicates who their ancestors were, but if we assume that they had their origins in Nara busshi stock, they must have had a connection with the Kei school.

Two of Zen'en's statues have survived: the Shaka Nyorai produced in 1225 for the Kaijusen-ji, in Kyoto Prefecture, but now housed in the Todai-ji's Sashizudo (Directors' Hall), and the Aizen Myo-o (Fig. 11) at the Saidai-ji, in Nara, produced in 1247. The latter statue was made under the sponsorship of the priest Eison. Both works are relatively small and are of a unique style that combines moderation with a brilliant carving technique.

Zenkei produced a statue of Shaka Nyorai (Fig. 14) for the Saidai-ji in 1249, and this work, too, was sponsored by Eison. There are no detailed historical facts about the relationship between Zen'en and Zenkei, but because they both used the character zen in their names and carved statuary under Eison's patronage, we may surmise that they did have some sort of close connection.

In 1249, immediately after the completion of the Shaka Nyorai for the Saidai-ji, Zenkei traveled to the island of Awaji in the Inland Sea, where he carved an image of Yakushi Nyorai for the Sho-fuku-ji. The folds in the robes of this statue are somewhat too intricate, but in the firm sculpturing and in the painstaking attention to detail we see a

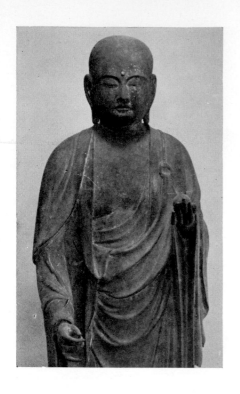

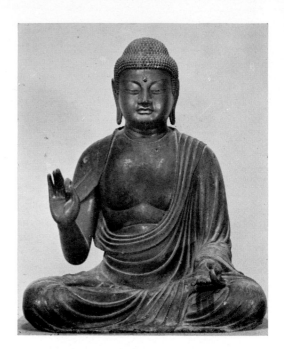

style similar to that of Zen'en's two extant works.

Zenkei died in 1258 at the age of sixty-one. His son Zenshun produced two statues that exist today: those of Shotoku Taishi at the Gokuraku-bo, or Paradise Hall (once part of the now vanished Gango-ji), in Nara, completed in 1268, and of Eison (Figs. 133, 158) at the Saidai-ji, completed in 1280. With their boldly carved robes, these two statues remind us of the Kei school more than any other works of the Zen school.

Even though Zen'en, Zenkei, and Zenshun were all sculptors from the same school, we can see that each had his own style and was active in his own particular way. The traditions of Buddhist sculpture in the Nara region were carried on by the Zen school into the Muromachi period.

FIGURE 11. Aizen Myo-o, by Zen'en. This statue is the main image of the Saidai-ji's Aizendo (Hall of Aizen Myo-o). According to the postscript of a

sutra found inside the body, it was completed on the eighteenth day of the eighth month in 1247 with the priest Eison as sponsor. For a long time this Aizen Myo-o was a secret religious image and was displayed to the public only on rare occasions. Thus the colors remain remarkably fresh and vivid, and the original pedestal and mandorla are still intact. The sculpturing technique is restrained, and the facial expression of anger, with mouth and eyes wide open, is not too exaggerated. The body is clothed in very skillfully carved robes. The statue has a unique style not to be found in the Unkei school, the Kaikei school, or the traditional Kyoto schools.

FIGURE 14. Shaka Nyorai, by Zenkei. The work shown here is a copy of a statue of Shaka Nyorai brought to Japan from China by the priest Chonen at the close of the tenth century and now enshrined at the Seiryo-ji (more popularly called the

156 (opposite page, left). *Jizo Bosatsu, by Injo. Painted wood; height of entire statue, 166 cm. Dated 1295. City of Kyoto.*

157 (opposite page, right). *Amida Nyorai, by Kaikei. Painted wood; height, 89 cm. Late twelfth century. Matsuno-o-dera, Kyoto Prefecture. (See also Figure 116.)*

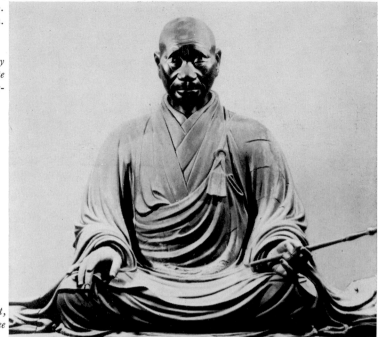

158. Eison, by Zenshun. *Painted wood; height, 89.4 cm. Dated 1280. Saidai-ji, Nara. (See also Figure 133.)*

Shakado), in Kyoto. The Seiryo-ji statue is said to be a copy of the very first image of the Buddha, which, according to Buddhist legend, was carved in India for King Udayana. During the Kamakura period the production of copies of the Seiryo-ji Shaka Nyorai was much in vogue, and Zenkei's statue is one of many such copies. From an inscription on the pedestal and from various documents, a detailed history of Zenkei's sculpture can be traced. We learn that in 1249, from the fifteenth day of the third month to the third day of the fourth month, a total of eighteen days, the sculptor Zenkei and nine assistants sojourned at the Seiryo-ji, where they copied the statue. After another five days the copy was delivered to the Saidai-ji. Then nine days, from the fifteenth to the twenty-third day of the fourth month, were spent in decorating the image with finely cut gold leaf, and finally, on the fourth day of the fifth month, it was enshrined in the

Saidai-ji's Shiodo (Hall of the Four Guardian Kings). We also learn that in addition to Zenkei and his nine assistants, the painter Joshun with four assistants and the carpenter Yukihisa with five assistants participated in the project, which was sponsored by the priest Eison.

The statue, with mandorla and pedestal still intact, is a faithful reproduction of the Shaka Nyorai at the Seiryo-ji. The robes expose almost none of the flesh and fall about the body in beautiful folds like patterns of running water, and the hair is arranged in tight braids. It is rather difficult to grasp Zenkei's individual style here, but we can see that he had very refined tastes and a restrained carving technique. In this, we may note a stylistic trait common to both Zenkei and Zenshun.

FIGURE 158. Eison, by Zenshun. (See also Figure 133.) This statue was completed in the eighth month of 1280. Zenshun was the chief busshi for the

project, with Shunsho, Zenjitsu, and Gyozen assisting him. This much has been proved by an inscription on the inside of the statue. Eison, the celebrated priest who revived the Ritsu sect of Buddhism during the Kamakura period, was still alive (at the age of seventy-nine) in 1280; so we may surmise that he sat for the portrait. Indeed, the priest's strongly individual face, with its sloping eyebrows, large nose, and thin, pursed mouth, has been skillfully portrayed in this work. The folds of the robes are too intricately carved to be called realistic, and the long sleeves flow out much farther than usual on either side. If we go back nearly a century, we find the same kind of robes on Kokei's Six Patriarchs of the Hosso Sect and Unkei's Jizo Bosatsu. Thus we can see that Zenkei's style is more closely related to the Kei school than that of his predecessors was.

THE KEI SCHOOL AND THE TRADITIONAL SCHOOLS IN KYOTO

As we have noted previously, the two leading schools of busshi active in Kyoto throughout the Fujiwara period were the In and the En schools. Both were supported by the aristocratic Fujiwara clan, and both followed the placidly beautiful style of classical sculpture established largely by Jocho in the first half of the eleventh century. Although the busshi of these two schools did not bring their activities to an end during the Kamakura period, they were overwhelmed by the sheer force of the newly arrived Kei school and gradually lost almost all the glory of their former state. Myoen and Inson, busshi from the two schools who worked during the closing decades of the twelfth century, were the last great sculptors of the gilded years of the Fujiwara period. When Inson died in 1198 and Myoen followed him in 1199, Unkei and his disciples, in one concerted effort, moved from Nara to Kyoto. The change from the old to the new in sculpture was taking place, even in the capital city. Unkei set up his workshop there in the Shichijo (Seventh Avenue) area, and his school came to be known as the Seventh Avenue Workshop. It was not long before Unkei, Kaikei, and all their followers enjoyed a positively thriving business in Kyoto. The Kei school had reached its zenith.

But the deep-rooted power of the In and the En schools—or the traditional schools, as they might be termed—could not be obliterated completely, and the busshi from these schools continued to work as before. There was a difference, however, for even though a few of them kept to the time-honored traditions of their predecessors, the majority gradually blended their own techniques with the style of the more fashionable Kei school. Eventually the statuary produced by the In and the En schools no longer bore any resemblance to that of the Fujiwara period.

THE WORK OF THE KEI SCHOOL IN KYOTO

During the early years of the Kamakura period, when the creative powers of Japan's great sculptors were at their peak, there were no projects in Kyoto to compare in importance with the restoration work at the Todai-ji and the Kofuku-ji—an undertaking that came about only by chance in Nara. Thus Unkei and Kaikei accepted relatively small-scale assignments in Kyoto. It might be that Kaikei was more active than Unkei in the Kyoto area because his elegant, delicate style was more suited to the tastes of the sophisticated citizens of the capital.

In the middle of the thirteenth century such large-scale projects as the carving of the thousand statues of the Thousand-armed Kannon materialized in Kyoto, and Tankei, Koen, and other busshi of the Kei school called forth the finest of their skills as they participated in these prodigious undertakings. Unfortunately, throughout its long history, the city of Kyoto has been the scene of recurring disasters, both natural and man-made, and many of the famous Buddhist statues produced there during the Kamakura period were destroyed before the beginning of the present century. Let us look briefly here at some of those that survive.

FIGURE 58. Jizo Bosatsu, attributed to Unkei. (See also Figure 45.) Although this statue is now housed in a modern ferroconcrete museum at the Rokuhara Mitsu-ji, it was once the main image of the Jizo Jurin-in, a small but no longer extant sub-

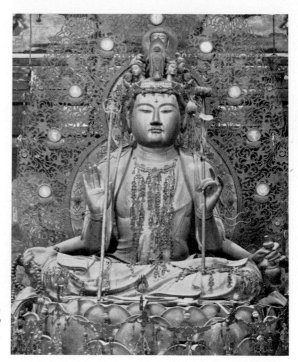

159. *Juichimen (Eleven-headed) Kannon, by In'en, Kakushun, Inkitsu, and others. Painted wood; height, 69.2 cm. Dated 1319. Hokongo-in, Kyoto.*

temple located on the same grounds. This sub-temple is thought to have replaced Unkei's family temple, also called the Jizo Jurin-in, which he built in the Hachijo (Eighth Avenue) Takakura area near the present location of the Rokuhara Mitsu-ji. Thus there is ample reason to believe that Unkei himself carved the statue.

It is important to note that the method employed for making the statue is quite similar to the old *ichiboku* method. The entire body is carved from a single block of wood, but because the eyes have been inlaid with crystal from the inside, in the new Kamakura-period fashion, we know that the head would have had to be split into two pieces and joined together again. Thus the work is excluded from the category of pure *ichiboku* construction.

We can see here just how skillfully Unkei blended the old and the new in his art. The statue is seated firmly, with knees spread wide apart. In its dignified pose we can truly appreciate the sense of complete-ness inherent in the *ichiboku* technique. The classic features could only have been created by a man of Unkei's great talent. In the numerous intricate folds of the robes we note a special feature of the Kei-school style. Although the statue has darkened with age, there is evidence that it was once painted with beautiful colors, and on close inspection we find traces of finely cut gold-leaf patterns on the robes. The necklace was carved from a separate piece of wood and glued on.

FIGURE 70. Senju (Thousand-armed) Kannon, by Tankei. The Rengeo-in, or Sanjusangendo (Hall of Thirty-three Bays), as it is popularly called, was built at the request of the retired em-peror Goshirakawa (1127–92; reigned 1155–58). Completion ceremonies were held on the seven-

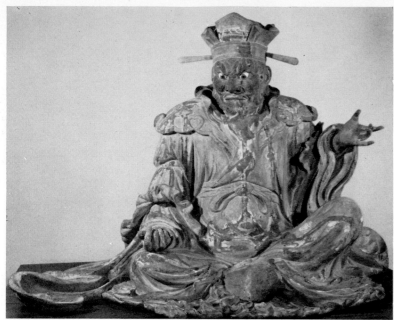

160. *Shoko-o, one of the Ten Kings of Buddhism, by Koyu. Painted wood; height, 102 cm. Dated 1251. En'o-ji, Kamakura. (See also Figure 36.)*

161. *Jizo Bosatsu. Painted wood; height, ▷ 51.5 cm. About 1231. Ganjoju-in, Shizuoka Prefecture.*

teenth day of the twelfth month in 1164, and a thousand and one images of the Thousand-armed Kannon, including the larger main image, were enshrined in the hall. Unfortunately the Sanjusangendo was destroyed by fire in 1249. Although a few of the statues were rescued from the flames and can be seen today in the reconstructed building, most of those now housed there were produced after 1249.

The present main image, a huge statue of *joroku* proportions, was originally constructed in front of the Golden Hall of the Hossho-ji, a temple once located in the area of Kyoto's Okazaki Park but no longer extant today. The work began on the twenty-fourth day of the seventh month in 1251 and was completed on the twenty-third day of the first month in 1254, whereupon the statue was transported to the Sanjusangendo. The chief busshi was the *hoin* Tankei, who was eighty-one years old at the time when the statue was finished. He was assisted by two busshi of *hogen* rank: Koen and

Kosho's son Kosei. These details are recorded in an inscription on the statue.

The Thousand-armed Kannon is seated on an octagonal lotus pedestal with seven rows of petals. Behind it is a large oval mandorla with small images of the thirty-three manifestations of the Kannon amidst an openwork pattern of clouds and sacred trees, all intricately and skillfully formed. The statue and its accessories have been almost perfectly preserved since 1254. Each part is well balanced with the whole. No doubt it was from Unkei that Tankei learned the technique of rendering the naturally draped robes, which are thickly and deeply carved. The plumpness of the face is a characteristic found in all statues by Tankei, and the features, in comparison with those of Unkei's works, have a more placid and refined expression. When we consider that Tankei was in his eighties at the time, it is indeed astounding that he was able to produce such a powerful, massive statue, even with the aid of two younger busshi.

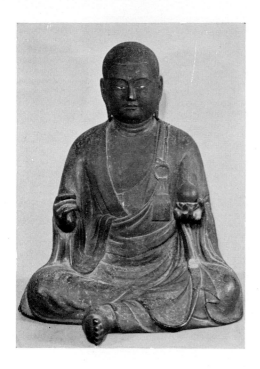

achieve a lifelike effect. Kosho's ability as a master of realistic sculpture is expressed to the fullest in this work.

FIGURE 76. Aizen Myo-o, by Koen. According to an inscription on its pedestal, this statue was produced between the eleventh and the twenty-first days of the third month in 1275. The sculptor was the *hogen* Koen, who was sixty-eight at the time. He was the son of Unkei's second son, Koun.

Both the pedestal and the mandorla are contemporary with the statue itself. It is a well-preserved piece, quite small in size. The workmanship of the details is polished, but the sculptor has resorted a little too much to artifice. Embossing and gold-leaf inlay are combined to create patterns of delicate beauty on the robes, while the armlets and the necklace are made of intricate copper openwork. Koen's tendency to emphasize his technical skills in his later years is well demonstrated in this statue. We should also note here that the latter-day Unkei school came to favor such sculpture.

FIGURE 74. Juntei Kannon, by Jokei II. (See also Figure 154.) This work is one of the six Kannon statues at the Kyoto temple Daiho-on-ji. An inscription found inside the statue during recent repairs states that it was completed on the fourth day of the fifth month in 1224 by the *betto* Jokei from Higo Province (the present Kumamoto Prefecture). Although the other Kannon statues give no indication of the sculptor's name, from a stylistic viewpoint they appear to be the work of either Jokei II or one of his apprentices.

This standing figure of the Juntei Kannon has eighteen arms. It is made of unpainted wood and shows hardly any application of color. The most remarkable aspects of the carving are to be found in the lively shaping of the folds of the garments and in the decorative diversity of the topknot and the hair around the forehead. All these features point to the influence of the Sung-dynasty style and are quite common in the work of Jokei II. Since the carving of the plain wood is quite precise and clean, the statue seems all the more fresh and vital. The mandorla and the pedestal, which are contemporary with the statue, are well preserved.

FIGURE 116. Amida Nyorai, by Kaikei. (See

FIGURE 72. Kuya, by Kosho. (See also Figures 131, 153.) From an inscription inside this statue, we know that it was made by Unkei's fourth son, Kosho. Unlike the usual portrait sculptor, Kosho placed the emphasis on the clothing and gestures of his subject rather than on the facial features. Kuya is clad in short peasant's garb and has nothing but straw sandals on his feet. He clutches an antler-tipped staff in his left hand and, in his right, holds a T-shaped wooden stick with which he beats the gong suspended from his neck. The six tiny images of Amida emerging from his mouth represent his prayers. With back hunched, chin thrust forward, and robe nearly slipping off the right shoulder—as if Kuya had forgotten about it in the zeal of reciting his prayers—this statue is a very realistic representation of the famous priest. In such details as the Adam's apple and the bony chest, the veins in the legs, and the shabby, wrinkled robes with the seams showing inside the openings of the sleeves, we can see what great efforts were made to

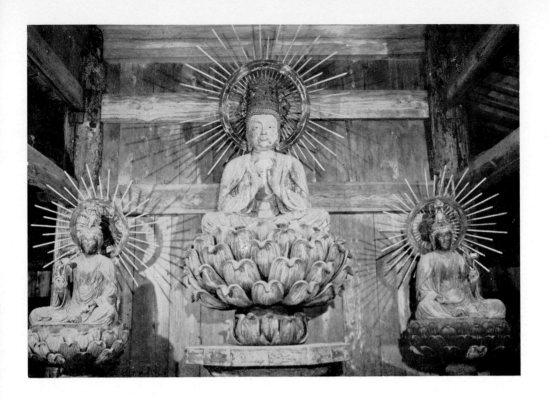

also Figure 157.) The Matsuno-o-dera, in Maizuru, Kyoto Prefecture, is a temple of the Daigo branch of the Shingon sect. The Amida Nyorai shown here is a very rare example of Kaikei's work discovered only recently at this temple. As we have noted before, Kaikei was unusual in that he preferred to sign his sculptures. His Buddhist name, An Amida Butsu, is written in black ink on the inside of the upper half of this statue's head. The characters are large and bold—a style not often found in other examples of his signature. This could very well mean that Kaikei produced the Amida Nyorai when he was still quite young and vigorous.

Kaikei carved many statues of Amida Nyorai, but most of them were standing figures of less than a meter in height. In contrast with these, the present statue is a seated figure of life size—a representation quite unusual for Kaikei. The tightly wound curls on the head are extremely small, and the face, with its short nose and fully fleshed cheeks, brims over with youthful vitality. The folds of the robes are relatively simple, but in this they lend themselves all the more to the general impression of strength. The statue retains the realistic style typical of Kaikei's early period.

FIGURE 115. Shaka Nyorai, by Gyokai. (See also Figure 107.) This statue is the central image about which stand the statues of the Ten Great Disciples of the Buddha produced by Kaikei and his apprentices for the Daiho-on-ji. The inside of the statue bears the inscription "the skilled craftsman Gyokai of the rank *hogen*," thereby establishing that it is a work by Kaikei's senior apprentice. It is of interest to note that Gyokai's signature is very similar to Kaikei's.

The slanted eyes and the intellectual expression

162. Amida Triad. At center, Amida Nyorai; at left, Kannon Bosatsu; at right, Seishi Bosatsu. Painted wood; height of Amida Nyorai, 144 cm.; height of each attendant, 107 cm. About 1299. Jokomyo-ji, Kamakura. (See also Figure 39.)

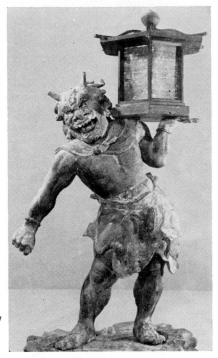

163. Tentoki, attributed to Koben. Painted wood; height, 77.8 cm. About 1215. Kofuku-ji, Nara. (See also Figure 80.)

are stylistic features inherited from Kaikei, but we note the absence of Kaikei's painstaking attention to detail. For example, the individual curls on the head are rather large, and the eyes and nose are thickly molded. In these points we can recognize Gyokai's individual style as well. He also expresses his own kind of realism in the robes, which display considerable variety of sculptural treatment. Most of Kaikei's followers merely copied the Annami style without any spirit or force. Among all of them, Gyokai alone left behind a statue that bears the mark of his own personality, thus proving himself worthy of his position as Kaikei's senior apprentice.

FIGURE 104. Kukai (Kobo Daishi), by Chokai. The signature that appears on the inside of the body of this statue reads as follows: "Kosho Jo Amida Butsu Chokai" (the skilled craftsman Chokai of the Buddhist name Jo Amida Butsu). It closely resem-

bles Kaikei's signatures, even to the Buddhist name, for Chokai was one of Kaikei's many apprentices. The statue shows the famous priest Kukai in a commonly represented form: seated and holding a rosary in his left hand and a *vajra* in his right. (The *vajra*, or thunderbolt, is a Buddhist symbol taken from Indian mythology.) It is a realistic piece of sculpture done in a restrained, polished style. Although it is not a particularly great work of art, it is worth mentioning here as a relatively rare example of portrait sculpture in the Kaikei school.

THE SCULPTORS OF THE TRADITIONAL SCHOOLS IN KYOTO
Now let us examine some of the Kamakura-period statues produced by busshi of the traditional In and En schools in Kyoto. By way of introduction we should consider the thousand smaller statues of

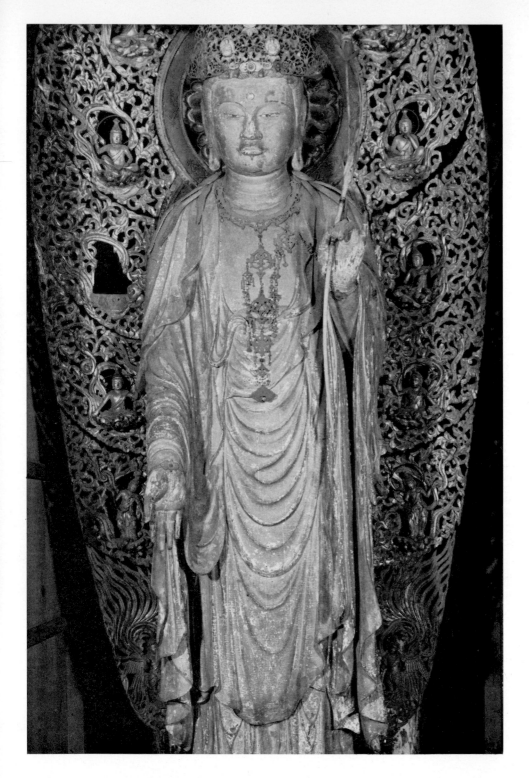

165. Dainichi Nyorai, by Koyo. Lacquer and gold leaf over wood; height, 51 cm. Dated 1346. Henjo-ji, Tochigi Prefecture.

the Thousand-armed Kannon at the Sanjusangen-do (Fig. 71). Most of these images were produced between 1251 and 1266. In addition to Tankei, Koen, and other busshi of the Kei school, many sculptors from the In and the En schools participated in the project. What is of most interest here is that although some sculptors of the traditional schools, including Inkei, Inshin, and Impen, kept to the tranquil Fujiwara-period style, the majority of them—men like Ryuen, Shoen, Eien, Insho, In'e, and In'yu, to name a few—produced works seasoned with the popular realistic style of the Kamakura period. Here we have an actual example of how the busshi of these schools grafted the new style onto their own. Fortunately there were a few who managed to add a judicious touch of the new style to their own traditions in order to create unique works of art.

Figures 19–23. The Five Great Kings of Light

(Go Dai Myo-o), by Myoen. As we have noted before, Myoen, a great busshi of the En school, was active at the end of the twelfth century. It is most fortunate that this group of statues at the Kyoto temple Daikaku-ji is still extant today. The group consists of the Five Great Kings of Light, who represent Dainichi Nyorai's wrath against the wicked: Kongo Yasha Myo-o (Fig. 19), Fudo Myo-o (Fig. 21), Daiitoku Myo-o (Fig. 20), Gozanze Myo-o (Fig. 23), and Gundari Myo-o (Fig. 22). On the pedestal of the Kongo Yasha Myo-o is an inscription to the effect that the *hogen* Myoen began work on this statue on the sixteenth day of the eleventh month in 1176.

The five statues all display the same style and are all recognized as works by Myoen. They are small in scale, and the carving shows a painstaking attention to detail. The garments are decorated with beautifully delicate patterns in finely cut gold leaf,

but these are now difficult to discern. Although the statues have the fearsome, mobile expressions appropriate to these deities, the sculptor has not exaggerated this aspect. All the features we have noted here are typical of Fujiwara-period tastes. When we compare this group of statues with the Dainichi Nyorai at the Enjo-ji, produced in the same year but reflecting the vigorous, youthful spirit of the Nara busshi Unkei, we cannot help noting the tremendous differences between the styles of the Nara and the Kyoto busshi.

FIGURE 117. Juichimen (Eleven-headed) Kannon, by Impan and In'un. This statue is the main image of the Hoshaku-ji, an ancient temple located in the village of Oyamazaki, a few miles southwest of Kyoto. According to an inscription on a block of wood found inside the statue, work on it began on the twenty-third day of the sixth month in 1233. We also learn that the *hoin* Impan and the *hokkyo* In'un were in charge, and thus we know that it is a work of the In school.

The Kannon is a standing figure of tranquil mien, with ample flesh on the shoulders and the chest. The face is round, the eyebrows are long, and the eyes are half closed. There can be no doubt that this is a statue in the tradition of Jocho. The flowing robes, however, have a judicious touch of realism. Here, indeed, is a work of sculpture that serves as an excellent example of how the traditional style of the In school was revived by the new style of the Kamakura period. It is also of interest to note how the long scarves tie together at the knees and how the robes swirl to the floor below —both features of the early Heian-period style.

FIGURE 119. Shitta Taishi (Prince Siddhartha), by Inchi. (See also Figure 124.) According to documents discovered inside this statue, it was produced by the *hogen* Inchi in 1252. The documents also reveal that the statue represents Prince Siddhartha, a manifestation of the historical Buddha (Shaka) in his youth, and not the famous Japanese statesman Shotoku Taishi, as had been previously believed. Indeed, even though it is ostensibly the image of a young layman, the statue is furnished with emblems that were probably added in consideration of Siddhartha's status as one of the

former reincarnations of the Buddha: a simple circlet of a crown and an *urna*—the small disc in the center of the forehead that represents divine insight and is one of the thirty-two marks of superiority by which a Buddha is identified.

Siddhartha is dressed in Chinese fashion, and the influence of the Sung style can be seen in the frilly half-sleeves that flare out at the elbows and in the long flowing sleeves that hang down from the wrists. Even though Inchi was a member of the traditional In school, he added these up-to-date features—an addition that demonstrates once again how difficult the Kyoto busshi found it to resist the pull of the changing trends in sculpture.

FIGURE 156. Jizo Bosatsu, by Injo. When this statue was repaired not long ago, there was found inside the head an inscription to the effect that it was made by the *hoin* Injo in 1295. The figure has an extremely tranquil air, and the hands, in particular, are skillfully represented. It is difficult to discover any of the stylistic traits of the traditional In school here. Instead, in the soft appearance of the wood and in the free-flowing robes, the statue brings to mind the new style of the Kamakura period.

FIGURE 159. Juichimen (Eleven-headed) Kannon, by In'en and others. Numerous objects were discovered inside this statue, including memorial urns, documents recording prayers for the dead, and inked prints of the Buddha and other deities. There were also small slips of paper bearing the names of sixteen busshi, among them the *hoin* In'en, the *hogen* Kakushun, and the *hogen* Inkitsu. These are undoubtedly the names of the busshi who produced the statue, and the majority of them belonged to the In school. An inscription at the base of the statue states that its decoration with armlets, a necklace, and other accessories was completed on the twenty-first day of the fifth month in 1319.

The work is unusual in that it portrays the Eleven-headed Kannon in a seated position and with four arms instead of two. The decorations on the body, the pedestal, and the mandorla all match. The features that most outstandingly display the technical skills of the sculptors are the hanging decorations on the crown, the chest, and the knees;

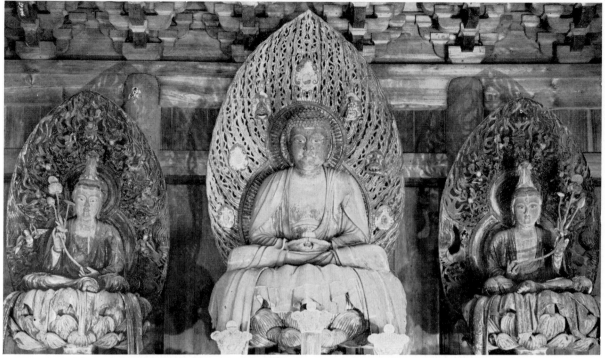

166. *Yakushi Triad. At center, Yakushi Nyorai; at left, Nikko Bosatsu; at right, Gakko Bosatsu. Painted wood; height of Yakushi Nyorai, 181 cm.; height of each attendant, 150 cm. Late thirteenth or early fourteenth century. Kakuon-ji, Kamakura.*

the patterns in embossed paint and in finely cut gold leaf on the garments; the exquisitely worked lotus flower and staff held in the hands; the delicate openwork mandorla of copper; and the complex seven-tiered lotus pedestal hung everywhere with ornamental chains. These features connect the statue with the opulently adorned Buddhist statuary created by the traditional schools at the end of the Fujiwara period, when this style was highly popular, and it is quite surprising to find that the In school produced such a work so late in the Kamakura period. The tranquil expression of the face also reminds us of the old Kyoto, but the carving of the folds in the garments is quite thick and deep in the realistic manner of Kamakura sculpture.

KAMAKURA-PERIOD SCULPTURE IN THE KAMAKURA REGION Kamakura was once a poor out-of-the-way fishing village in eastern Japan, but when Minamoto Yoritomo established himself there as shogun after the defeat of the Taira in 1185, it became the center of Japan's new military government. As the building of temples for this new city got under way, the architects, sculptors, and painters required for the work of construction and decoration were brought from Kyoto and Nara, for there were no local artisans capable of handling such undertakings. We have already noted that Unkei and Seicho went to eastern Japan in the mid-1180s. Jokei II, Kojo (an apprentice of Unkei's second son, Koun), and other busshi of the Kei school also traveled to

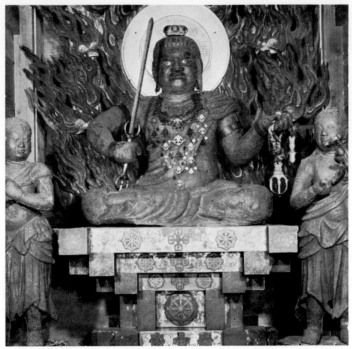

167. *Fudo Triad. At center, Fudo Myo-o; at left, Seitaka Doji; at right, Kongara Doji. Cast iron; height of Fudo Myo-o, 99 cm.; height of each attendant, 95.5 cm. Daisen-ji, Kanagawa Prefecture.*

Kamakura, and later on, even busshi from the traditional In school—for example, In'en—produced Buddhist statuary that was transported from Kyoto to Kamakura. Thus the Buddhist statuary for the temples of Kamakura was created either by bringing busshi from Kyoto or Nara or, if the sculptors could not go to eastern Japan, by importing statues from western Japan. It should be stressed again here that the Nara busshi, not those of Kyoto, were the first to receive assignments from the warriors of Kamakura, who scorned the aristocratic culture of the imperial court—represented by the Kyoto busshi—and welcomed instead the new, heroic realism then being developed by the Nara busshi.

The desire for the new in Kamakura also manifested itself in the introduction of Sung and Yuan art from China. In 1200, Yoritomo's widow, Masako, commissioned the Zen priest Eisai to found the Jufuku-ji there. From that time on, the Zen sect spread rapidly throughout eastern Japan, and other Zen temples such as the Kencho-ji and the Engaku-ji were established in the military capital. Among the Chinese priests who were invited to establish temples there were Mugaku Sogen (Wu-hsueh Tsu-yuan), founder of the Engaku-ji; Rankei Doryu (Lan-ch'i Tao-lung), founder of the Kencho-ji; and Doryu's successor, Gottan Funei (Wu-an Pu-ning). Under the influence of men like these, the art of the Zen sect and, by connection, that of the Sung and the Yuan dynasties came to be introduced and, in time, gave a special flavor to the sculpture and painting of the Kamakura region. Still other new forms of expression—for

example, portraits and even nude statuary—gained popularity there, with the result that the sculpture of the region developed a unique style quite independent from that of Kyoto and Nara. It should be noted that the Kamakura region, as referred to here, includes the Izu Peninsula as a matter of course, since the two leading families of the Kamakura shogunate, the Minamoto and the Hojo, had close connections there.

THE UNKEI STYLE IN THE KAMAKURA REGION

The genre of sculpture thus developed in the Kamakura region had its roots in the style of sculpture created by Unkei. When Unkei first arrived in the east, he found no old, established sculptural traditions there. Nevertheless, throughout eastern and northern Japan, there was a distribution of statues in the *arabori* (rough-hewn) style—works that at first glance appear to be unfinished—and there is evidence that sculpture in the style of the early Fujiwara period (tenth century), before Jocho, was still being produced in these parts of the country during the early years of the Kamakura period. These rather crude regional works, so different from the elegant statuary of Kyoto and Nara, must have attracted the young Unkei's attention, for at the same time that he was making a great contribution to the sculpture of eastern Japan, he was absorbing certain elements of the climate of the east that played no small role in the perfection of his art. Toward the middle of the thirteenth century, the Unkei style was gradually intermingled with the styles of the Sung and the Yuan dynasties, and truly original sculpture of high artistic merit evolved in the Kamakura region.

FIGURE 57. Amida Nyorai, by Unkei. (See also Figures 25, 26.) Almost all statues of Amida Nyorai from the Fujiwara and the Kamakura periods make either the mudra of seated meditation, with both hands folded in front of the stomach, or the mudra by which believers are welcomed to paradise: the left hand outstretched in greeting and the right hand raised, with thumb and forefinger joined to form a circle. The present Amida Nyorai, produced in 1186 for the Ganjoju-in, in Shizuoka Prefecture,

is quite unusual in that it makes the mudra of expounding the Buddha's teachings, with both hands raised in front of the chest. This mudra was mainly used for images of Amida Nyorai in the statuary of the late Nara and the early Heian periods—that is, from 710 to 897.

The statue gives a somewhat rustic impression, with its stolid face, firmly closed mouth, short neck, tensed shoulders, and heavy-looking chest, arms, and knees—all features that may be found in the pre-Jocho sculpture of the early Fujiwara period. The robes show still another trend. The folds are intricately and deeply carved, and the ends of single folds are often forked (Fig. 25). We can find other examples of statues with the same kind of robes in the Amida Triad at the Chogaku-ji (Figs. 7, 8), the Six Patriarchs of the Hosso Sect at the Kofuku-ji (Figs. 33–35, 55, 146, 147), the Amida Triad at the Joraku-ji (Figs. 30, 52), and the Jizo Bosatsu at the Rokuhara Mitsu-ji (Figs. 45, 58). In other words, the robes of this statue connect it with the works of the Kei school. Because of the striking similarity between the statue and the Jizo Bosatsu of the Rokuhara Mitsu-ji, which is surmised to be the work of Unkei, I believe that it is from Unkei's hand. The rustic touches reminiscent of the early Fujiwara period, as noted above, only confirm that Unkei worked together with the busshi of the Kamakura region, where the powerful genre of pre-Jocho sculpture was still preferred, even at the end of the twelfth century.

FIGURE 161. Jizo Bosatsu. An inscription giving the Kangi era (1229–32) as the date of production appears on the inside of this statue, which, like the Amida Nyorai just described, is at the Ganjoju-in. Although part of the inscription is illegible and some of it may have been written at a later date, it also proves that the statue was commissioned as a memorial to Yoritomo's widow, Masako, who died on the eleventh day of the seventh month in 1225. Because 1231, by Japanese count, was the seventh year after Masako's death—a significant anniversary in Buddhist ritual—we can make the fairly accurate assumption that the statue was produced in that year.

In most respects this is an ordinary representa-

tion of Jizo Bosatsu, except that the left foot is thrust out in an unusually casual manner. The hair around the forehead is carved in curls, and the nose has a classical elegance that, interestingly enough, brings to mind the Jizo Bosatsu at the Rokuhara Mitsu-ji. The robes of the statue are quite different, however, for they are comparatively simple. We do not know the name of the sculptor, but he was probably a busshi who came under the influence of Unkei.

FIGURE 36. Shoko-o, by Koyu. (See also Figure 160.) Shoko-o is one of the Ten Kings of Buddhism (Ju-o), who pass judgment on the dead in the underworld. He is portrayed here in the usual way, with a fearsome face and Chinese-style priest's garments. According to an inscription on the inside of the statue, the busshi Koyu completed it on the fifth day of the eighth month in 1251. We know nothing of Koyu's lineage, but his artistic style is clearly based on the free, heroic genre of the Unkei school, with the conspicuous addition of wavelike folds in the robes in the Sung manner. Koyu's skill in carving was exceptional, and this is one of the most prominent masterpieces among all the works from the mid-thirteenth century onward in which the Unkei and the Sung styles are blended.

FIGURE 168. Amida Nyorai (Kamakura Daibutsu). The documentation on the production of this famous bronze statue, popularly known as the Kamakura Daibutsu (Great Buddha), is rather vague. We know that a priest named Joko first canvassed Japan for funds to build a wooden Daibutsu in Kamakura and that the ceremony celebrating the completion of the statue took place in 1243. Nine years later, in 1252, the casting of a bronze Daibutsu began in the same area under the sponsorship of the same Joko. That work is thought to be the present statue at the Kotoku-in, in Kamakura. But the relationship between the bronze statue and the previous wooden one remains unclear. In any case, this work represents a new trend in the production of Buddhist statuary in that it was constructed with funds raised among the common people rather than with the financial contributions of a single powerful man.

The upper half of the body looms large in com-

parison with the lower half. If we view the head from the side, we can see that it bends forward noticeably. Perhaps the reason for the considerable forward inclination is that the great size of the statue prevented the image makers from maintaining the correct visual balance. The robes, however, are handled with consummate skill. Molded in thick, deep folds, they create a vivid impression of flowing movement in the best tradition of the Unkei school. The beautiful face has an expression of ineffable calm. In its size as well as in its workmanship, this statue marks the zenith of Unkei-style sculpture to be found in the Kamakura region.

FIGURE 164. Miroku Bosatsu. An inscription inside the head of this statue gives its date of production as 1276. A number of objects, including woodblock prints of the Three Thousand Buddhas, copies of the *Lotus Sutra*, lists of contributors to the temple (the Shomyo-ji), and prayer sheets—all dated the second day of the eleventh month, 1278 —were discovered stored away inside the statue. The tall, slender figure holds in its left hand a long-stemmed lotus topped with a miniature stupa symbolizing the five cardinal elements of Buddhism. The garments are skillfully carved. Although there is a slight hint of fussiness in the overall effect, the statue conveys the spirit of the Unkei style. The mandorla and the pedestal are contemporary with the statue. Such decorative touches as the mythical Chinese lion carved out of one tier of the pedestal indicate that here too the influence of Sung art made itself felt.

THE SUNG-DYNASTY STYLE AND OTHER NEW TRENDS

As we have noted earlier, sculpture in the style of the Sung and Yuan dynasties became more and more popular in Kamakura as the thirteenth century advanced. We find in the Kamakura region many statues with the jeweled crowns, long, flowing sleeves, and lavishly decorative robes of Sung art. Statues of cast iron, a medium favored by Sung sculptors, are found throughout eastern Japan but are rare in Kyoto and Nara. The custom of making portrait sculptures of priests was also introduced into Kamakura from China with the Zen sect.

168. Amida Nyorai (Kamakura Daibutsu). Bronze; height, 11.5 m. About 1252. Kotoku-in, Kamakura.

Besides the imported genres, there are a number of portrait statues of laymen as well as some examples of nude statuary in the Kamakura region—sculptures that again reflect the demands of the warrior class for the new and the different.

FIGURE 39. Amida Triad (Amida Sanzon). (See also Figure 162.) A number of miniature five-storied pagodas and slips of paper with prayers to Amida written on them were discovered inside the head of the central figure of this triad, Amida Nyorai. One of the slips of paper bears the date of the eighth day, eleventh month, 1299, and the date of the production of the triad is placed around that time. Amida Nyorai sits with both hands raised in front of his chest in the mudra of expounding the Buddha's teachings—an unusual feature in an Amida Nyorai statue of the Kamakura period, as we have noted in the discussion of the work shown

in Figure 57. The jeweled crown, the long finger-nails, and the raised clay decorations on the robes all point to the influence of Sung art. The clay decorations were made from molds and glued to the wooden surface of the statue to produce a rough-textured effect that clearly reflects the tastes of eastern Japan in Kamakura times. (See Foldout 3.) The heads of the attendant Bodhisattvas are rather slender in comparison with their bodies. Their high and decoratively arranged topknots and their rippling robes are also recognizable as strong manifestations of the Sung style.

FIGURE 166. Yakushi Triad (Yakushi Sanzon). From a stylistic point of view, this triad should be classified as a work of the late Kamakura period, but the documentary evidence can be interpreted in a number of different ways. An inscription on Yakushi's left-hand attendant, Nikko Bosatsu,

reads: "Choyu of the rank *hogen* from Hoki Province [part of the present Tottori Prefecture], the twenty-first day of the third month, 1422." Perhaps the differences in style between the image of Yakushi Nyorai and those of his two attendants, Nikko Bosatsu and Gakko Bosatsu, can be attributed to major repair work done by Choyu on the latter two statues. The original triad was probably produced around the same time as the establishment of the Kakuon-ji, the temple where it is housed, in 1296.

The pose of Yakushi Nyorai, facing directly forward and holding a medicine jar with his hands placed one on top of the other, is rather unusual. The way in which the folds of his robes flow down over the pedestal is typical of Sung and Yuan Buddhist statuary and painting. His face is stern, and his robes are carved in clear, straightforward lines. In contrast, the faces of his attendants have gentle expressions, and their robes fall in numerous intricate folds. Their high, pointed topknots and long, flowing sleeves reflect the influence of Sung art. Each of the statues has a magnificent mandorla. That of Yakushi Nyorai contains images of the seven reincarnations of the Buddha, while those of the attendant Bodhisattvas are decorated with bright, lively representations of flying angels and *kalavinka*, or mythical Indian bird-women with bell-like voices. Each of the three pedestals is an elaborately shaped seven-tiered lotus flower. Although, in the main, these statues reflect the refined spirit of the Sung dynasty, parts of the pedestals show a bold, almost rough carving technique in which we see the untamed character of eastern Japan at work.

FIGURE 167. Fudo Triad (Fudo Sanzon). This cast-iron statuary group, which epitomizes the sculptural art of eastern Japan, is housed at the Daisen-ji, several miles northwest of Kamakura. Fudo Myo-o's eyes are opened wide, and his elbows are thrust out forcefully. In one hand he holds a sword and in the other a rope. One of his boy attendants, Kongara Doji, has a noble, dignified expression, while the other, Seitaka Doji, looks stern. All three statues have a heroic look, and their robes are quite plain. It goes without saying that this triad, in which so rough a material as iron has

been so skillfully employed, was made during the Kamakura period. Although the popularity of cast-iron statuary in the Kamakura region was partly due to the influence of Sung art, as we have noted before, a receptive atmosphere was necessary as well. If we recall here that *arabori* sculpture, in which the chisel marks were purposely left in the wood, was also widely produced in the Kamakura region, we can appreciate just how consistent the men of eastern Japan were in their artistic sensibilities when they accepted the harsh cast-iron sculpture of the Sung dynasty.

FIGURE 139. Mugaku Sogen (Bukko Kokushi). The Chinese priest Mugaku Sogen (Wu-hsueh Tsu-yuan) came to Japan in 1279 and founded the great Zen temple Engaku-ji in Kamakura. He died there in 1286, and this statue was probably produced not long after his death. The head is thrust forward slightly, the mouth is pursed in a thin line, and the eyes stare out piercingly. Indeed, the old priest's spirited personality has been captured brilliantly by the unknown artist. The folds of the robes are not molded but flow with a realistic air. There are many examples of portrait statues of Zen priests in the Kamakura region, but this is one of the oldest and best.

FIGURE 37. Uesugi Shigefusa. When Prince Munetaka, the second son of Emperor Gosaga, came to Kamakura in 1252 to be invested as shogun, his retainer Uesugi Shigefusa accompanied him from Kyoto. Shigefusa is famous as the founder of the Yamanouchi branch of the Uesugi clan in eastern Japan—a clan that produced many *kanrei* (shoguns' deputies or governor generals). Until the mid-thirteenth century, priests were generally considered the only subject appropriate for portrait sculpture, and this statue of Shigefusa is one of the first examples of a layman represented in this medium. Other statues of laymen, including those of Hojo Tokiyori (Fig. 138) at the Kencho-ji and Minamoto Yoritomo at the Tokyo National Museum, were produced in Kamakura around this time. With these works, the city had indeed given birth to an entirely different genre of sculpture.

Shigefusa is shown in the typical garb of a nobleman of his time. He has full cheeks and well-propor-

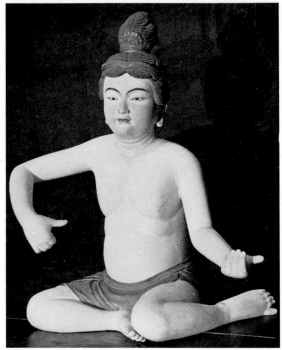

169. Benzai Ten. Painted wood; height, 96 cm. Dated 1266. Tsurugaoka Hachiman-gu, Kamakura.

tioned features. In contrast with his sharply alive face, his garments seem formalized and plain. Not only is this effect quite interesting sculpturally, but it also draws our attention to the face—the main objective in any portrait.

FIGURE 169. Benzai Ten. According to an inscription carved behind its knees, the production of this statue of the goddess Benzai Ten began on the twenty-ninth day of the ninth month in 1266. The work was then enshrined in the Bugakuin (Shrine of Music) on the grounds of the Tsuruga-oka Hachiman-gu, in Kamakura. In the Buddhist pantheon, Benzai Ten is both the goddess of good fortune and the goddess of music, and in the present representation her arms are positioned for playing a lute. The most important feature of the work is

that a nude body is shown in sculpture, although the statue is usually clothed in appropriate garments of silk. The lower half of the body, seated with bent knees, is slightly too small in comparison with the head, but the plump feminine flesh is well rendered. The hair, drawn up into a topknot and prettily showing the traces of a comb, also has a youthful appeal. Statues of naked figures were first produced in Japan during the Kamakura period. Although we also find them in Kyoto and Nara, they were even more popular in Kamakura, where we have such examples as the statues of Kukai (Kobo Daishi) at the Seiren-ji and of Jizo Bosatsu at the Emmei-ji. In nude statuary we can further appreciate the enthusiasm of the warriors of eastern Japan for the new and the exotic.

Glossary

NOTE: This glossary concerns itself with the names of Buddhist deities and other figures represented in the sculpture and painting of the Kamakura period. Existing Sanskrit or Chinese equivalents appear in parentheses after the Japanese names. Relevant illustration references are included in a number of the entries.

Aizen Myo-o (Ragaraja): a deity-king symbolic of love but represented with a wrathful outward appearance (Figs. 11, 76)

Amida Butsu: *see* Amida Nyorai

Amida Nyorai (Amitabha): the Buddha of the Western Paradise, symbolic of eternal life and boundless light; also called Amida Butsu. As the chief deity of the Jodo sect, which flourished during the Kamakura period, he is an extremely popular subject in the sculpture of that period. *See also* Amida Sanzon. (Figs. 8, 13, 25, 26, 30, 39, 52, 57, 78, 84, 94, 96, 100, 101, 103, 106, 116, 118, 123, 157, 162, 168)

Amida Sanzon: a triad consisting of Amida Nyorai and his two attendants, Kannon Bosatsu and Seishi Bosatsu (Figs. 13, 52, 162)

Ananda (Ananda): *see* Ju Dai Deshi

Anaritsu (Aniruddha): *see* Ju Dai Deshi

Anokudatsu Doji (Anavatapta): *see* Fudo Hachi Dai Doji

Basu Sennin (Vasu Vasistha): *see* Nijuhachibu Shu

Bato Kannon (Hayagriva): the Horse-head Kan-non, represented with an angry expression, a crown surmounted by the figure of a horse, and multiple heads and arms (Fig. 154)

Benevolent Kings: *see* Ni-o

Benzai Ten (Sarasvati): goddess of music, oratory, and good fortune (Fig. 169)

Bishamon Ten (Vaisravana): chief of the Four Celestial Guardians and ruler of the north; also called Tamon Ten. *See also* Shitenno. (Figs. 24, 32, 50, 73, 92)

Bon Ten (Brahma): guardian deity and ruler of the world of the living (Fig. 90)

Bosatsu (Bodhisattva): a class of Buddhist deities who have the power to attain enlightenment but refrain from doing so in order to work for the salvation of mankind. *See* Daimyoso Bosatsu, Gakko Bosatsu, Ho-onrin Bosatsu, Jizo Bosatsu, Kannon Bosatsu, Kongoho Bosatsu, Miroku Bosatsu, Monju Bosatsu, Nikko Bosatsu, Seishi Bosatsu.

Bukko Kokushi: *see* Mugaku Sogen

Butsu: *see* Nyorai

Byakko Shin: an indigenous Shinto deity adopted by the Kozan-ji, in Kyoto (Fig. 79)

Byodo-o: *see* Ju-o

Daibutsu: the Great Buddha—any statue of the Buddha greater than *joroku* (about five meters) in height (Fig. 168)

Daiitoku Myo-o (Yamantaka): one of the Five Great Kings of Light and guardian of the west. *See also* Go Dai Myo-o. (Fig. 20)

Daikaku Zenji: *see* Rankei Doryu

Daimyoso Bosatsu: one of the attendants of Miroku Butsu (Fig. 3)

Dainichi Nyorai (Mahavairocana): the Great Sun Buddha and the central deity of Esoteric Buddhism (Figs. 17, 49, 60, 61, 145, 165)

Daito Kokushi: *see* Shuho Myocho

Doji (Kumara): a class of Buddhist deities who are boys between the ages of eight and twenty and who serve as attendants to other deities, notably Fudo Myo-o. *See* Fudo Hachi Dai Doji, Fudo Sanzon, Zennishi Doji.

Eight Attendants of Fudo Myo-o: *see* Fudo Hachi Dai Doji

Eison: a Japanese priest (1201–90) noted for his revival of the Ritsu sect (Figs. 133, 158)

Eki Doji (Matisadhu): *see* Fudo Hachi Dai Doji

Eko Doji (Matijvala): *see* Fudo Hachi Dai Doji

Eleven-headed Kannon: *see* Juichimen Kannon

Emma-o: *see* Ju-o

Five Great Kings of Light: *see* Go Dai Myo-o

Followers of the Four Celestial Guardians: *see* Shitenno Kenzoku

Four Celestial Guardians: *see* Shitenno

Four Indian Lokala: *see* Shitenno

Fudo Hachi Dai Doji: the Eight Attendants of Fudo Myo-o, namely Anokudatsu Doji, Eki Doji, Eko Doji, Kongara Doji, Seitaka Doji, Shitoku Doji, Shojobiku Doji, and Ukubaga Doji (Fig. 81)

Fudo Myo-o (Acala): the central deity of the Five Great Kings of Light. He is depicted with a wrathful countenance, a sword in one hand, and a rope in the other. *See also* Fudo Sanzon, Go Dai Myo-o. (Figs. 21, 29, 31, 40, 56, 77, 105, 167)

Fudo Sanzon: a triad consisting of Fudo Myo-o

and his two attendants, Seitaka Doji and Kongara Doji (Figs. 27–29, 167)

Fujin: god of wind. Although he does not appear in any of the Buddhist sutras, this deity is portrayed in Japanese art as one of the attendants of the Thousand-armed Kannon, together with Raijin, the god of thunder. (Fig. 65)

Fukukenjaku Kannon (Amoghapasa): one of the many manifestations of Kannon Bosatsu; also called Fukukensaku Kannon (Figs. 9, 12)

Fukukensaku Kannon: *see* Fukukenjaku Kannon

Furuna (Purna): *see* Ju Dai Deshi

Gakko Bosatsu (Candraprabha): the Moonlight Bodhisattva, one of the two attendants of Yakushi Nyorai. *See also* Yakushi Sanzon. (Fig. 166)

Gembo: *see* Hosso Rokuso

Gempin: *see* Hosso Rokuso

Genku: *see* Honen

Go Dai Myo-o: the Five Great Kings of Light, namely Daiitoku Myo-o, Fudo Myo-o, Gozanze Myo-o, Gundari Myo-o, and Kongo Yasha Myo-o; also called Go Dai Son (Figs. 19–23)

Go Dai Son: *see* Go Dai Myo-o

god of thunder: *see* Raijin

god of wind: *see* Fujin

Godotenrin-o: *see* Ju-o

Gokan-o: *see* Ju-o

Gozanze Myo-o (Trailokyavijaya): one of the Five Great Kings of Light and guardian of the east. *See also* Go Dai Myo-o. (Fig. 23)

Great Buddha: *see* Daibutsu

Great Sun Buddha: *see* Dainichi Nyorai

Gundari Myo-o (Kundali): one of the Five Great Kings of Light and guardian of the south. *See also* Go Dai Myo-o. (Fig. 22)

Gyoga: *see* Hosso Rokuso

Gyoki: a Japanese priest (668–749) who made important contributions to the establishment of Buddhism in Japan (Fig. 128)

Hachiman: the name under which Emperor Ojin (reigned 270–310) is honored as a Shinto god. Hachiman is sometimes portrayed as a Buddhist priest. (Figs. 86, 108)

Henjo-o: *see* Ju-o

Hojo Tokiyori: a Japanese statesman (1226–63) and the fifth regent of the Kamakura shogunate (Fig. 138)

Honen: a Japanese priest (1133–1212) who established the Jodo sect in Japan. He is also called Genku. (Fig. 125)

Ho-onrin Bosatsu: one of the attendants of Miroku Bosatsu (Fig. 3)

Horse-head Kannon: *see* Bato Kannon

Hosso Rokuso: the Six Patriarchs of the Hosso Sect, namely Gembo, Gempin, Gyoga, Joto, Shin'ei, and Zenju. According to the traditions of the Kofuku-ji, these six priests lived during the Nara period (646–794) and were active in establishing the Hosso sect in Japan, but there is little historical evidence concerning them. (Figs. 33–35, 55, 146, 147)

Hotto Kokushi: *see* Shinchi Kakushin

Jie Daishi: *see* Ryogen

Jikoku Ten (Dhrtarastra): one of the Four Celestial Guardians and ruler of the east. *See also* Shitenno. (Fig. 5)

Jinja Taisho: a demonlike deity said to have protected the Chinese priest Genjo (Hsuan-chuang) when he crossed the desert to India in the seventh century (Fig. 111)

Jizo Bosatsu (Ksitigarbha): the Bodhisattva who guards children and protects travelers (Figs. 15, 45, 58, 83, 152, 156, 161)

Joto: *see* Hosso Rokuso

Ju Dai Deshi: the Ten Great Disciples of the Buddha, namely Ananda, Anaritsu, Furuna, Kasennen, Makakasho, Mokukenren, Ragora, Sharihotsu, Shubodai, and Ubari. These legendary Indian priests are said to have been the followers of the historical Buddha, Shaka Nyorai. (Figs. 113, 114, 121, 122, 126)

Juichimen Kannon (Ekadasamukha): the Eleven-headed Kannon, who symbolizes the all-seeing power of Kannon Bosatsu (Figs. 117, 154, 159)

Juntei Kannon (Cundi): the Kannon who symbolizes purity and grants protection against illness and natural disasters (Figs. 74, 154)

Ju-o: the Ten Kings of Buddhism, namely Byodo-o, Emma-o, Godotenrin-o, Gokan-o, Henjo-o,

Shinko-o, Shoko-o, Sotei-o, Taizan-o, and To-tei-o. These fierce-looking deities, probably of Chinese origin, judge the dead in the underworld. (Figs. 36, 160)

Kannon Bosatsu (Avalokitesvara): one of Amida Nyorai's attendant Bodhisattvas and one of the most popular of all Buddhist deities. Kannon Bosatsu can assume any form necessary to save human souls. *See* Amida Sanzon, Bato Kannon, Fukukenjaku Kannon, Juichimen Kannon, Juntei Kannon, Nyoirin Kannon, Senju Kannon, Sho Kannon, Suigetsu Kannon.

Kannon of Water and Moon: *see* Suigetsu Kannon

Kasennen (Katyayana): *see* Ju Dai Deshi

Kichijo Ten (Srimahadevi): goddess of beauty, wealth, and good fortune; one of Bishamon Ten's attendants; also called Kissho Ten (Fig. 63)

Kissho Ten: *see* Kichijo Ten

Koben: *see* Myoe

Kobo Daishi: *see* Kukai

Komoku Ten (Virupaksa): one of the Four Celestial Guardians and ruler of the west. *See also* Shitenno.

Kongara Doji (Kimkara): *see* Fudo Hachi Dai Doji, Fudo Sanzon

Kongoho Bosatsu (Vajraratna): one of the Five Great Bodhisattvas (Fig. 44)

Kongo Rikishi (Vajrapani): *see* Ni-o

Kongo Yasha Myo-o (Vajrayaksa): one of the Five Great Kings of Light and guardian of the north. *See also* Go Dai Myo-o. (Fig. 19)

Kujaku Myo-o (Mayurasana): the Peacock King, always shown mounted on a peacock (Fig. 109)

Kukai: a celebrated Japanese priest (774–835) who traveled to China, introduced the Shingon sect from there into Japan, and founded the famed Kongobu-ji on Mount Koya in 816. He is also known as Kobo Daishi. (Fig. 104)

Kuya: a Japanese priest (903–72) who traveled throughout Japan reciting prayers for the salvation of all men. He founded the Rokuhara Mitsu-ji in Kyoto and is popularly known as the Saint of the Common Folk. (Figs. 72, 131, 153)

Makakasho (Mahakasyapa): *see* Ju Dai Deshi

Minamoto Yoritomo: one of Japan's most gifted warriors and statesmen (1147–99). Having led the Minamoto clan to victory over the Taira in the Gempei War (1180–85), he established the Kamakura shogunate, which marked the beginning of Japan's long age of military feudalism. (Fig. 140)

Miroku Bosatsu (Maitreya): the Buddha of the Future; also called Miroku Butsu (Figs. 3, 46, 47, 51, 97, 98, 110, 164)

Miroku Butsu: *see* Miroku Bosatsu

Misshaku Kongo (Guhyapada Vajra): *see* Ni-o

Mokukenren (Maudgalyayana): *see* Ju Dai Deshi

Monju Bosatsu (Manjusri): the Bodhisattva who symbolizes the Buddha's wisdom and compassion. He is frequently shown astride a lion. (Figs. 120, 151)

Mugaku Sogen (Wu-hsueh Tsu-yuan): a Chinese Zen priest (1226–86) who came to Japan in 1278 at the invitation of the sixth shogunal regent, Hojo Tokimune, and founded the Engaku-ji in Kamakura. He is also called Bukko Kokushi. (Fig. 139)

Mujaku (Asanga): an Indian theologian from the province of Gandhara who probably lived in the early fifth century and is known in Japan as the legendary founder of the Hosso sect (Figs. 16, 48, 149)

Myoe: a Japanese priest (1173–1232) noted for his revival of the Kegon sect. He is also called Koben. (Fig. 130)

Myo-o (Vidyaraja): fierce-looking Buddhist deities who symbolize Dainichi Nyorai's wrath against the wicked. *See* Aizen Myo-o, Daiitoku Myo-o, Fudo Myo-o, Go Dai Myo-o, Gundari Myo-o, Kongo Yasha Myo-o, Kujaku Myo-o.

Naraen Kongo (Narayana Vajra): *see* Ni-o

Nijuhachibu Shu: the Twenty-eight Followers of Kannon, including a variety of gods, goddesses, demons, and holy hermits such as Basu Sennin. Their exact identities differ according to various sources. (Fig. 38)

Nikko Bosatsu (Suryaprabha): the Sunlight Bodhisattva, one of the two attendants of Yakushi Nyorai. *See also* Yakushi Sanzon. (Fig. 166)

Ni-o: the Benevolent Kings, who stand as guardians on either side of a temple gate. The one on the right, portrayed with a closed mouth, is called Naraen Kongo, while the one on the left, portrayed with an open mouth, is called Misshaku Kongo. Together they are known as the Kongo Rikishi. (Figs. 2, 41–43, 53, 69, 89, 91, 155)

Nyoirin Kannon (Cintamanicakra): one of the manifestations of Kannon Bosatsu (Fig. 154)

Nyorai (Tathagata): a fully enlightened Buddha; also called Butsu. *See* Amida Nyorai, Dainichi Nyorai, Shaka Nyorai, Yakushi Nyorai.

Peacock King: *see* Kujaku Myo-o

Ragora (Rahula): *see* Ju Dai Deshi

Raijin: god of thunder. Although he does not appear in any of the Buddhist sutras, this deity is portrayed in Japanese art as one of the attendants of the Thousand-armed Kannon, together with Fujin, the god of wind. (Fig. 66)

Rankei Doryu (Lan-ch'i Tao-lung): a Chinese Zen priest (1213–78) who came to Japan in 1246 and founded the Kencho-ji in Kamakura with the support of the fifth shogunal regent, Hojo Tokiyori. He is also called Daikaku Zenji. (Fig. 136)

Ryogen: a Japanese priest (912–85) of the Tendai sect who was chief of the temples on Mount Hiei, in Kyoto. He is also called Jie Daishi. (Fig. 127)

Ryutoki: literally, "dragon lantern demon," who, together with Tentoki, holds up a lantern as an offering to the Buddha (Fig. 67)

Saint of the Common Folk: *see* Kuya

Seishi Bosatsu (Mahasthamaprapta): one of Amida Nyorai's attendant Bodhisattvas. *See also* Amida Sanzon. (Figs. 7, 13, 52, 162)

Seitaka Doji (Cetaka): *see* Fudo Hachi Dai Doji, Fudo Sanzon

Senju Kannon (Sahasrabhuja): the Thousand-armed Kannon, one of the many manifestations of Kannon Bosatsu. Most representations have only forty or forty-two arms. (Figs. 70, 71, 154)

Seshin (Vasubandhu): an Indian theologian of the early fifth century, the younger brother of Mujaku (Figs. 54, 59, 148)

Shaka Nyorai (Sakyamuni): the historical Buddha and founder of Buddhism, said to have been born into a princely family of Nepal around the sixth century B.C. (Figs. 14, 99, 102, 107, 115)

Sharihotsu (Sariputra): *see* Ju Dai Deshi

Shikkongo Shin (Vajradhara): a fierce-looking guardian deity; also called Shukongojin (Fig. 112)

Shinchi Kakushin: a Japanese priest (1207–98) who founded the Fuke branch of the Zen sect. He is also called Hotto Kokushi.

Shin'ei: *see* Hosso Rokuso

Shinko-o: *see* Ju-o

Shinran: a Japanese priest (1173–1262) and controversial founder of the Jodo Shin sect (Fig. 132)

Shitenno: the Four Celestial Guardians; originally the Four Indian Lokala, who lived on Mount Sumeru, center of the Buddhist universe, and ruled over the four cardinal points of the compass. They are Bishamon Ten (also known as Tamon Ten), Jikoku Ten, Komoku Ten, and Zocho Ten. (Figs. 5, 6, 24, 32, 50, 73, 92)

Shitenno Kenzoku: the Followers of the Four Celestial Guardians (Fig. 82)

Shitoku Doji: *see* Fudo Hachi Dai Doji

Shitta Taishi (Prince Siddhartha): the name by which the historical Buddha, Shaka Nyorai, was known as a boy (Figs. 119, 124)

Shojobiku Doji: *see* Fudo Hachi Dai Doji

Sho Kannon (Aryavalokitesvara): one of the many manifestations of Kannon Bosatsu (Figs. 93, 154)

Shoko-o: *see* Ju-o

Shotoku Taishi: a Japanese statesman (574–622) renowned as one of the leading propagators of Buddhism and the builder of many temples (Fig. 85)

Shubodai (Subhuti): *see* Ju Dai Deshi

Shuho Myocho: a Japanese Zen priest (1282–1337), founder of the Daitoku-ji in Kyoto. He is also known as Daito Kokushi. (Fig. 135)

Shukongojin: *see* Shikkongo Shin

Shunjobo Chogen: a Japanese priest (1121–1206) noted for his fund-raising campaign for the restoration of the Todai-ji after the Great Nara Fire of 1180 (Figs. 10, 137)

Six Patriarchs of the Hosso Sect: *see* Hosso Rokuso

Sotei-o: *see* Ju-o

Suigetsu Kannon: the Kannon of Water and Moon, one of the thirty-three manifestations of Kannon Bosatsu (Fig. 144)

Taira Shigemori: a Japanese warrior and statesman (1138–79), eldest son of Taira Kiyomori, powerful leader of the Taira clan (Fig. 142)

Taizan-o: *see* Ju-o

Tamon Ten: *see* Bishamon Ten

Ten (Deva Loka): literally, "celestial beings"—a class of Buddhist deities of a heavenly nature. *See* Benzai Ten, Bishamon Ten, Jikoku Ten, Kichijo Ten, Komoku Ten, Shitenno, Zocho Ten.

Ten Great Disciples of the Buddha: *see* Ju Dai Deshi

Ten Kings of Buddhism: *see* Ju-o

Tentoki: literally, "heavenly lantern demon," who, together with Ryutoki, holds up a lantern as an offering to the Buddha (Figs. 80, 163)

Thousand-armed Kannon: *see* Senju Kannon

Totei-o: *see* Ju-o

Twenty-eight Followers of Kannon: *see* Nijuhachi-bu Shu

Ubari (Upali): *see* Ju Dai Deshi

Uesugi Shigefusa: a Japanese warrior and statesman who lived during the thirteenth century and founded the powerful Yamanouchi branch of the Uesugi clan (Fig. 37)

Ukubaga Doji (Ukubhaga): *see* Fudo Hachi Dai Doji

Unkei: one of Japan's most brilliant sculptors (d. 1223), creator of the new Kamakura-period style of sculpture (Fig. 18)

Yakushi Butsu: *see* Yakushi Nyorai

Yakushi Nyorai (Bhaisajyaguru): the Buddha of Healing and Medicine. He is also called Yakushi Butsu. *See also* Yakushi Sanzon. (Figs. 87, 166)

Yakushi Sanzon: a triad consisting of Yakushi

Nyorai and his two attendants, Nikko Bosatsu and Gakko Bosatsu (Fig. 166)

Yuima (Vimalakirti): a wealthy merchant of India who, according to Buddhist legend, heard the teachings of the Buddha and, although he was only a layman, became an eloquent orator for the faith (Figs. 75, 150)

Zemmyo Shin: an indigenous Shinto deity adopted by the Kozan-ji, in Kyoto (Fig. 68)

Zendo (Shan-tao): a Chinese priest (613–81) who made important contributions to the formation of the Jodo (Ching-t'u) sect in China (Figs. 129, 134)

Zenju: *see* Hosso Rokuso

Zennishi Doji: one of the attendants of Bishamon Ten (Fig. 64)

Zocho Ten (Virudhaka): one of the Four Celestial Guardians and ruler of the south. *See also* Shiten-no. (Fig. 6)

TITLES IN THE SERIES

Although the individual books in the series are designed as self-contained units, so that readers may choose subjects according to their personal interests, the series itself constitutes a full survey of Japanese art and will be of increasing reference value as it progresses. The following titles are listed in the same order, roughly chronological, as those of the original Japanese editions. Those marked with an asterisk (*) have already been published or will appear shortly. It is planned to publish the remaining titles at about the rate of eight a year, so that the English-language series will be complete in 1975.

The "weathermark" identifies this book as having been planned, designed, and produced at the Tokyo offices of John Weatherhill, Inc., 7-6-13 Roppongi, Minato-ku, Tokyo 106. Book design and typography by Meredith Weatherby and Ronald V. Bell. Layout of photographs by Sigrid Nikovskis. Composition by General Printing Co., Yokohama. Color plates engraved and printed by Nissha Printing Co., Kyoto. Gravure plates engraved and printed by Inshokan Printing Co., Tokyo. Monochrome letterpress platemaking and text printing by Toyo Printing Co., Tokyo. Bound at the Makoto Binderies, Tokyo. Text is set in 10-pt. Monotype Baskerville with hand-set Optima for display.